Cakes to Dream On

Cakes to Dream On

A MASTER CLASS IN DECORATING

COLETTE PETERS

JOHN WILEY & SONS, INC.

Published by John Wiley & Sons, Inc., Hoboken, New Jersey

Published simultaneously in Canada

For general information on our other products and services or for technical support, please contact our Customer Care Department within the United States at (800) 762-2974, outside the United States at (317) 572-3993 or fax (317) 572-4002.

Wiley also publishes its books in a variety of electronic formats. Some content that appears in print may not be available in electronic books. For more information about Wiley products, visit our web site at www.wiley.com.

Library of Congress Cataloging-in-Publication Data:

Peters, Colette.

 Cakes to dream on / By Colette Peters.

 p. cm.

 ISBN 0-471-21462-0 (cloth)

 1. Cake decorating. I. Title.

 TX771.2.P43 2004

 641.8'6539—dc22

 2004018712

Printed in the United States of America

10 9 8 7 6 5 4 3 2

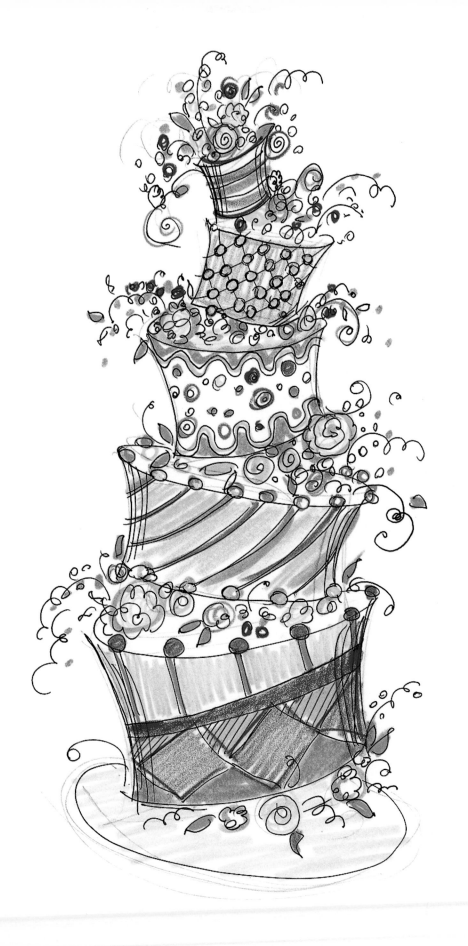

Contents

Thank You's

I could not have completed this book without the dedicated help of my faithful assistant, Ryan Hurley. Ryan, like Radar O'Riley, knew what I was thinking before I did, and handed me tools before I could think of their names. He also kept things going in the kitchen when I was working on this book. He's the best assistant anyone could ever have.

Ellen Silverman and Marina Melchin were great in doing the photography and styling for this book. They were the reason I had such beautiful photos.

Thanks to Anja Riebensahm for helping me put many of my ideas into words. I also want to thank my interns—Cara Chollick and Teruka Nagataki—for pitching in with so much of their time, beyond the call of duty. To Gigi Burton, for helping me pull things together at the last minute. Without their humor, good natures, and hard work I couldn't have gotten through some tough times. Also, thanks to Peter Chollick, for his Photoshop help and fabulous delivery skills.

I want to thank Donna Ferrari, of Brides Magazine, who has been my friend for almost twenty years, for her fertile imagination and inventive suggestions that helped make so many of my ideas a reality.

To Ewald Notter, of the Notter School of Pastry Arts, who has been very generous and supportive to me over the years. And to Chris Hamner, his former assistant, for his patience in teaching me the technique of growing sugar crystals on gumpaste beads, and making silicone molds.

To my brother-in-law, Pat Riley, who came up with the title of this book.

To my dad, who never got to see this book, but would have loved to have shown it to all the neighbors.

To Jane Dystel, my agent, who has been very patient with me through the entire production of this book.

To my editor, Pam Chirls, who helped me through some tough times with my manuscript.

Introduction

For as long as I can remember I wanted to be an artist. A painter in New York City, to be exact, was what I decided when I was 11. I never dreamed of using food as art, although everything I did seemed to be pointing me in that direction. I worked in the local bakery decorating cookies. I worked at Dunkin' Donuts, decorating the donuts out of boredom. I worked in a local restaurant. One of the family jokes was the story about when I baked my first cake, at least it was my earliest memorable one, when I was about eight years old. I had been visiting my Aunt Rose and Uncle Bill in their somewhat rustic house, with their unfamiliar old-fashioned oven, and I wanted to make a cake for my aunt as a surprise. I mixed up the batter and asked my uncle to turn on the oven for me. He and I both looked bewilderingly at the oven, both of us trying to figure how to light it. (I guess he had never used it before.) Finally, I looked inside and saw a flame and figured it was lit, so I put the cake inside.

I kept checking on that cake all day to see if it was done. Finally, eight hours later, knowing my aunt was due home soon and wanting to finish it before she arrived, I felt the cake and it seemed firm enough. So I iced the cake and left for home.

Well, my aunt called later to tell me what a wonderful cake it was. Unfortunately, she told my mother, it was totally raw inside, since we only had the pilot light on! But she wanted me to know that she scraped the icing off and baked it correctly, and it was delicious!

In art school, I was given a piece of marble in sculpture class and shown how to carve it. I wanted to do something different, so I turned it into a wedge of Marble Cake, complete with thick, brown acrylic paint for the icing. In graduate school, I did paintings using thickened acrylic paint, which I piped onto the canvas out of ketchup squeeze bottles, as if it were icing. Wayne Thiebaud and Claus Oldenberg were my favorite artists because I loved the way each of them depicted cakes and pastries, using thick luxurious paint as if it were icing. I made cakes for friends and family as a hobby, but never took baking that seriously because I was still pursuing painting as a career.

My assistant and I had to create this prize winning cake for the Television Food Network's first "Wedding Cake Challenge" from start to finish in six hours in front of an audience. The theme of the competition was the Four Seasons, and we depicted each one with piped seasonal flowers on each tier, using the brush embroidery technique.

One of the main ingredients in my cakes is humor. I love it when I make a cake that has some sort of pun, play on words, subtle joke, or gravitational twist. I am always being asked where I get your my ideas. Well, I'm tempted to say something like "The Bronx", but what I do say is that looking around is where I get ideas. I get ideas from architecture and decorative plaster detailing, I get ideas from furniture and fabrics and sewing. I get ideas from traveling, paintings, commercials, movies, china patterns, sculptures, wedding gowns, other cakes, donuts, and just plain "tinkering." Sometimes I'll wake up in the middle of the night with an idea I just dreamed and quickly feel around for a piece of paper and a pencil. In the morning, I can't always understand what I've drawn, but it's usually pretty funny.

Anyway, I hope that this book will fill your mind with new ideas and some practical knowledge, to boot. And I hope you enjoy looking at and making some of these cakes as much as I did!

How to Use this Book

If you've bought this book, you're probably toying with the idea of making a cake. So, you will want to know how to get the most out of this book. The first thing you will come upon is a section called "How to Make a Decorated Cake," which will explain all about the construction of a multi-tiered cake. This is essential if you have never made a tiered cake before because when a cake is to be taller than one tier, there are certain gravitational concerns to keep its structure together. Also, if you are going to make a tier that is taller than 4 inches, you need to read the section that deals with how to make a double-layered tier, which involves a bit more structure than a shorter tiered cake.

If you plan on being a little more ambitious, you can try to make one of the crooked cakes. This also involves some extra dowels and even more attention to structure, so read the section on constructing crooked cakes before attempting to make one, or you may have a cake tumbling off the table.

All the cakes in this book are covered with rolled fondant, which involves first *crumb-coating* the cake with buttercream or ganache before finishing the cake with a layer of fondant. One of the 12 steps to a decorated cake includes how to use fondant and all the techniques involved with icing the cakes.

Toward the back of the book "Masterclass Techniques and Materials," tells you all you need to know about dividing cakes for decorating, sculpting, making bases, and creating drums; it even offers delivery tips. Reading this before you start to decorate will make the process much easier.

The sugarwork techniques you need for decorating each of the cakes are next, so refer to these before you start to decorate, in case there is something that needs to be prepared ahead of time. In the beginning of the directions for each cake, I list all the techniques used for that particular cake, so you can see in advance what you will need to know. Read the sections that pertain to that cake before you proceed.

Once you feel you understand the steps and techniques for the cake that *captures* your dream, just get going and enjoy the process. I hope you'll find it as much fun and as gratifying as I do.

How to Make a Decorated Cake

Plan the **architecture** of the cake.

Decide how many **servings** you need so you can design the right-size cake.

Choose appropriate **cake pans** for the size and shape you are planning.

Make all of the **decorations** that can be prepared in advance.

Make the **base** that will hold the cake and cover it with royal icing.

Bake the cakes and let them cool. Also prepare the **fillings** and **icings**.

Make **foamcore boards** for each tier.

Cut the cakes, fill them, and **crumb-coat** them. Chill well before decorating.

Cover the cakes with **fondant**.

Insert **dowels** for double- or multitiered cakes.

Stack the cakes on the base.

Put at least one supporting **dowel** through the entire cake to reinforce the cake for delivery.

Decorate the cake.

How to Start

SERVINGS

Knowing the number of servings is the first thing that determines the size of the cake. You can't, for example, make a cake for 25 people that's 15 tiers high. Nor, on the other hand, can you make a cake for 300 that's only one tier high (unless you have really wide doorways). Most cake recipes yield approximately 6 cups of batter, or enough to serve about 20 people.

The following table indicates how many servings you can expect to get out of cakes of various shapes and sizes. This chart will also help you determine how many recipes of cake you will need. To ensure maximum baking efficiency, each pan should be filled only halfway. Although serving sizes will vary depending on who is cutting the cake, the numbers of servings listed below are based on pieces about 3 to 4 inches high and 1 by 2 inches wide.

Baking a cake is easy. What you do with that cake next is a little more difficult. Before you bake the cake, the first things you have to determine are what the occasion is, the design you want to make, and the number of people you need to feed.

CAKE PANS

Cake Shape and Size	Number of Servings	Cake Shape and Size	Number of Servings
ROUND, HEXAGON, OR OCTAGON		SQUARE	
		6 inch	15
6 inch	10	8 inch	25
8 inch	20	10 inch	40
10 inch	30	12 inch	70
12 inch	50	14 inch	100
14 inch	70	16 inch	125
16 inch	100		
18 inch	125	PETAL SHAPE	
		6 inch	8
OVAL		9 inch	20
8 inch	15	12 inch	35
10 inch	25	15 inch	60
13 inch	40		
16 inch	60	HEART SHAPE	
		6 inch	8
		9 inch	20
		12 inch	45
		15 inch	70

DECORATIONS

Make as many decorations as you can in advance so you don't have to rush to finish them at the last minute.

CAKE BASES

The board that the cake sits on may not seem like an important thing to think about, but when you start making cakes that are large and heavy, the board will soon become very important. The base must be strong enough to support the cake's weight, and it should look like it's part of the overall design, not something simply utilitarian. I often make the base at least 4 inches larger than the bottom cake tier, usually larger. If you plan to put flowers or other decorations around the bottom edge, make sure the base is big enough to accommodate them. I think that a wider base makes the cake look more impressive.

Bases can be made from many materials, including wood, Plexiglas, metal, foamcore, and fiberboard. Wood and Plexiglas are strong, but also heavy and difficult to cut into circles or odd shapes, and Plexiglas can be very expensive. I find that ready-made ½-inch-thick fiberboard drums and ½-inch-thick foamcore boards are the strongest and lightest choices. They are available at cake-decorating stores and at craft stores. You can cover these boards with thinned royal icing to match the cake and not worry about the board warping. Another advantage to these is that when you are constructing your cake, you may need to insert a dowel into the entire cake for support. This dowel should also go into the board to keep the cake from sliding, and these are the only kinds of boards that will allow you to do this.

You can make your own bases by gluing together two or more sheets of $3/16$-inch-thick foamcore, then cutting it with an X-acto knife to the size and shape you want. Unless the cake is very small (6 to 9 inches), don't use a single layer of foamcore because the board may bend from the weight of the cake when you lift it. If a base bends, it will crack the cake.

Covering the base with thinned royal icing is one way to give the board a professional finish. You can tint the icing to match the color of the cake or to contrast with it. To cover a board with royal icing, thin enough icing to

cover the board by adding a few drops of water at a time until the icing is the consistency of thick syrup. Add a few drops of liquid food coloring to the icing to match a colored cake, if you wish. Pour the icing onto the board and smooth it with an offset spatula. Let it dry overnight. Attach a ribbon around the edge of the board with white or hot glue. The ribbon should be the same thickness as the edge of the board.

Another way to cover a board is to use food-grade foil. This can be found at cake-decorating stores. Place the paper on the board with about 2 inches extra all around to wrap under. Tape the paper under the board, stretching the sections tightly as you go.

CAKES AND FILLINGS

Create the cakes, fillings, and icings that you can mix and match.

CAKE ARCHITECTURE

Once you know what size and shape cake you are going to make, then you can bake the cakes and make the icing. I always bake cakes in pans whose bottoms are covered with a piece of parchment, which I first spray with a coating of vegetable oil. By doing this, you can cool the cakes completely in the pans, refrigerate them, and then remove them easily when they are cold. Just run a knife or metal spatula around the inside of the pan to separate the cake from the sides. A cake that is properly baked will pull away from the sides of the pan when it is done, so there shouldn't be much sticking. The cake will then come out of the pan easily with a quick tap when held upside down. And since the cake is now cool, it will be firm enough to hold together. Cakes crack if they are removed from the pan too soon.

To prepare a multitiered cake, first you need a support on which to place each tier, such as cardboard or foamcore. You can buy ready-made cardboard, which comes in the same sizes and shapes as most cake pans, or you can make your own cakeboard out of foamcore, which I recommend. To do this, place the bottom of the pan in which your cake was baked on a piece of foamcore, trace the outline, and cut it out with a sharp X-acto knife.

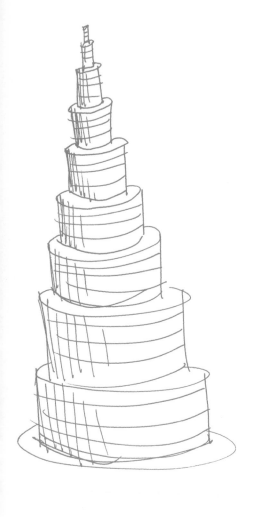

When you are ready to construct the cake, slice each cake horizontally to prepare it for the filling. My cakes are usually made in two pans, with each cake sliced in half. This will give you four layers of cake and three layers of filling. Place the bottom of one of the split layers on your foamcore board, attaching it with a little of the filling. Spread some filling on the cake and then place the next layer of cake on top. Continue adding layers and filling, but leave the bottom of one of the layers for the top so the top of the cake is flat. Place this layer on top of the last filled layer, with the bottom up. At this point, you can trim the layer to make sure that it is perfectly horizontal and straight. Crumb-coating is a layer of icing you spread on the cake to seal in the cake crumbs, smooth the surface, and help the fondant adhere to the sides of the cake. Next, crumb-coat the whole cake with a thin layer of icing, filling any gaps between the layers so that the cake is perfectly smooth for receiving the fondant layer. Refrigerate until the icing is firm.

FONDANT

Now you are ready to cover the cake with fondant. Dust a clean, smooth surface with cornstarch or confectioners' sugar. This will prevent the fondant from sticking to the table. Also, make sure you have enough fondant to cover the entire cake. Here is a guide to how much fondant you will need to cover a 4-inch-high cake:

Cake Shape and Size	Pounds of Fondant	Cake Shape and Size	Pounds of Fondant
ROUND, OCTAGON, PETAL, HEART, OR OVAL		SQUARE	
6 inch	1½	6 inch	2
8 inch	2	8 inch	2½
10 inch	2½	10 inch	3
12 inch	3	12 inch	4
14 inch	4	14 inch	5
16 inch	5	16 inch	6½

Roll out the fondant with a rolling pin, giving it a half-turn after every few rolls to make sure it's not sticking to the table and to make sure that you're rolling it evenly. It should be about ¼ inch thick when you put it on the cake. Slide your hands, palms up, under the fondant and center it on top of the cake (Figure 1). Smooth the top of the cake, then smooth the top edge. Pull the folds sideways to flatten them, then gently press to the side of the cake. Cut off the excess fondant around the bottom edge with a pizza cutter. (You can reuse the extra fondant; just make sure there is no residue from the crumb-coating before you store it—this could get moldy eventually.)

FIGURE 1

DOWELS

When you have more than one tier, you need to put dowels in the lower tiers to support the weight of the other tiers. Start stacking the cakes on the prepared royal icing–covered base. First, place the bottom tier on the base, using a little royal icing to "glue" the cake in place. Take the pan in which the next smaller tier was baked in and place it on top of the bottom tier. Use a toothpick to emboss the outline of the pan in the fondant so you will have a boundary within which to place the dowels. Insert a dowel all the way into the center of the bottom tier and mark the place on the dowel where it is level with the top of the fondant. Remove the dowel and cut it at the mark with a pair of clippers. Cut as many dowels as you need for this tier, making them the same height as the first dowel. Insert dowels in the center and around the inside of the outline—the wider the tier, the more dowels you will need. Smaller tiers need fewer dowels, and the top tier doesn't need any unless you are putting a heavy ornament on top (Figure 2).

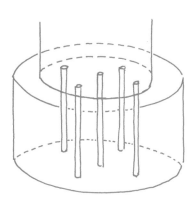

FIGURE 2

STACK THE CAKES

Use royal icing to "glue" one tier on top of another tier.

If you are going to deliver the cake stacked, you should put a dowel through the entire cake to keep it from shifting during delivery. First, measure the height of the whole cake, then cut a dowel to that length. Sharpen one end of the dowel to a point and push it through all of the tiers and the boards. When you get near the top, use a hammer to gently tap the dowel through the rest.

DECORATIONS

Finally, you are ready to start decorating. Whew!

Double-Layered Cakes

If your design calls for a tier that is going to be much more than 4 inches high, you need to separate it, as if it were two tiers, so that the slices of cake are not bigger than the plate. Start by stacking the layers on a foamcore board, as mentioned earlier, but rather than just piling cake layer upon cake layer, stop midway (for example, if the cake is going to be 6 inches high, stop at 3 inches) and crumb-coat the cake. Then, put a piece of rolled fondant *only* on the top of the cake, and insert dowels. Place the next layer of cake, which will also be on a board, on top of the fondant with the dowels. Finally, crumb-coat the whole cake. Chill and then cover the cake with fondant as you normally would. Insert a sharpened dowel through the entire cake (Figure 3).

When the upper tier is cut, the knife will go down until it hits the middle board. That tier will be cut, the board will be removed, and then the bottom tier will be cut. So, when you are figuring how many servings you'll have, if the cake is 10 inches high, which usually serves 30, you should figure that it will serve 60, since it is a double layer.

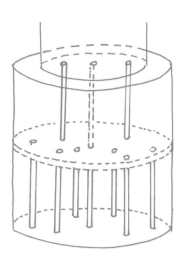

FIGURE 3

Making a Cake Crooked, on Purpose

I made my first topsy-turvy cake for a book by John Loring entitled *Tiffany Taste*, in 1985. I was asked by him to make something wacky and whimsical, but had no other guidelines, so I was a little nervous. I thought making a crooked cake would be playful and ironic, since making a cake as straight as possible so it doesn't fall over is the number one goal of every cake maker. I don't think I had ever before seen a cake made crooked on purpose. Since it didn't fall over, I had the confidence to make many crooked cakes in different configurations, colors, sizes, and styles.

The main thing to remember when making a crooked cake is that you need to have enough stabilizing supports in the cake to keep it from falling over, especially if you have to deliver it in its completed state, which I don't recommend but is sometimes unavoidable. (Try to put the cake together when you get to the party if at all possible.) I use sharpened dowels inserted into the tiers as I build it so that it is very difficult for the cake to fall over.

Here are some guidelines for making a crooked cake:

Always sketch the design first, preferably on graph paper, to make sure that what you are planning is doable.

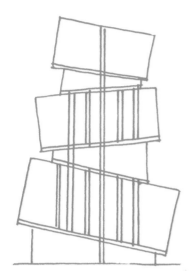

FIGURE 4

One method for making a cake crooked is to use Styrofoam wedges between normal-shape cake tiers. This way, the wedges make the cake look crooked when stacked, even though the cakes are straight.

Another method is to cut the top and/or bottom of the cake crooked, so you will not need any wedges between the layers.

When you stack the tiers, using either method, do so as you would a normal cake, with dowels in each tier. Make sure, though, that you put the dowels in each tier once they have been stacked—otherwise the dowels will be crooked and they will not give support. Then put one long sharpened dowel through the entire cake and into the base.

Put any top ornaments on the cake after you arrive at your destination (Figures 4 and 5).

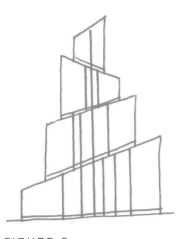

FIGURE 5

Dreams

of Youth

Homage to Dr. Seuss

SERVES 110

See the cake pictured? I made it with swirls.

I made it with wiggles and lopsided curls.

It's great for a shindig for a girl or a boy.

Or even for big ones, the grand hoi polloi!

In advance

Make the pastel-colored gumpaste curls on wires. Let these dry at least two days.

Carve the Styrofoam hat and hot-glue to a 4-inch round foamcore board. Carve the other wedge of Styrofoam. Cover both of these with white fondant.

Tint equal amounts of fondant pale pink, green, yellow, blue, and purple. Attach the large Styrofoam wedge to the base with royal icing.

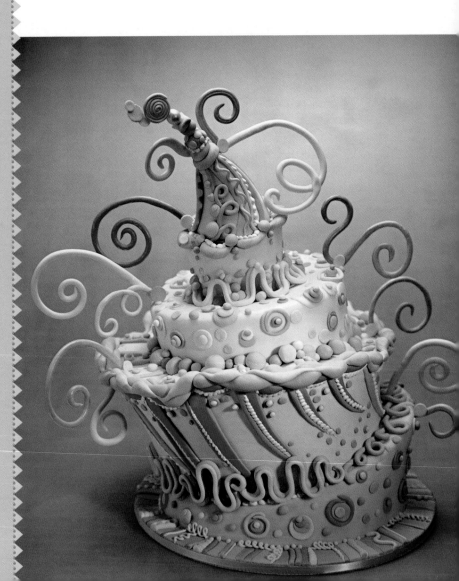

To decorate

Stack the two 14-inch cakes with the foamcore rounds in between (see Double-Layered Cakes, page 8). Carve so that the top remains 14 inches, the bottom becomes 11 inches, and two opposite sides are 7½ and 3 inches high, respectively. Cover all the cakes with white fondant. Stack all of the tiers on the board, placing dowels as you go, as shown in the illustration. Make balls, stripes, circles, and thick and thin borders with different colored pieces of fondant. Decorate the base, the wedge, and the hat with colorful stripes, dots, and circles.

Use white royal icing to pipe dots, loops, and lines in the areas indicated on the cake and on the base.

Finally, place the hat on the top of the cake and insert the curls on wires.

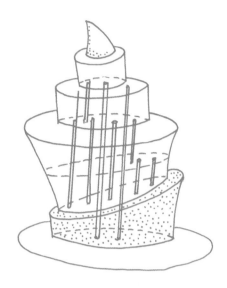

Decorating tip

WHEN YOU DRY THE GUMPASTE CURLS ON CORNSTARCH, PILE UP THE CORNSTARCH TO MAKE A LITTLE BED SO THAT THE UNDERSIDE OF EACH CURL IS CUSHIONED AND WON'T DRY WITH A FLAT SIDE.

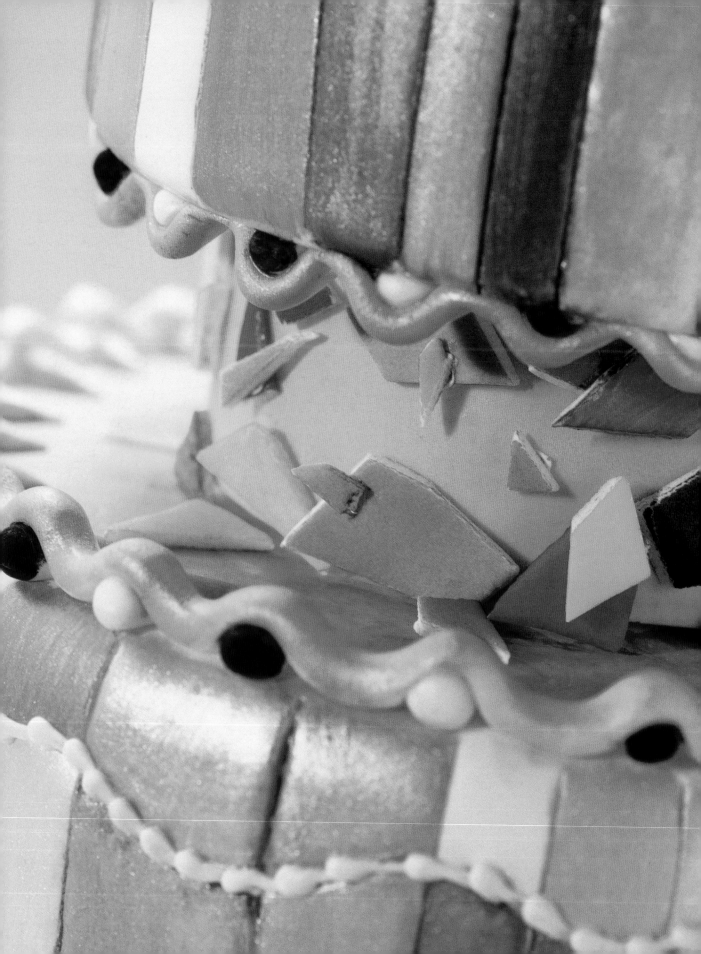

Rainbow Carousel

I can't tell you where I got the idea for this cake. I remember

waking up in the middle of the night, after dreaming about a

cake I was making. I immediately sketched the idea and

returned to sleep. In the morning, I found a very strange pic-

ture that looked more like a lamp than a cake, but I was

curious to see what it would look like if I actually made it.

So, this is what I dreamed.

In advance

Cover the base with white royal icing and cover all of the Styrofoam drums with rolled fondant. The only one that is embossed is the bottom one, so emboss vertical lines on it with a tracing wheel or gumpaste tool. The other Styrofoam drums are airbrushed purple (use purple mixed with pink), lime green (use green mixed with yellow), and light blue (blue mixed with water).

On the drum embossed with vertical lines, paint stripes randomly with the colors in the photo, using the dust colors mixed with lemon extract. Attach this drum with royal icing to the center of the prepared base. Make about ¼ cup of fondant black by kneading in black paste coloring.

Roll out small white and black balls of fondant and attach these around the base of the drum.

Roll out a piece of fondant about 6 inches square and very thin, about $1/16$ inch. With a pizza cutter, divide this into 7 equal strips. Let these dry a bit, so they can be handled without bending. When the strips are hard, cut them into a lot of small, irregular shapes with a pizza cutter or scissors. You should have 7 small piles of thin fondant pieces. Using one color of paint at a time, lay out a group of fondant pieces on a paper-covered surface and airbrush them blue, green, red, yellow, peach, purple, and pink. Attach these pieces randomly with royal icing to the purple, green, and blue drums.

Attach the purple drum to the top of the lower drum on the base.

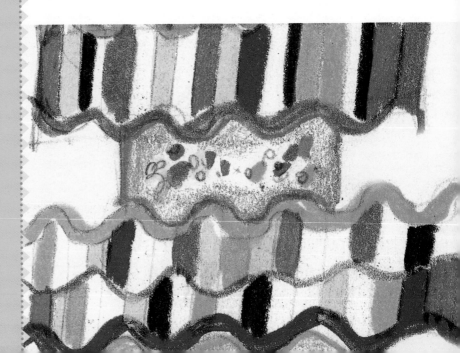

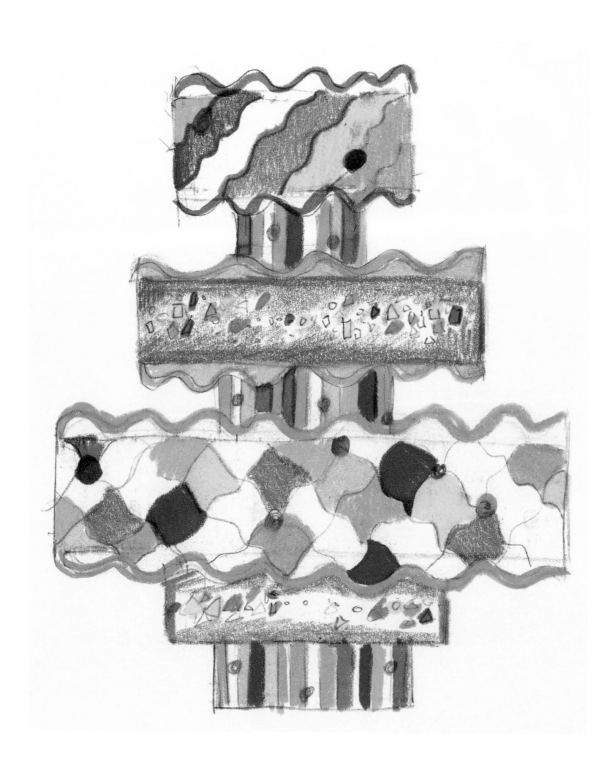

To decorate

Cover the cakes with white rolled fondant and emboss the lines with a tracing wheel. The top and bottom tiers have vertical lines, and each has one wavy line across the middle. Using the petal and luster dust mixed with lemon extract, paint the stripes and squares a variety of colors. Paint the top of the largest tier lime green, the next tier blue, and the top tier orange.

Stack the largest tier on the bottom drums with royal icing. Make teardrops out of white and black fondant and attach them, evenly spaced, with water around the top and bottom edges of the tier.

Next, roll out a rope of fondant about ¼ inch thick and the circumference of the tier. With water, attach the rope in a wave over the

teardrops (see illustration). Then continue stacking the cakes and the drums, making the teardrops and waves on each tier before stacking the next one.

Finally, insert a sharpened dowel through the entire length of the cake and into the base.

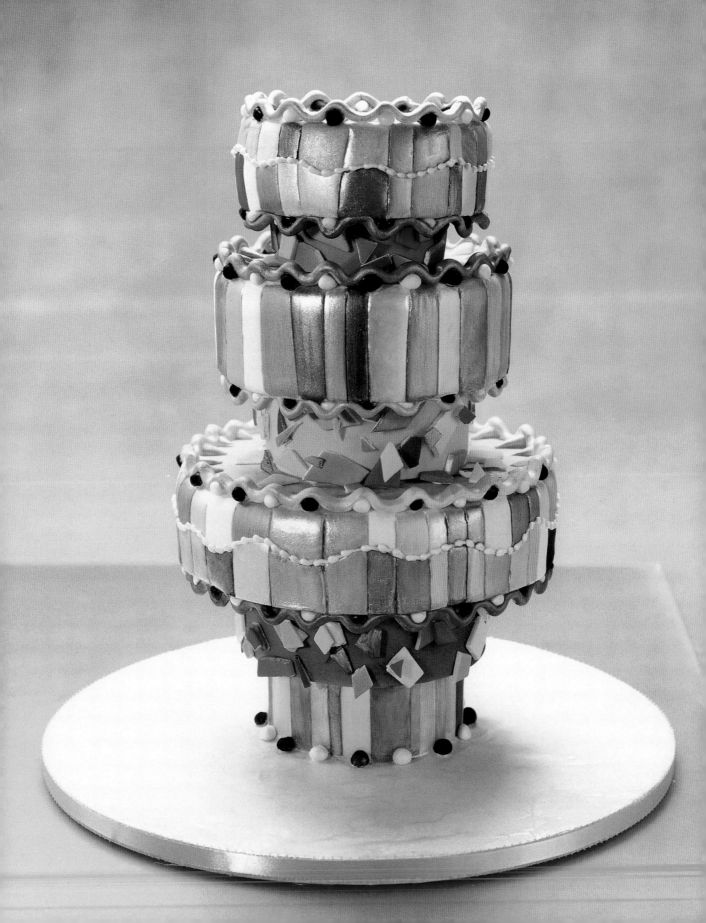

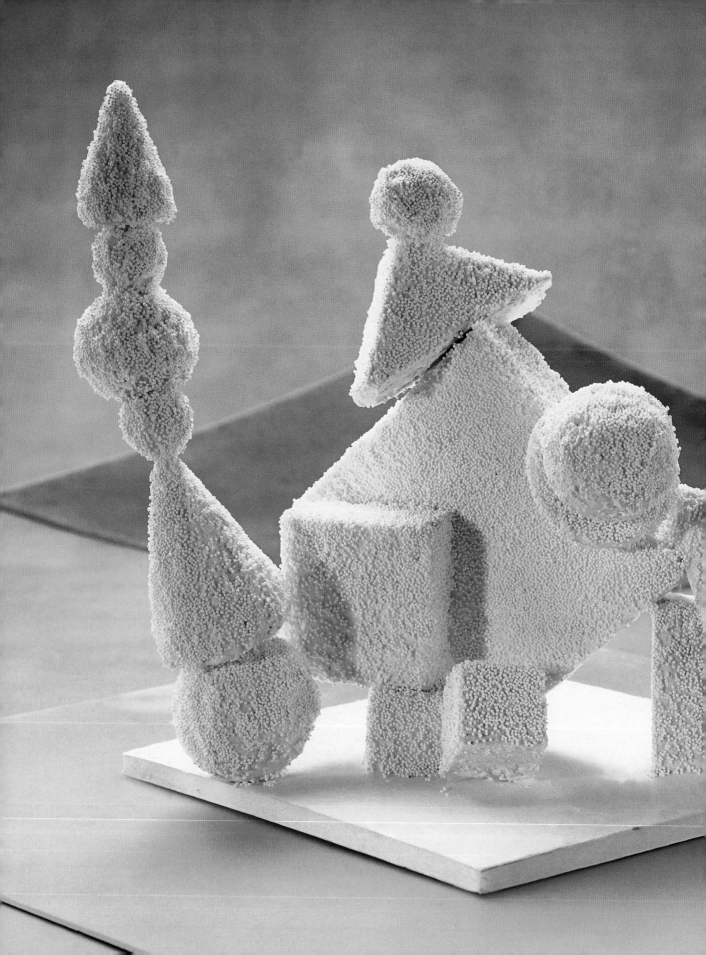

Styrofoam Nonpareil

SERVES 45

Cake decorators often use Styrofoam to make dummy cakes for displays. But I thought I would turn the tables and make a trompe l'oeil confection. What if, instead of Styrofoam looking like a cake, a cake looked like Styrofoam? Using Rice Krispie Treats, which are lightweight, makes it easy to balance the shapes on top of each other in all sorts of anti-gravitational ways.

MATERIALS

- 3 recipes Rice Krispie Treats (follow package directions)
- white royal icing
- nonpareils
- toothpicks or skewers

To form the treats

Make the Rice Krispie Treats and cut them up into various shapes. The squares can be made by pressing the treats into a cake pan and cutting them into pieces. The balls and cones can be shaped by hand, or you can use a mold.

Let the shapes cool completely, then cover them with a layer of royal icing. While the icing is still wet, sprinkle nonpareils over them. Stack the shapes in interesting ways, using toothpicks or skewers to attach them, as you would if you were building something with real Styrofoam.

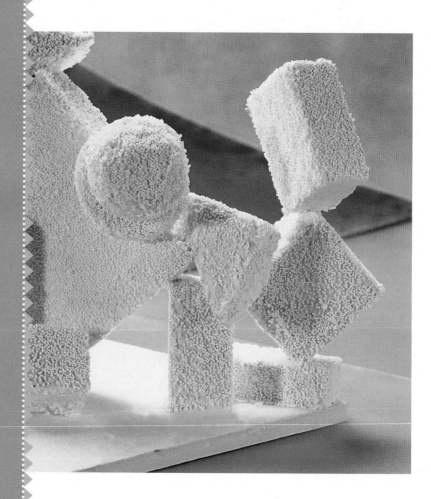

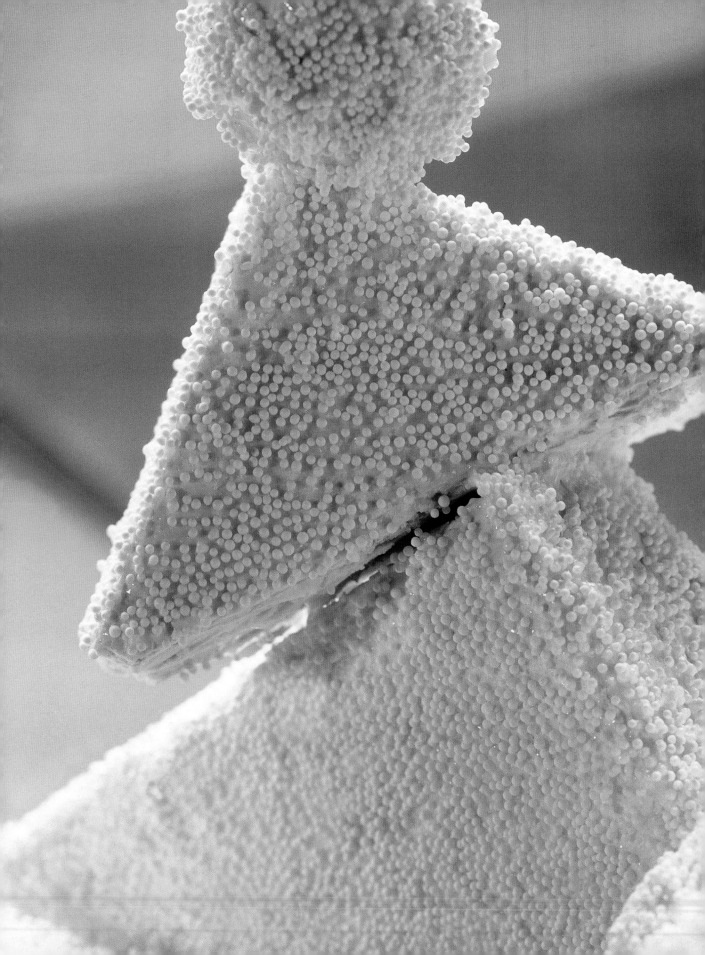

Enchanted Flora

SERVES 100

Gumpaste is so flexible it can mimic many other kinds
of materials, such as paper. I have always loved the art of
folding and quilling paper, and have created here some
fantasy flowers and leaves using similar methods in
gumpaste. I made the cake many layered to enhance
the fantasy look.

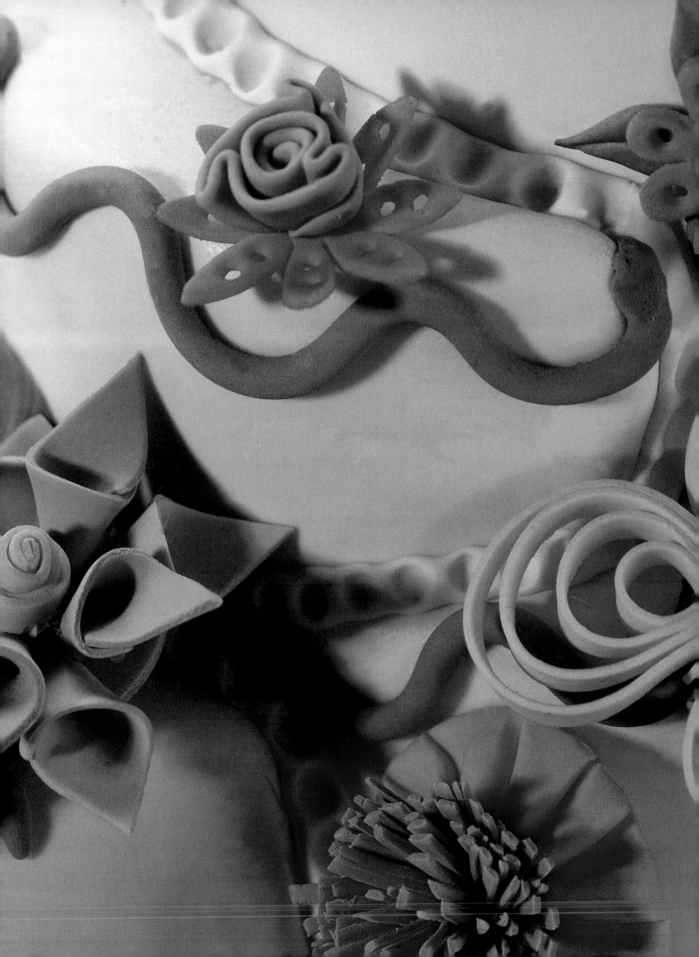

In advance

Make all of the flowers and leaves and the butterfly. To make the quilled flowers and butterfly, roll out pieces of gumpaste until very thin. Next, cut thin strips ¼ inch wide. Roll them, as they stand on their sides, as tightly or as loosely as you wish. To make a curl, simply lay the strip on its side and arrange into a curl. To make teardrop shapes, brush a little water on the ends and press them together, then let the loops dry on their side. To make multiple layers, such as the butterfly wings, start on the inside with the smallest loops and then attach longer loops, gluing the ends together as you add them.

To make the other "paper" flowers, see the section on fantasy flowers on pages 231 and 232. To make the body of the butterfly, roll out a thin rope of gumpaste, then wrap a long ¼-inch-wide piece of gumpaste down the length of the rope. Cover the base with pale yellow royal icing.

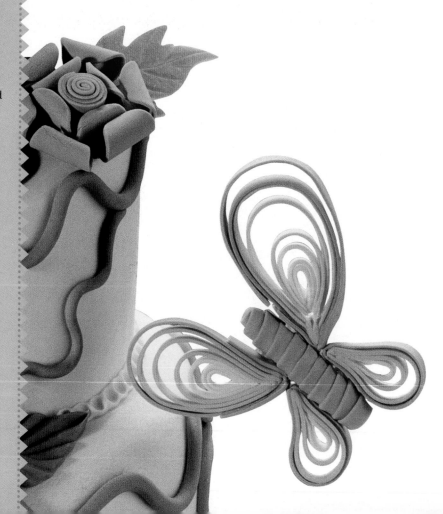

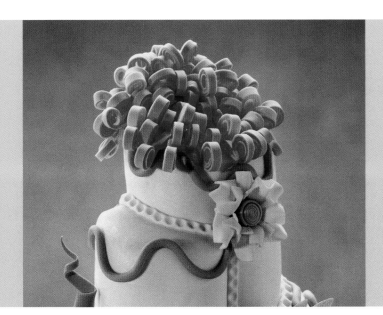
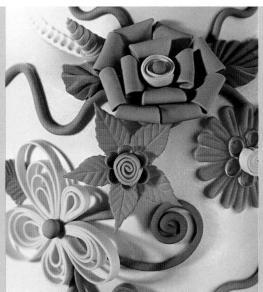

GUMPASTE CUTTERS

To decorate

Cover all of the tiers with pale yellow rolled fondant. Stack the tiers according to the illustration. To cover the gaps that may be formed from fitting the crescent shapes onto the cake, roll out ropes of yellow fondant about ¼ inch wide. Attach all of the ropes around the base of the cake and along the gaps between layers. Press with the ball tool along each line to make indented balls.

With green fondant, roll out ropes about ¼ inch wide and, with water, lay them on the cake in wavy lines, as shown. Attach all of the flowers and leaves and the butterfly with royal icing.

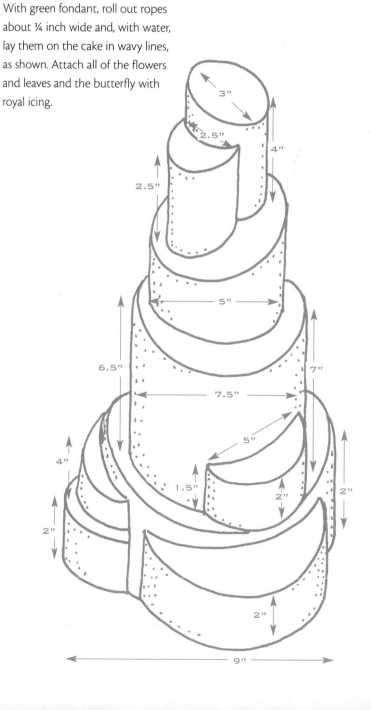

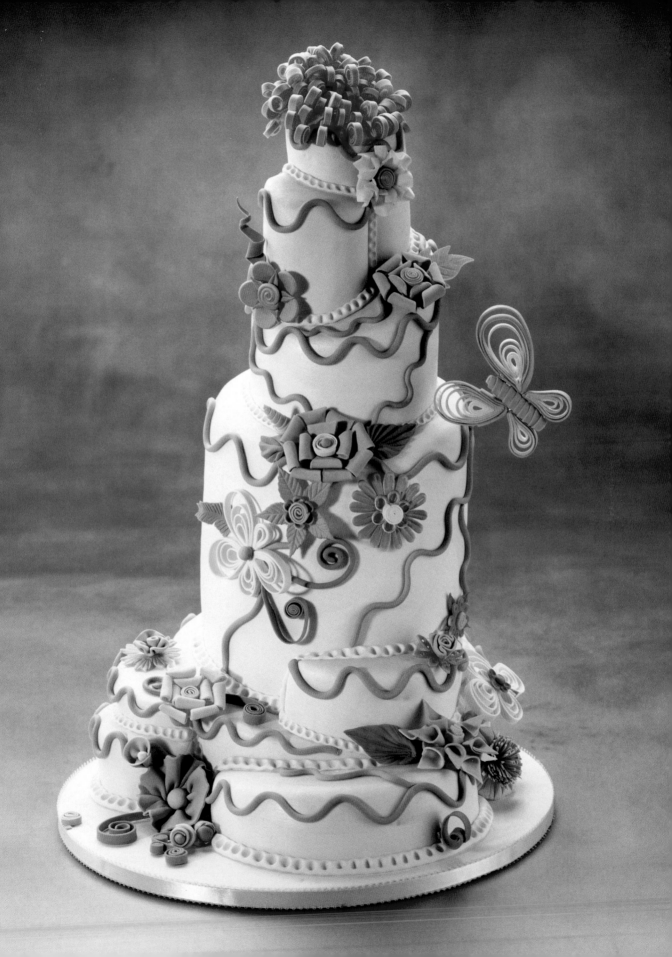

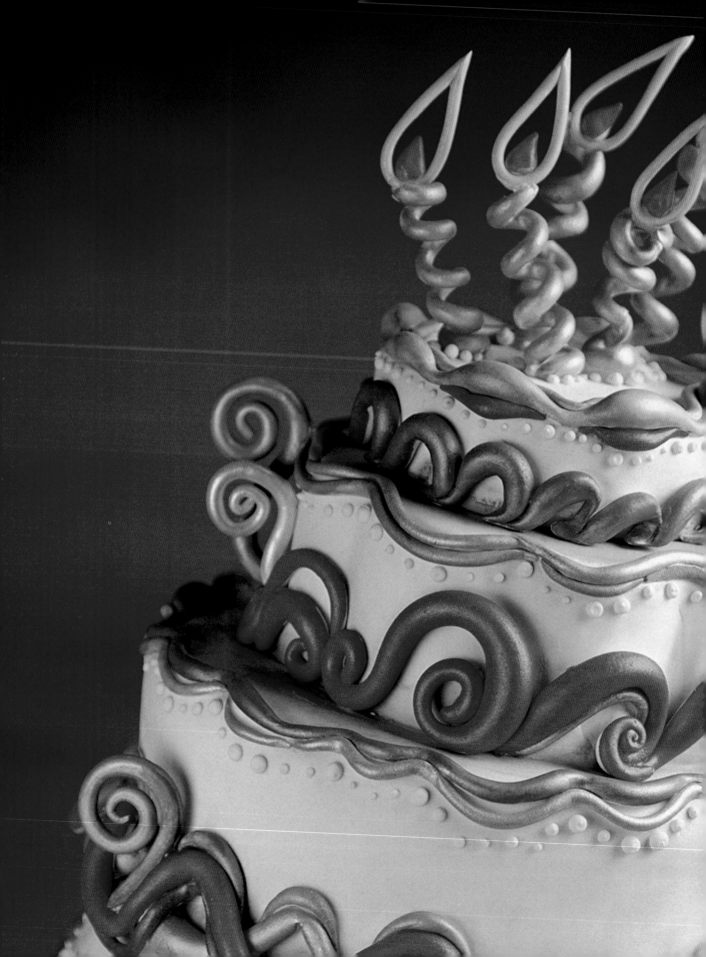

Walk'n Cake

SERVES 85

The idea for this cake came to me after looking at gowns at the Metropolitan Museum of Art's Fashion Institute. It occurred to me that wearing some of those dresses with bustles and trains, and huge extravaganzas of material and flounce, must have felt like wearing a giant birthday cake. This cake makes an entrance with the same boldness as someone in a breathtaking frock. Making the cake wedged and leaning backwards causes it to appear as if the cake is prancing on the table. Even the faux candles look as if they are in motion.

TECHNIQUES USED

Crooked cake, cake drum, gumpaste curls, fondant ropes, painting with luster dust, piping with royal icing, cake carving, double layers

CAKES

- ☐ 4-inch round, 1 inch high
- ☐ 6-inch petal, 2½ inches high
- ☐ 9-inch oval, 3 inches high
- ☐ 11-inch oval, 4 inches high

OTHER MATERIALS

- ☐ 8 x 6¾-inch oval Styrofoam wedge, measuring ½ inch high on one side and 2 inches high on the other side
- ☐ 20 x 16-inch oval board for base
- ☐ dowels
- ☐ royal icing
- ☐ white fondant
- ☐ gumpaste
- ☐ airbrush and blue airbrush color
- ☐ piping bag and #3 tip
- ☐ yellow, raspberry, pink, cobalt, and olive green luster dust
- ☐ 4½-inch round foamcore board
- ☐ 6-inch petal foamcore board
- ☐ 9-inch oval foamcore board
- ☐ 11-inch oval foamcore board
- ☐ lemon extract
- ☐ paintbrush

In advance

Make the candles and flames so that they are completely dry when you need them—at least 24 hours in advance, but even longer is better. To make the candles, roll out a rope of gumpaste and wrap it around a dowel so that the coil is 4 inches high. For the flame, roll out a thinner piece of gumpaste and make an open teardrop shape about 1 inch high. Make a smaller teardrop shape for the inside of the flame. When they are dry, attach the flames to the candles with royal icing. When this is dry, paint them according to the photo.

Make the gumpaste curls that swirl over the edges of the cake and let them dry completely. You'll need about 25. Paint them with luster dust mixed with lemon extract.

Carve the Styrofoam wedge. Cover the sides of the wedge with white fondant. Cover the base with white royal icing.

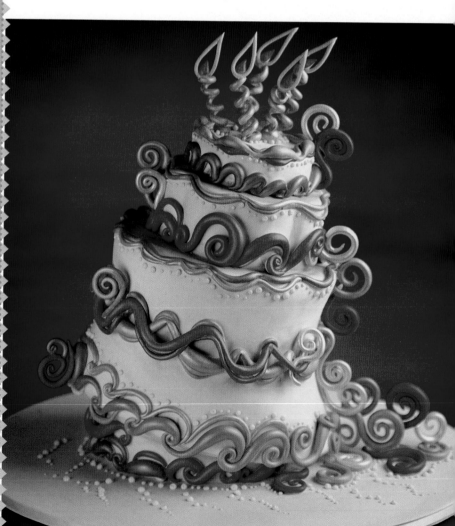

Decorating tip

THE EASIEST WAY TO ATTACH ROLLED FONDANT ROPES TO THE SIDE OF A CAKE IS TO BRUSH THE FONDANT ON THE CAKE SURFACE, NOT THE ROPE, WITH WATER.

To decorate

Assemble the cakes on the foam-core boards. Carve the 9-inch oval cake to measure 9 inches at the top and 8 inches on the bottom. Carve the 11-inch oval cake to measure 8 inches at the top (see Figure 1). Assemble the cakes and stack them. Insert a long sharpened dowel through the entire cake and into the base.

Airbrush a light mist of blue color on the bottom edges of each tier, in the middle of the bottom 2 tiers, and at the bottom edge of the wedge. Also, airbrush the top of the cake.

Roll out thick and thin fondant ropes and attach them to the cake with water (see page 224). Paint them with luster dust, as indicated in the photo.

Finish the cake by attaching the candles to the top of the cake with royal icing and the curls cascading down the sides. Finally, pipe pale yellow dots around the bottoms of the thick and thin ropes, as indicated in the photo.

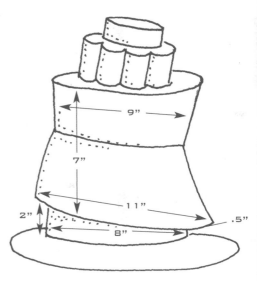

FIGURE 1

Dreams of

Chocolate

Bavarian Cream SERVES 60

As Homer Simpson says, "MMMMM. ... Donuts! Is there nothing they can't do?" Well, they can certainly inspire me to create a cake that looks like everybody's favorite snack. Believe it or not, with the Krispy Kreme donut craze, any number of people are starting to want wedding cakes made of stacks of donuts. Unfortunately, real donuts are tasty only hot out of the oil—not five hours later, after the wedding, when dessert is usually served. So, I came up with a solution that will let your guests have their donuts and eat their cake, too.

Here are two very distinct-looking cakes made from the exact same cake shapes, sizes, and designs, but one has two drums between the tiers and the other doesn't.

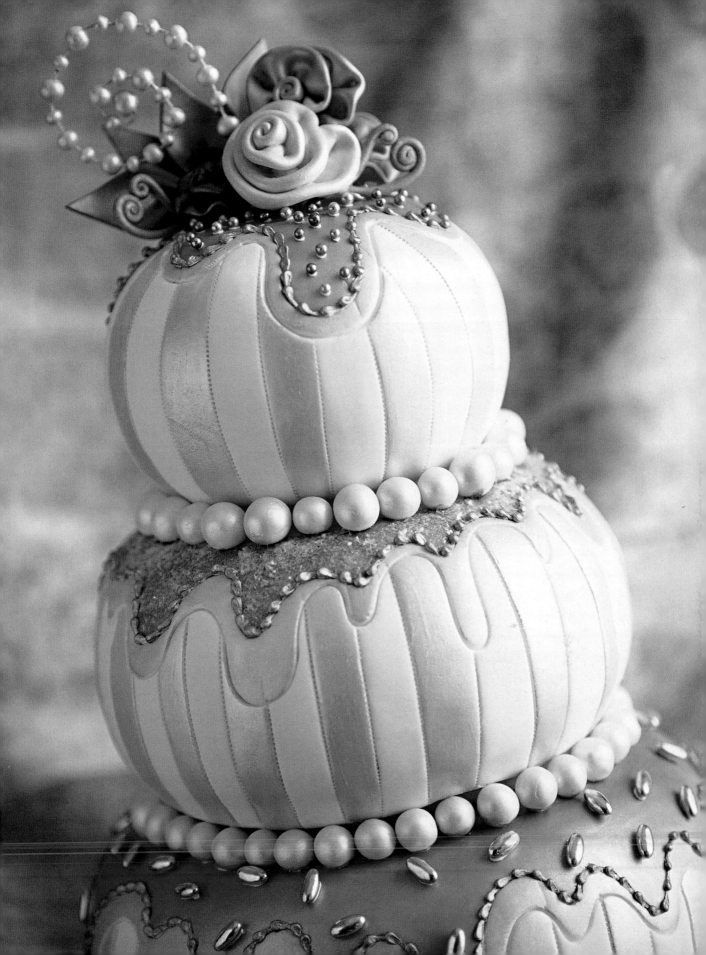

In advance

Make the gumpaste ribbon roses, leaves, and hearts (see pages 227-232). Make the royal icing dots on wires. Let dry. Paint them all with luster paint as shown. Cover the base with royal icing, and when dry, paint it with gold luster paint mixed with lemon extract, or use gold foil paper.

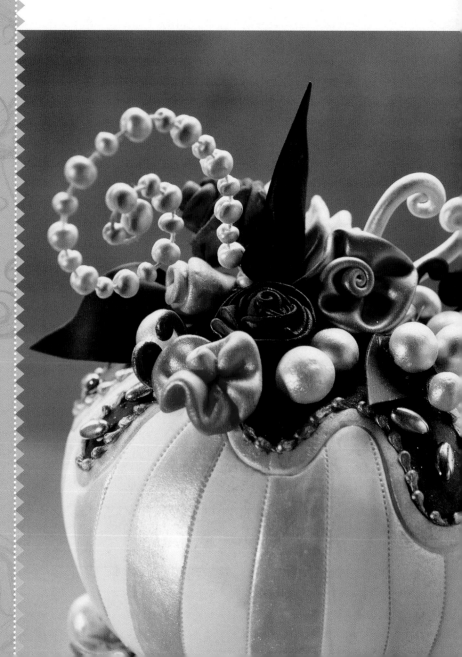

Decorating tip

USE A TINY TRACING WHEEL FOR EMBOSSING THE LINES ON THIS CAKE. PME HAS A SMALL WHEEL FOR CAKE DECORATING. IT WILL MAKE IT A LOT EASIER TO FORM TIGHT WIGGLES.

To decorate

Fill and assemble the cakes and place each on its foamcore board. The boards are smaller than the base of each cake to allow for the undercutting shape of the bottom of the donut. Carve each cake so that it gently rounds to fit the board. Cover each cake with fondant, doing a considerable amount of smoothing under the curve because you are fighting against gravity. Keep smoothing until the fondant sticks.

After you place the fondant on each cake, use a small tracing wheel to emboss the double wavy line and then the vertical stripes below. Paint every other stripe with gold pearl paint, the small curvy line with light blue luster, and the area above the wavy lines as pictured. Pipe a snail trail of royal icing along the second wavy line. When dry, paint it with gold paint. Sprinkle with edible glitter.

Stack the cakes, then roll fondant into pearls to use as a border around the bottom of the cake and to be interspersed with the flowers, leaves, and hearts. Paint the pearls with luster paint and attach the decorations and dragées with royal icing.

CHOCOLATE CREAM

This is basically the same cake as on the previous page, with a few key differences.

- ☐ 5-inch and 7-inch round Styrofoam drums, 2 inches high, covered with brown rolled fondant
- ☐ sharpened dowel
- ☐ 25 gumpaste ribbon roses with leaves
- ☐ 8 gumpaste curly hearts
- ☐ royal icing dots on curly wire
- ☐ gold pearl, gold, blue, pink, brown, and super-pearl luster dust
- ☐ oval-shaped dragées
- ☐ tracing wheel

Stack the cakes with the drums and insert a sharpened dowel through the entire cake, including the drums. Follow the directions as on page 41, then paint the cake according to the photograph.

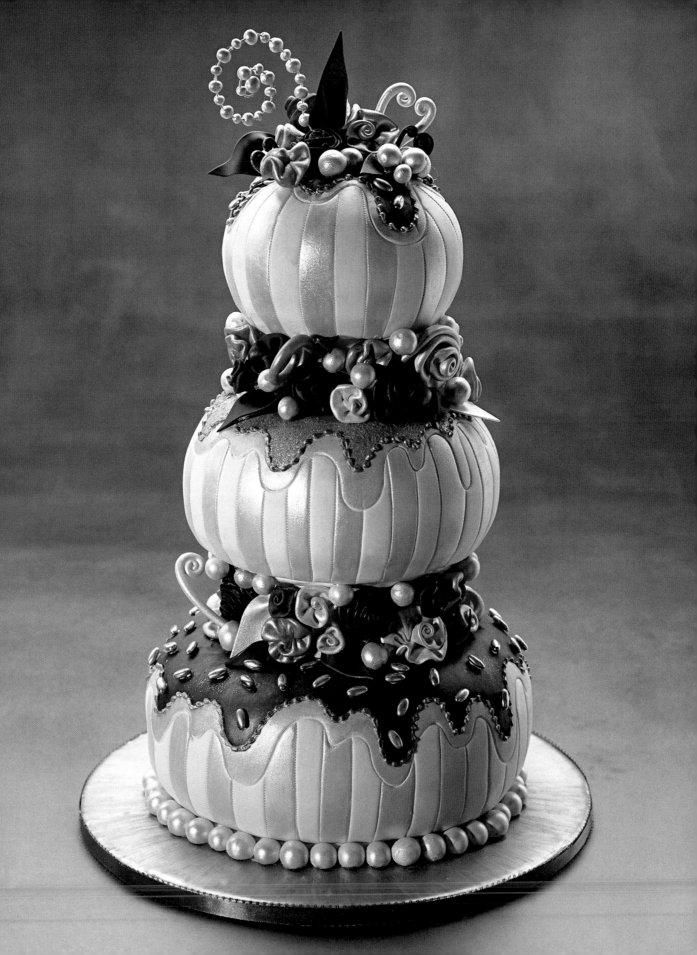

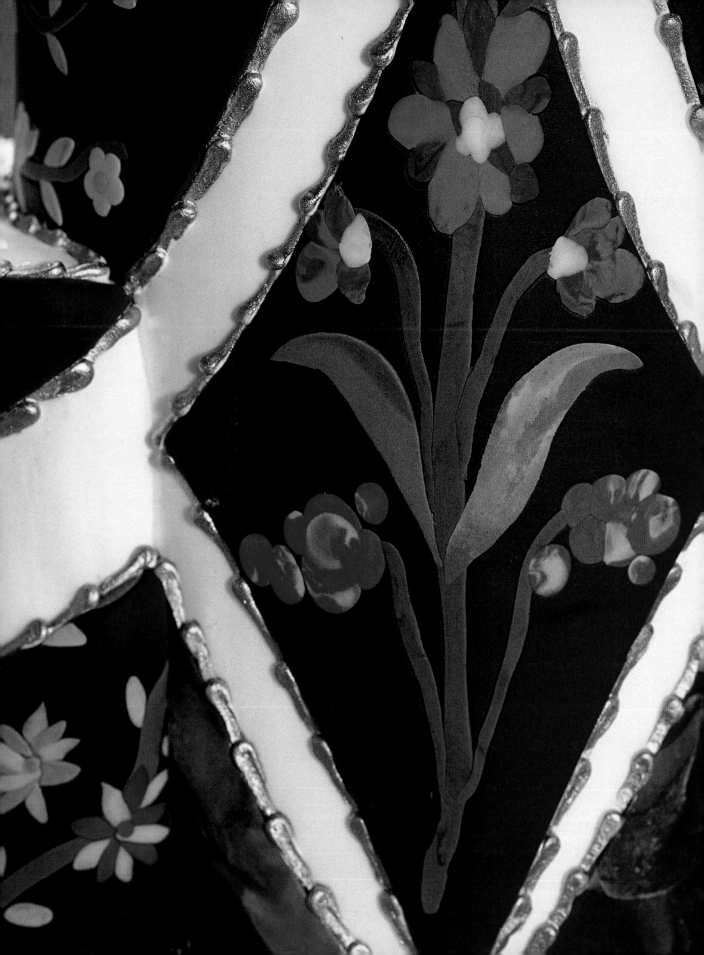

Floral Inlay

SERVES 125

Pietre dure, or "stone painting," is an amazing inlay technique whose use reached its zenith in Florence during the Renaissance. Pieces of semiprecious stones, such as lapis lazuli, jasper, amethyst, and quartz, were cut to fit perfectly into small depressed areas of a large piece of stone to form a picture of a flower, a landscape, fruit, or other decorative motifs.

The first time I saw examples of this in Florence, where it is everywhere—on floors, tables, walls, and alters—I was totally in awe. I wanted to learn more about this technique. After many years of trying, I was thrilled to find that they had built a museum in Florence dedicated to the art.

The cake pictured is my interpretation of *pietre dure* in fondant, with various colors rolled into the surface (see page 217).

In advance

Cover the base with white royal icing.

To decorate

Cover all of the cakes with white fondant. Stack the cakes as shown in Figure 1. The 6-inch tier is a double-layered tier (see page 8). To make the inlay pieces, first tint small amounts of fondant in various colors, such as red, blue, violet, and a range of greens and yellows. Roll out a piece of chocolate fondant and stop when it's a bit thicker than the finished piece will be. Use the patterns (on pages 48 and 49) to cut out the chocolate pieces. Rub the piece with shortening to keep it moist. Roll out or cut out thin pieces of the colored fondant and arrange them on the chocolate as you would like them to be. Run the rolling pin over the pieces, pressing lightly to attach them. Attach more pieces if you wish to have a more marbleized look.

Keep the chocolate and the colored fondant pieces wrapped tightly in plastic wrap and soften occasionally with shortening, so that they don't dry out. This technique will not work well if the fondant is at all dry.

Outline all of the sections with a royal icing snail trail. Paint the snail trails with gold. Finally, pipe elongated shells on the "shoulders" of the cake.

FIGURE 1

Note

When attaching the colored pieces to the chocolate fondant to make the designs, be sure the cutouts are very small because they will grow quite a bit when they are rolled out. Be sure to rub the surface of the chocolate fondant with shortening before adding the cutout pieces. This will help them adhere to the surface.

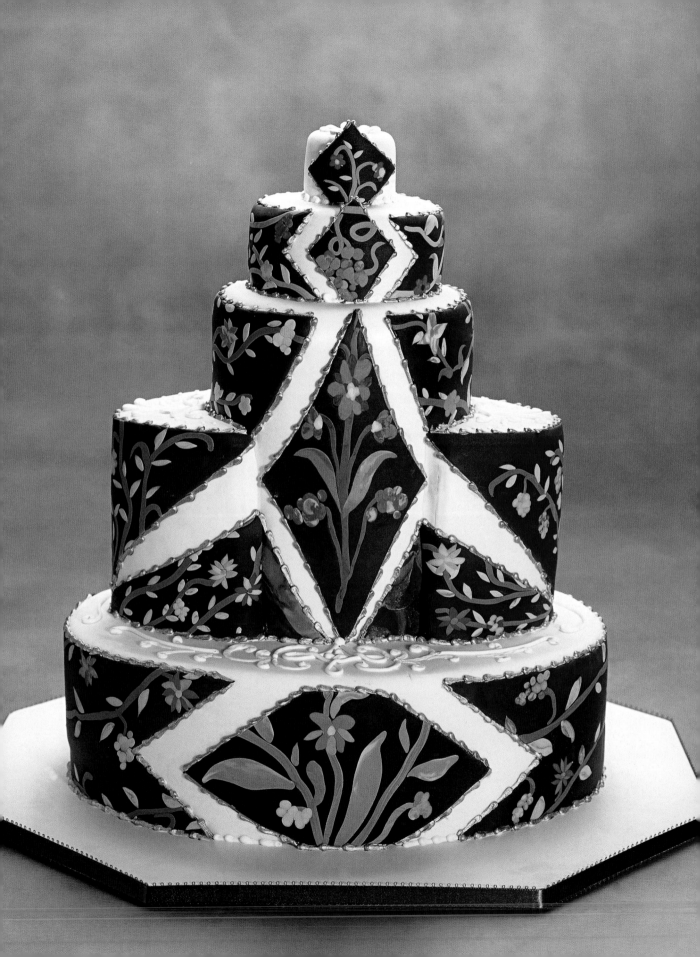

TOP

TOP

MAKE 2

MAKE 2

FRONT

RIGHT AND
LEFT SIDES

MAKE 2

← 33" LONG →

BOTTOM
SIDES

ENLARGE TEMPLATE TO 154%

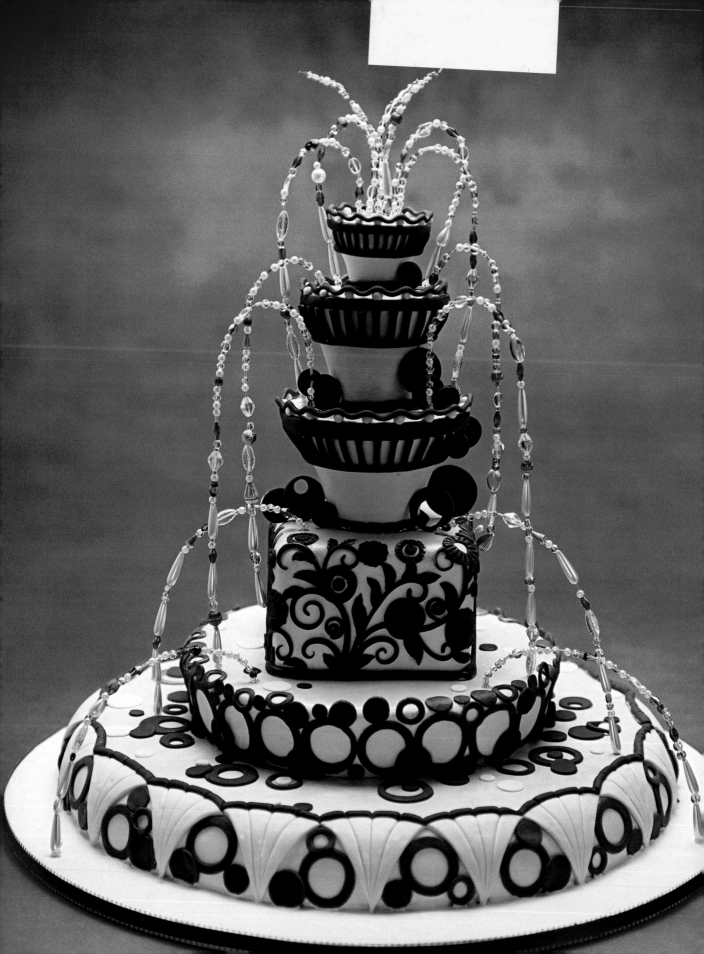

Eau de Buckingham Fountain

SERVES 225

One of my favorite sights is Buckingham Fountain in Chicago. The shape always reminds me of a beautiful, bejeweled wedding cake. But I decided to use a motif from one of my favorite artists, Edgar Brandt, an Art Deco architect and designer. Many buildings in New York City are decorated with his wonderful metalwork, so I guess I sort of bridged the gap between my hometown, Chicago, and my adopted home, New York.

The use of real crystal beads, an idea originally dreamed up by Donna Ferrari of *Brides* magazine for another cake that I made, gives the glistening impression of water cascading from the fountain.

TECHNIQUES USED

Fondant cutouts, fondant embossing, cake carving, fondant ropes

CAKES

- 6-inch square, 4 inches high

- 11-inch round, 3 inches high, carved at the base to measure 10 inches

- 20-inch round, 3 inches high, with the top edge rounded

OTHER MATERIALS

- 24-inch round board for base

- 3 Styrofoam vases:

 3 x 1½-inch round, 2 inches high

 5 x 2½-inch round, 3¾ inches high

 6 x 3-inch round, 3¾ inches high

- 6-inch square foamcore board

- 11-inch round foamcore board

- 20-inch round foamcore board

- dowels

- ivory and chocolate fondant

- ivory royal icing

- gumpaste veining tool

- various crystal beads and wires, 18-inch maximum

- cutters—set of circles, assorted small flowers and leaves

In advance

Carve the Styrofoam vases and cover them with ivory fondant. Roll out thin ropes of chocolate fondant and wrap one around the top of each vase, another around the middle, 2 inches below the top, and then a series of vertical ropes in between them. Use water to attach them.

String the beads on the wires, leaving one end of the wire uncovered so it can be inserted into the cake. Cover the base with ivory royal icing.

To decorate

Cover all of the tiers and the 3 Styrofoam vases with ivory fondant. Attach the bottom tier to the base with royal icing. Using the pattern below, cut out ivory rounded triangles and attach them with water around the bottom edge of the cake. Emboss 3 vertical lines down the triangle with a veining tool.

Stack the 2 other cakes and the 3 vases on top of the bottom layer. Insert a dowel through the entire cake, including the vases. Roll out a piece of chocolate fondant and cut out circles; add some of them to the tiers as shown. Let some circles dry a bit to be added later. Add the cutout flowers, leaves, and vines to

the top tier. Arrange the dried circles around the cake.

Insert the wire containing the different crystal beads into the vases and the cake.

Dreams

of Love

Black and Blue Heart

SERVES 20

I designed this cake stand before I designed the cake, so

when I was trying to decide what kind of cake would look

best on it I thought it should be something high, but I

wanted only one tier. I thought of a heart, but I wanted the

heart shape to be seen from eye level, rather than from

above, so I turned the heart on its side and this is the result.

58

TECHNIQUES USED

Airbrushing, splattering, painting, and sponging with luster dust, sculpting cakes, piping with royal icing

CAKES

- [] Two 8-inch squares, 2 inches high

OTHER MATERIALS

- [] 4 x 7-inch foamcore board
- [] 4 x 6½-inch foamcore board
- [] 12-inch round base or 12-inch cake stand (optional)
- [] 2 sharpened dowels
- [] royal icing
- [] airbrush and red, purple, black, and blue airbrush colors
- [] blue and gold luster dust
- [] lemon extract
- [] piping bag and #2 tip
- [] soft cloth or sponge
- [] veining tool
- [] toothbrush

To assemble

Cut the 2 cakes in half across the top, forming 4 rectangles measuring 4 x 8 inches each. Stack with filling, with a foamcore board in between, as indicated. Insert 2 dowels all the way through the cake and into the board to keep it sturdy (see illustration). Cut the cake as illustrated, cutting small amounts at a time with a small serrated knife.

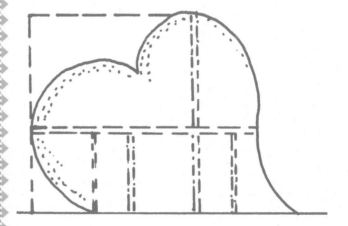

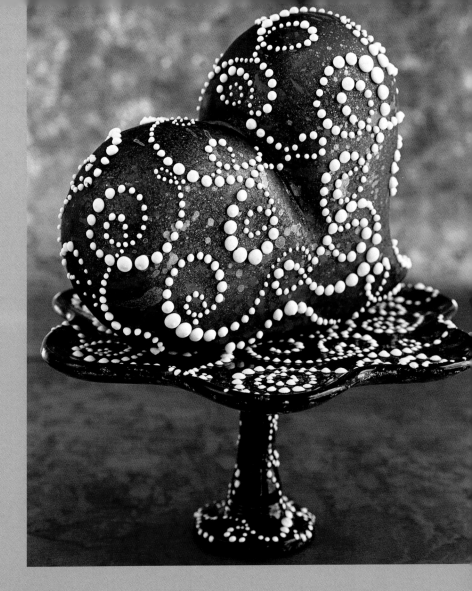

Decorating tip

THIS CAKE WOULD LOOK GREAT ON A CAKE STAND DECORATED TO MATCH. YOU CAN MAKE YOUR OWN AT A PAINT YOUR OWN POTTERY STORE!

To decorate

To paint the cake, start by using the airbrush. With red, purple, black, and blue, spray patches of color all over the cake, leaving a few areas uncovered. Next, using a soft cloth, such as cheesecloth, or a sponge, dab on a thin layer of blue luster dust mixed with lemon extract, but not enough to cover all the airbrush patches. Finally, make a paint of gold luster dust and splatter it with a toothbrush all over the surface (see the section on painting with luster dust, page 222).

To make the piped design, first mark the cake so you have a guide as to where the piping goes. The best way to do this is to emboss the design, using a veining tool or other sharp tool, into the fondant. Then, with royal icing and a #2 tip, pipe dots in a row, making them larger, then smaller, as shown in the photograph.

Counting Sheep

SERVES 100

These newlyweds will never make you drowsy as they leap over this stack of mattresses. This is really a very easy cake to make, since all of the layers are simply embossed. Just don't remove the mattress tag!

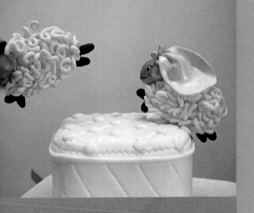

In advance

Make the sheep out of gumpaste: Make 2 thinly rolled 2½-inch-long gumpaste ovals for the bodies. Form 2 heads from 1¼-inch-long gumpaste ovals and attach them to the bodies along with 4 feet, which are ¾-inch gumpaste ovals. Use the clay gun to extrude gumpaste through the widest circular opening to make the wool. Attach the soft gumpaste "hairs" with water while still soft. When one side is dry, put wool on the other side. Make the hat and details of the face for the groom and add a veil for the bride. Paint the faces and feet with petal and luster dusts mixed with lemon extract (see illustration).

Prepare the foamcore base by rolling out a piece of white fondant about ⅜ inch thick to match the size of the board. Attach it to the board by brushing it with a little water, then setting the board on top. Flip the board over. Then emboss the fondant with a patterned rolling pin.

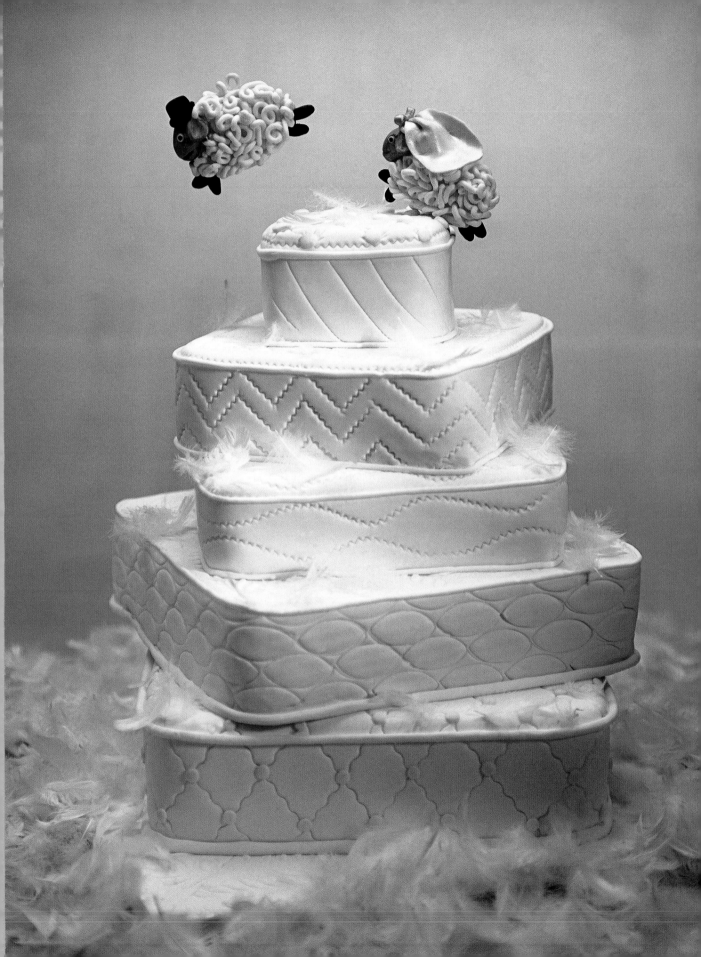

Ivory Wedding Cake

SERVES 40

Many an object can stir my imagination, and in this case, it

was the decoration on a piece of silverware. Bridal magazines

shower you with images of flatware, since this is one of the

more important acquisitions for a newlywed's home.

I started looking at the different patterns and styles. It

seemed to me, ornate silverware might make an interesting

subject for a wedding cake. But instead of making it look like

metal, I made it to look like antique, richly carved ivory, by

using a brown stain.

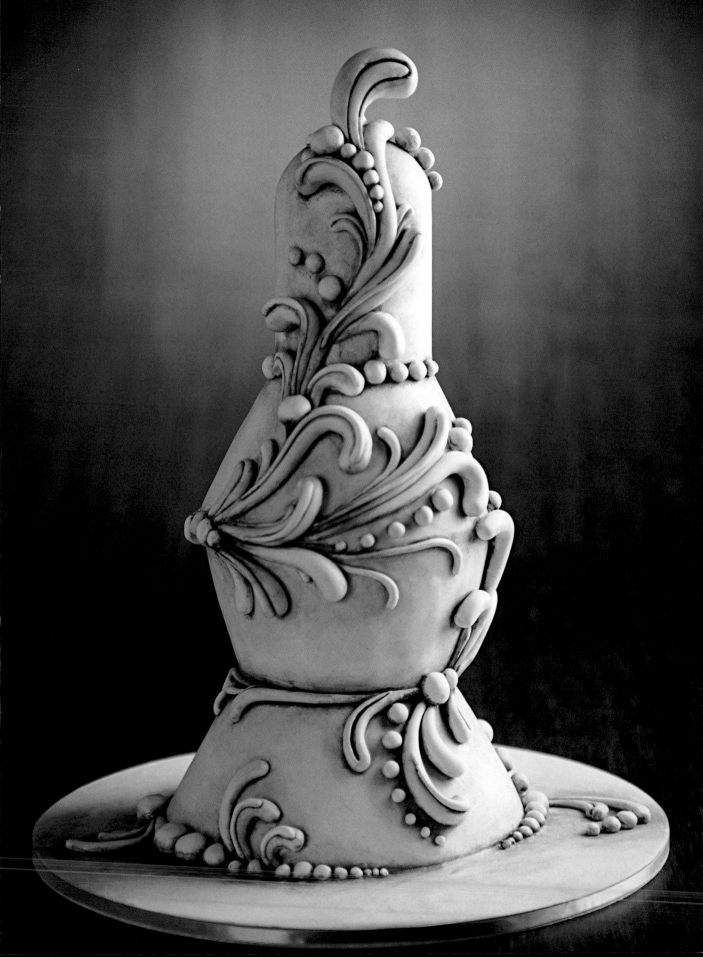

In advance

Make the teardrop for the top of the cake on a skewer. Let it dry for at least 2 days.

To decorate

Cover the Styrofoam drum with white rolled fondant and carve all the cakes according to Figure 1. Cover the cakes with rolled fondant and stack them on the Styrofoam drum. Insert a dowel through the entire cake.

Roll out the fondant into elongated teardrops and attach them to the cake with water. Some of the teardrops should have a second smaller teardrop on top of the first ones. Some of them should have an indented line, which is made with a veining tool, down the middle. Cover the seams between the tiers with teardrops and balls (see page 227).

To color, make a paint with the brown powdered food coloring and water. Paint all of the crevices, and the areas between all of the pieces, to give the cake an antique look. To remove any extra paint, or any paint caught in the wrong place, put a little water on the brush and rub or dab at the paint; it will come right off.

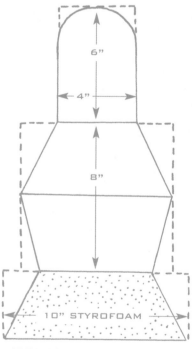

FIGURE 1

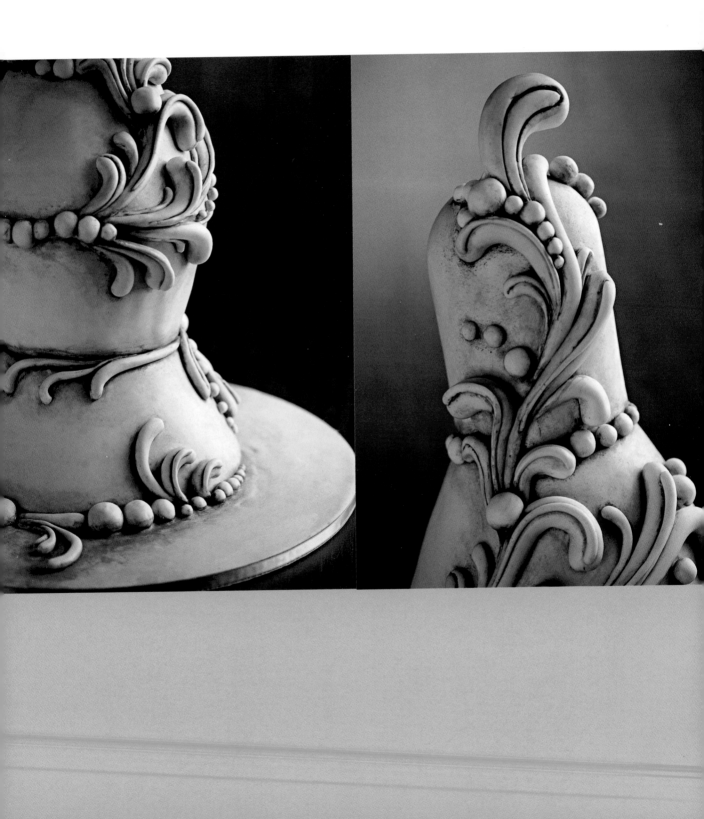

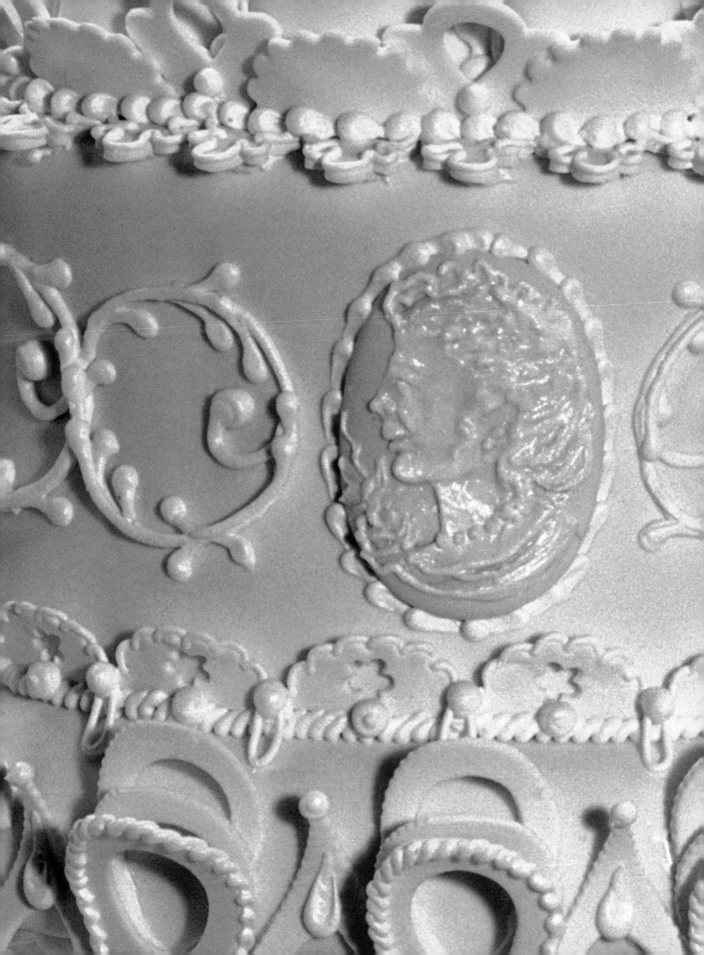

Bride's Vintage Cameo

SERVES 75

On two occasions, I was privileged to have been invited to the White House to make sugar decorations for Christmas. The First Family set aside their beautiful dining room as a workroom for all of the volunteers, complete with a tarp on the floor and the huge portrait of poor old Abraham Lincoln leaning against a wall. I couldn't help noticing the beautiful ornamental plasterwork on the ceiling. The walls were an off-white color, while the relief work was done in a pure white, making a striking, if subtle, contrast. I always wanted to create a cake that would remind me of the delicate designs I saw there.

The gumpaste cutouts give this cake a feeling of airiness, while the pure white piping lends the cake a refined elegance. The cake stand is decorated, too, so it looks as if it were part of the cake.

Piping with royal icing, gumpaste cutouts, cake carving, brush embroidery

CAKES

- ☐ 5-inch round half-ball, 3 inches high

- ☐ 8-inch round, 4 inches high, carved to 5 inches wide at the top, with 12 divisions

- ☐ 9-inch round, 4 inches high, with the middle carved to measure 8 inches

- ☐ 10-inch round, 1½ inches high, with rounded top and bottom

OTHER MATERIALS

- ☐ 5-inch round foamcore board

- ☐ 8-inch round foamcore board

- ☐ 9-inch round foamcore board

- ☐ 10-inch round foamcore board

- ☐ 12-inch cake stand or 12-inch round foamcore board for base

- ☐ sharpened dowel

- ☐ rolled fondant

- ☐ royal icing

- ☐ gumpaste

- ☐ ivory, brown, or caramel paste food coloring

- ☐ skewer

- ☐ gumpaste cutters

- ☐ flower formers

- ☐ piping bag and #2, #3, and #18 tips

- ☐ 3-inch-long oval cutter

In advance

Make all of the gumpaste cutouts and let them dry. They will need to dry on a flower former to give them a curved shape.

Decorate the stand. Use the photo and Figure 1 as a guide.

Make the gumpaste finial on a skewer and let it dry. Pipe the shells and lines on the finial (Figure 2).

FIGURE 1 FIGURE 2

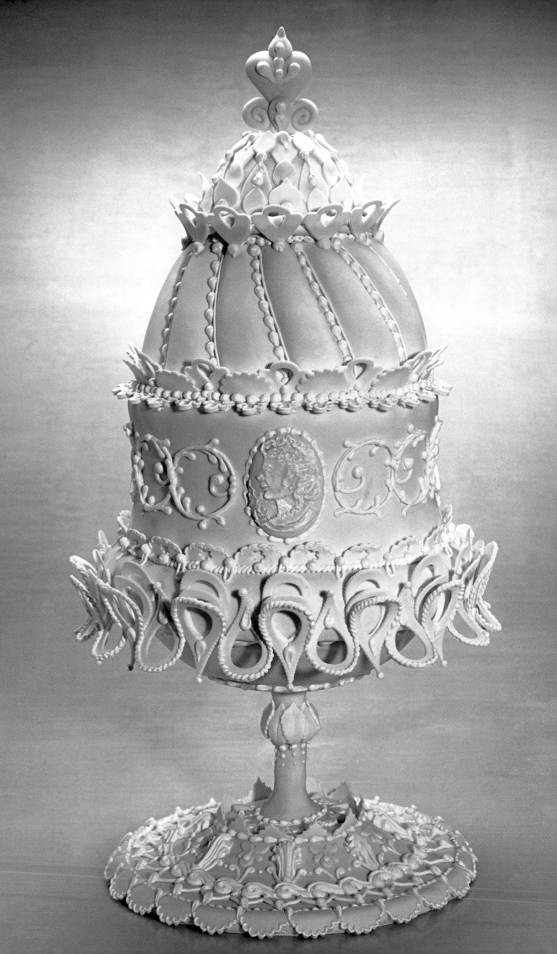

To decorate

Carve all of the cakes to their finished shapes. The "Jell-o mold" shaped tier has 12 sections (Figure 3). Cover all of the tiers with off-white fondant. Stack them on the stand. Insert a dowel through the entire cake.

The top tier has rose petal cutouts on top (Figure 4). Make a braid for the border of this tier, then attach the 12 gumpaste cutouts on this tier at the base.

On the next tier, pipe royal icing snail trails with the #3 tip in the crease of each division, then a straight line to the right of the snail trails. Add the 12 cutouts of each kind around the base of this tier. Pipe teardrops with the #3 tip around the base of the cutouts, then outline each one with the #2 tip.

Mark the large third tier for the cameo in the center using the 3-inch oval cutter, and the thirteen 1½-inch circular piped designs, using the patterns (Figure 5). Pipe the designs with the #18 tip. Add the cutout oval and the piping. Pipe the face on the cameo using the brush embroidery technique (Figure 6). Attach the cutouts around the border and pipe an outline around each cutout. Below each one, pipe a braid, a loop, then a dot in the center of the cutout.

On the bottom tier, attach the cutouts—one up, one down—with royal icing all around the center of the tier. (Note: The ones facing down have the tips removed.) Let the icing dry, then attach another down-facing cutout, also with the tip removed, on top of the previous one. Let these dry, then attach a third one with the tip. Pipe a braid around the edge of each cutout and a teardrop in the center of each one.

GUMPASTE CUTTERS

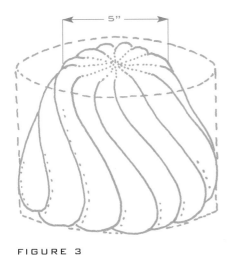

FIGURE 3

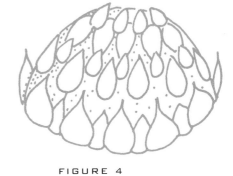

FIGURE 4

FIGURE 5

FIGURE 6

Decorating tip

THE LAST THING YOU SHOULD DO ON THIS CAKE IS THE GUMPASTE CUTOUTS ON THE BOTTOM TIER, SINCE THESE ARE THE MOST LIKELY TO BREAK IF ANYTHING BRUSHES AGAINST THEM.

Dreams

of Color

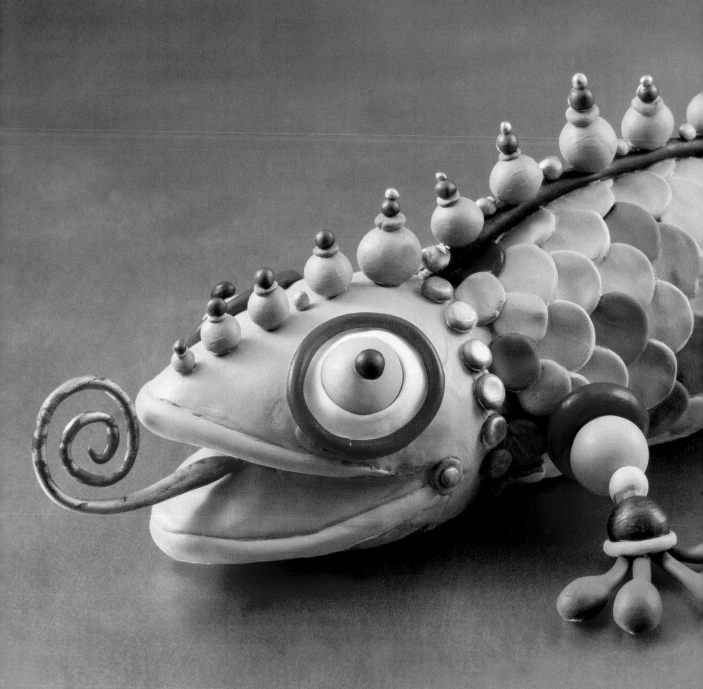

Mr. Sticky the Chameleon

Chameleons have always seemed to me to be elaborately adorned with a variety of colorful scales, spikes, horns, and the ability to change colors to match their surroundings. I envisioned Mr. Sticky to match the environment of a colorful children's birthday party. He almost looks like a friendly stuffed animal, but he is a delicious treat. Kids will love him, but they probably won't want to cut into him. Instead of a cake, you can also make another kid favorite: Rice Krispie Treats! Just decorate the same as you would the cake.

TECHNIQUES USED

Painting with luster dust, cake carving, gumpaste modeling, fondant cutouts

CAKE

- ☐ 9 x 13-inch rectangle, 2 inches high (see "To decorate")

OTHER MATERIALS

- ☐ 15-inch board for base, covered with royal icing
- ☐ foamcore board shaped like the top view of the chameleon
- ☐ rolled fondant
- ☐ royal icing
- ☐ gumpaste
- ☐ pink, royal blue, teal, violet, orange, yellow, leaf green, and red paste food coloring
- ☐ gold and blue luster dust
- ☐ piping bag and #2 tip
- ☐ paintbrush
- ☐ small pair of scissors
- ☐ ½-inch, 1-inch, 1¼-inch, and 2-inch circle cutters

In advance

Make the tongue, feet, balls for the legs, and tail out of white or colored gumpaste, as indicated in the photograph. Insert a dampened skewer (or toothpick) into these when you make them, so they can be easily attached to the cake when they are dry. Use the templates for the sizes, the photograph for the colors.

To decorate

Cut the cake in half horizontally, add the filling, then put the cake back together. Next, cut the cake in half lengthwise so that you have 2 cakes that measure 4½ inches by 13 inches, 2 inches high. Attach one layer to the foamcore board with a little icing, then add filling and the top layer. Now you can carve the cake to match the shape of the board and the shape of the side view as shown on pages 82–83. Carve the mouth so that it is open. Don't carve it too deeply or it may cave in.

Next, you need to cover the cake with rolled fondant. This needs to be done in pieces around the inside of the mouth, since it is concave and intricate. Cover the head and body in one piece of light blue fondant. The various colored sections of the head and body will be added later.

After the body has been covered, you can add the fondant to the inside of the mouth area. It's easier if you do it in 2 pieces (one for the upper part and one for the lower), rather than trying to do it in one. Measure the top and bottom of the mouth to get a rough idea of the shape and size, and cut 2 pieces of fondant. The lower mouth area piece should include under the chin also. The upper part may take awhile to adhere without falling, but if you are patient and continue to smooth it with your hands, it

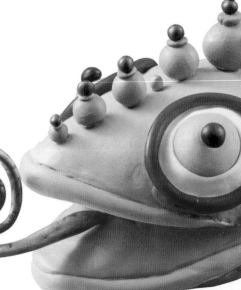

Decorating tip

IT'S FASTER IF YOU START WITH COLORED FONDANT FIRST, EVEN IF YOU ARE GOING TO PAINT IT LATER, JUST IN CASE YOU MISS A SPOT.

will eventually stick. Don't worry about the seams showing because there will be fondant pieces added to hide them. Trim the fondant to fit with a small pair of scissors. Once you have covered the mouth areas, you can add a rope to the top and bottom lip area, affixing them with water. At the corner of the mouth on each side, add a flat button of fondant to hide the seam.

To decorate the body of the chameleon, start at the neck and make a series of ⅜-inch-wide green fondant balls, and attach them with water all around the neck. Then starting right behind these balls, apply fondant ½-inch circles in orange, blue, green, pink, lavender, and teal fondant. These will be the scales. Make a row of circles, then make the next row slightly overlapping the first row, alternating the placement as if you were

placing shingles on a roof. After a few rows, switch to the 1-inch circle, then the 1¼-inch circle in the middle of his belly. Then gradually make the circles smaller.

At this point, you can attach the tail, using royal icing and the toothpick inserted at the end of the body. Roll out strips of fondant to hide the seam between the cake and the tail. Then roll out a royal blue rope of fondant to stretch across the top of his body from his neck to about 2 inches onto his tail.

Make a series of pink fondant balls, ranging in size from ¼ inch to ¾ inch, that can sit on the royal blue rope along the chameleon's back. Add a green button and then a blue ball on top of the pink ones. Make small buttons in between the pink ones, which will later be painted gold.

Make the eyes by cutting out a white circle 2 inches wide and attaching it with water. Then cut out a 1-inch orange circle and attach it to the center of the white part of the eye. Add a ½-inch-wide ball to the center of the orange part. Make a red rope and outline each eye with it.

Paint dark blue luster stripes on the tail, the first ball on the foot, and the second ball on top of the pink ones. Paint the blue rope along the back of the body.

Paint gold stripes next to the blue ones on the tail, on the tongue, and on the green buttons on the neck and back. Also paint the dots between the pink dots.

Insert the legs into the body with the toothpick and a little royal icing.

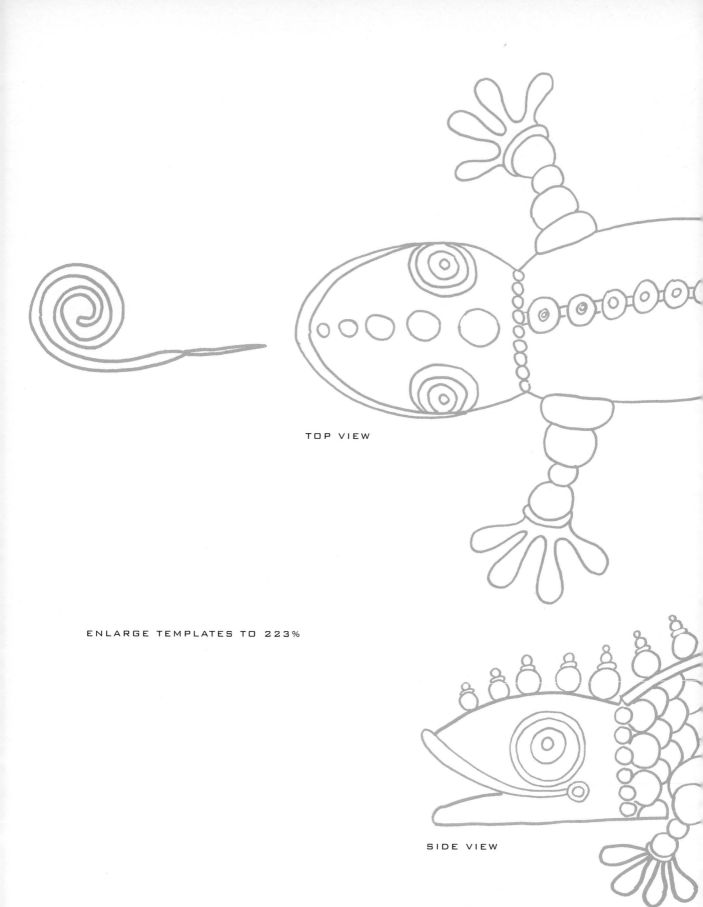

TOP VIEW

ENLARGE TEMPLATES TO 223%

SIDE VIEW

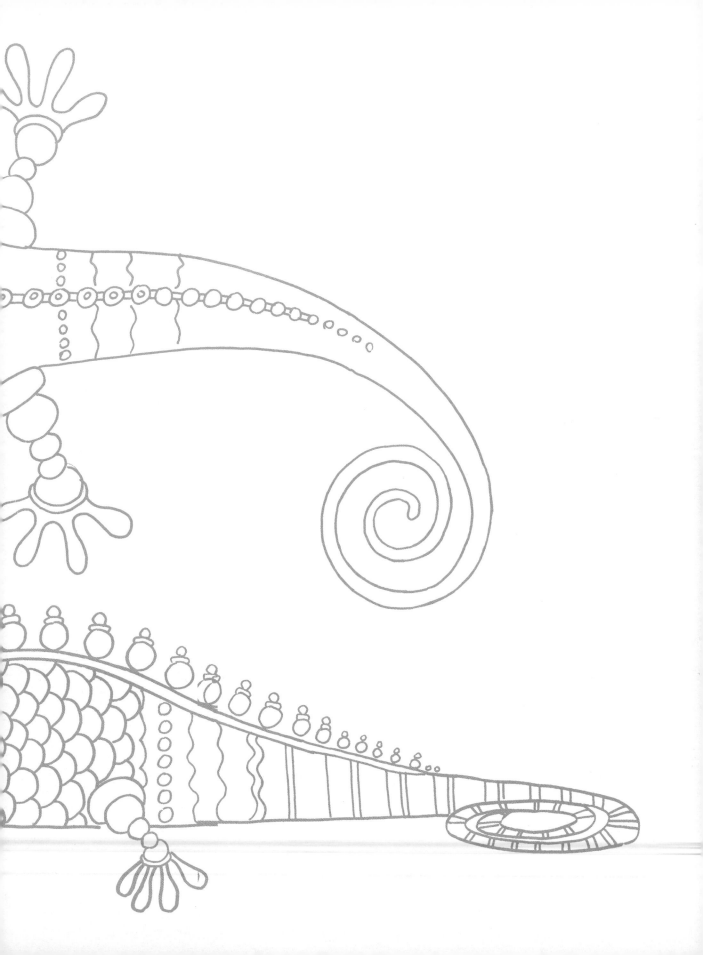

Comfort Food

Pillows are the perfect metaphor for the easy life. This is comfort food in every sense of the word. Who could resist the temptation to melt into a comfortable chair and sink a fork into a slice of velvety cake?

Many of the cakes I design are based on fabric decorations, such as tassels, buttons, quilting, and braids. Gumpaste and fondant provide perfect pliable media for embossing, extruding, rolling, and wrapping, as with fabric.

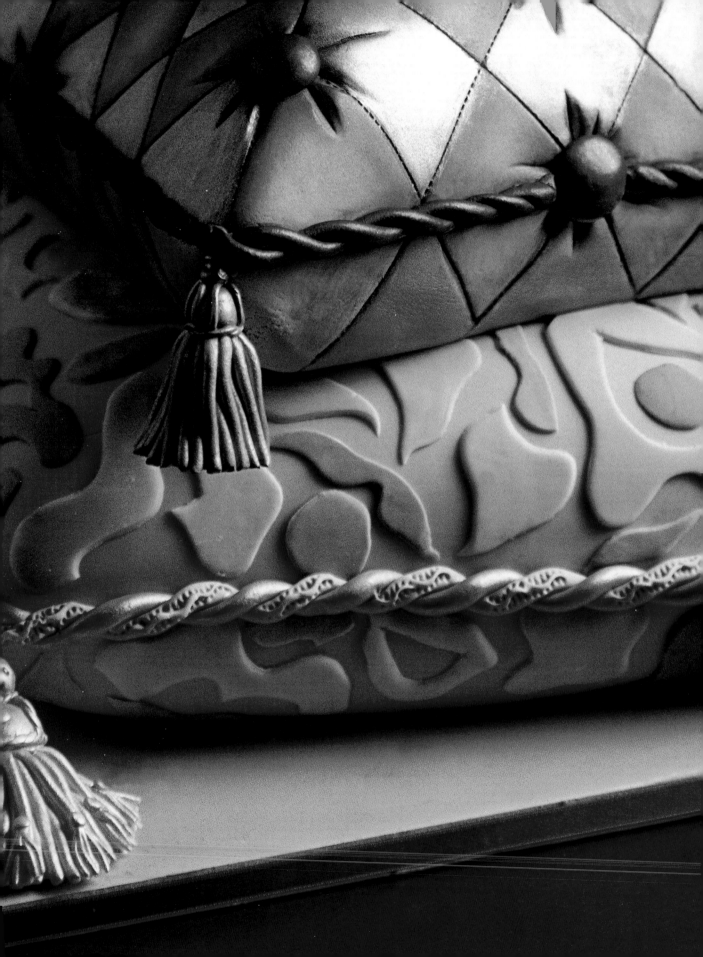

In advance

Make the 9 gumpaste tassels and the ball fringe. The ball fringe is made using the #22 wire with a hook on the end. Dampen the hooked end of each wire and press a ½-inch ball of gumpaste on the end. Mix powdered coloring with lemon extract and paint with red paint. The other tassels are described on page 231.

Cover the base with thinned ochre-colored royal icing.

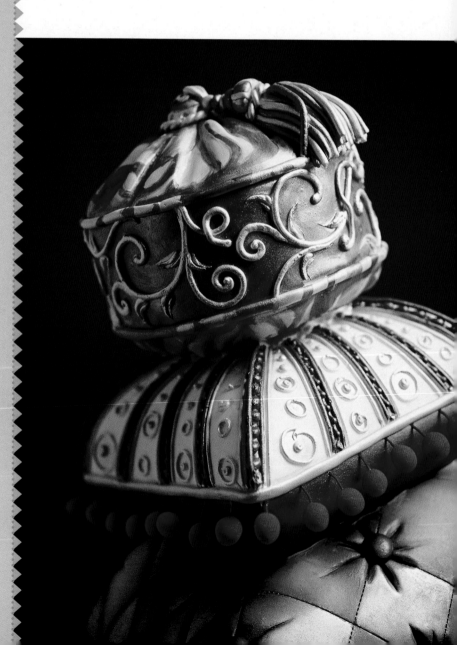

To decorate

Place each tier on its corresponding foamcore board and carve the cake tiers, using the illustrations as a guide. The bottom of the cake should eventually meet the edge of the board. Cover the bottom tier with peach-colored fondant, the next tier with pale blue. Cover the third tier with white fondant and the top tier with off-white fondant. Set the peach tier on the prepared base, using royal icing to hold it in place. Insert dowels into each tier.

To decorate the bottom tier, make about ½ cup of lime-green fondant. Roll out a thin piece of it and, using a small pizza cutter, cut out a lot of random shapes, using the photo as a guide. Attach these to the peach tier, using water as the glue. Make a peach braid of fondant and attach it with water around the middle edge of the side of the cake. Crimp every other twist of the rope with the "S" crimper. Paint the peach tassels and the rope with pink luster paint.

The second tier, with the blue fondant, should be quilted (see page 225) as soon as the icing is placed on the cake, while it is still soft. To do so, divide the sides of the cake into 4 equal sections. Using a straightedge and the tracing wheel, make a line from one corner to the opposite one (top left to bottom right) of each section. Then move over to the next mark and connect it to the next one on the perpendicular side.

To make the wrinkles for the buttons, use a gumpaste tool with the flat curved side to make indentations at each intersection of the lines (see illustrations). Continue the lines on the underside of the cake, then repeat the same steps as above. Make the buttons and attach them at the intersection of the wrinkles. Paint every other square with green luster paint.

The next tier is also divided into 4 sections, like the one above. Pipe lines from the middle of the tier up to where the next tier will sit. Pipe 2 royal icing lines with the #3 tip at ¼-inch intervals and then at 1-inch intervals. Pipe circles in the 1-inch spaces. In the ¼-inch intervals, pipe a snail trail, then overpipe with a straight line.

Roll out a rope of fondant about ¼ inch thick and attach it with water to the center of the cake. Paint the piping in the ¼-inch intervals and the underside of the "pillow" with burgundy luster paint. Paint the rest of the piping and the center rope with gold pearl. Insert the red ball fringe around the center edge.

To decorate the top tier, make two ¼-inch fondant ropes and attach them to the top and bottom

edges. Attach the tassel to the top of the cake. Paint the middle section with a mixture of beige and burgundy powder. Paint a random swirl on the top and bottom of the cake with the same color, including the tassel. Pipe the curlicue design shown on the middle section with the #3 tip. Paint the rest of the tier with beige luster paint. Stack the cakes and insert dowel through the entire cake.

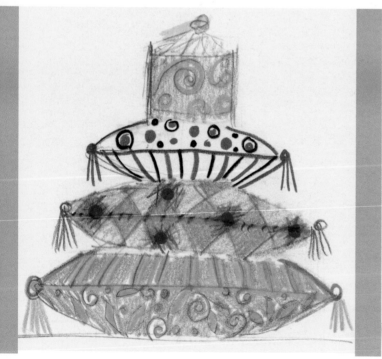 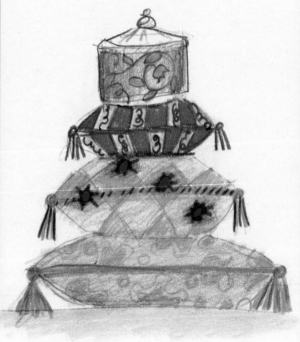

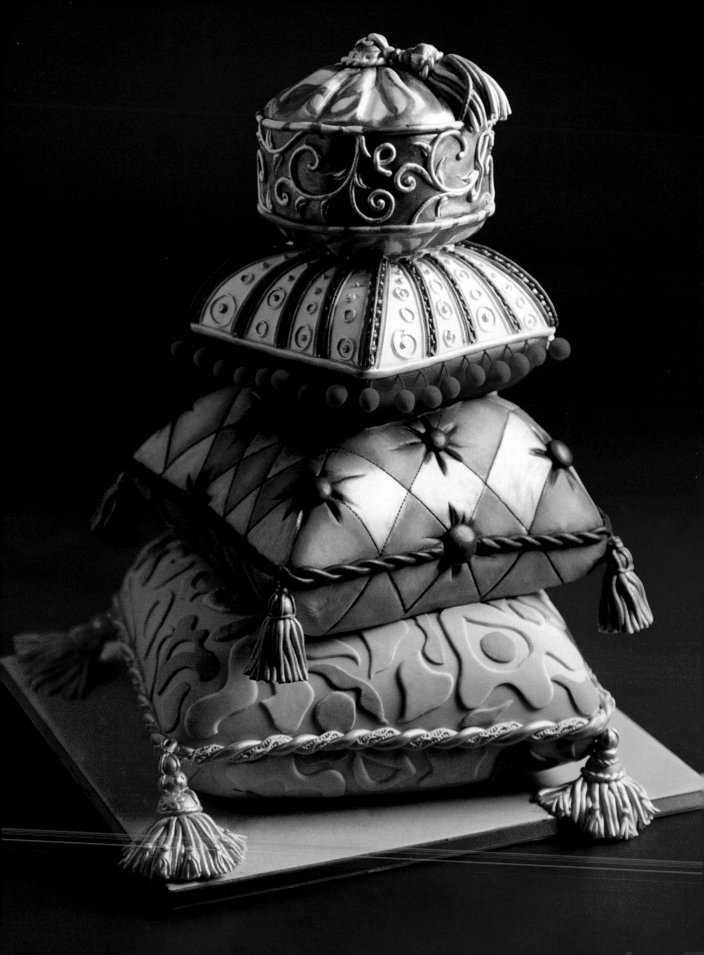

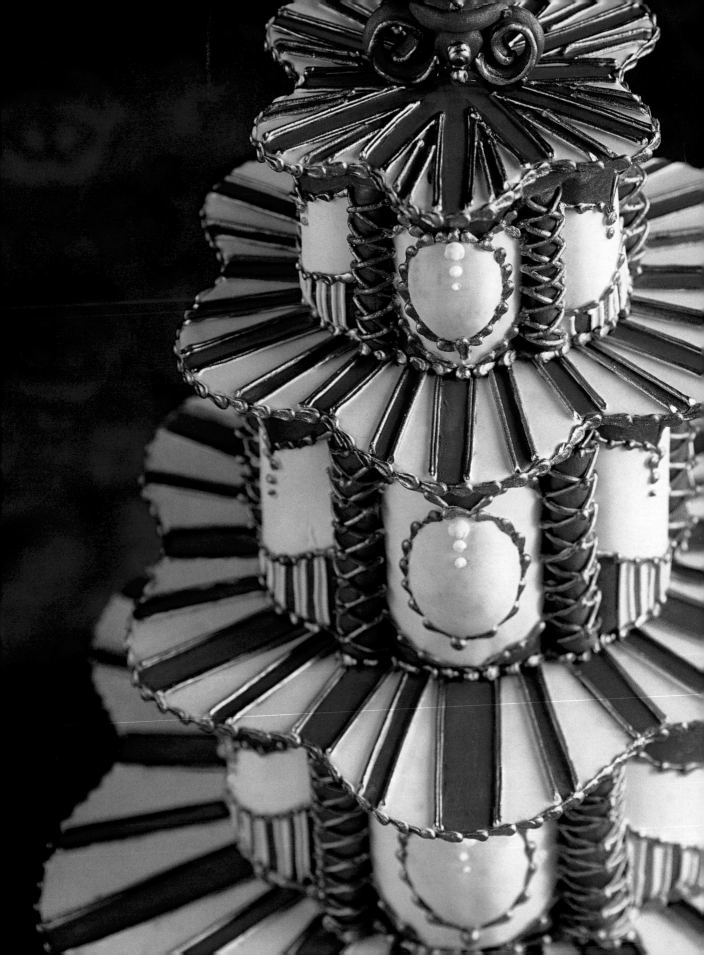

Blue Pagoda

SERVES 40

Sometimes I get an idea for a cake based on one thing; then, when it's created, it ends up looking nothing like the original inspiration! That's what happened here. For a bridal event, I was asked to make a cake based on a particular china pattern on display at the store Scully and Scully in New York City. I used some of the elements from the china, but the idea for the "rooftop" effect came from a pagoda on the china.

TECHNIQUES USED

Gumpaste collar, painting with luster dust, piping with royal icing

CAKES

- 3½-inch petal, 2 inches high
- 4¾-inch petal, 3 inches high
- 6-inch petal, 3 inches high
- 8-inch petal, 4 inches high

OTHER MATERIALS

- 4 petal-shaped gumpaste collars ⅛ inch thick, sized 12 inches, 8 inches, 6½ inches, and 4½ inches
- 3½-inch petal-shaped foam-core board
- 4¾-inch petal-shaped foam-core board
- 6-inch petal-shaped foamcore board
- 8-inch petal-shaped foamcore board
- 12-inch petal-shaped foamcore board for base
- white fondant
- royal icing
- dowels
- gumpaste
- blue and gold luster dust
- lemon extract
- piping bag and #2 PME tip
- toothpick or skewer
- paintbrush

In advance

Make the gumpaste collars (Figure 1) and the finial (Figure 2) for the top and give them plenty of time to dry, at least 2 days. Place a toothpick or skewer in the finial while it is soft so that it can be easily inserted into the top of the cake.

Paint the stripes on the gumpaste collar, but don't do the piping until the collars are placed on the cake, so they won't get disturbed during stacking. Paint the finial and add the piping, which will be painted gold.

Cover the base with white royal icing. When it dries, paint the stripes on the base. Add the piping after the cake has been placed on the board.

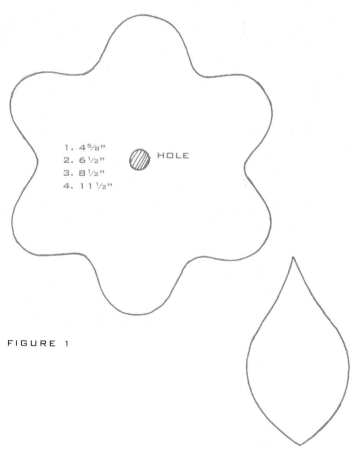

1. 4⅝"
2. 6½"
3. 8½"
4. 11½"

HOLE

FIGURE 1

FIGURE 2, ENLARGE
TEMPLATE TO 154%

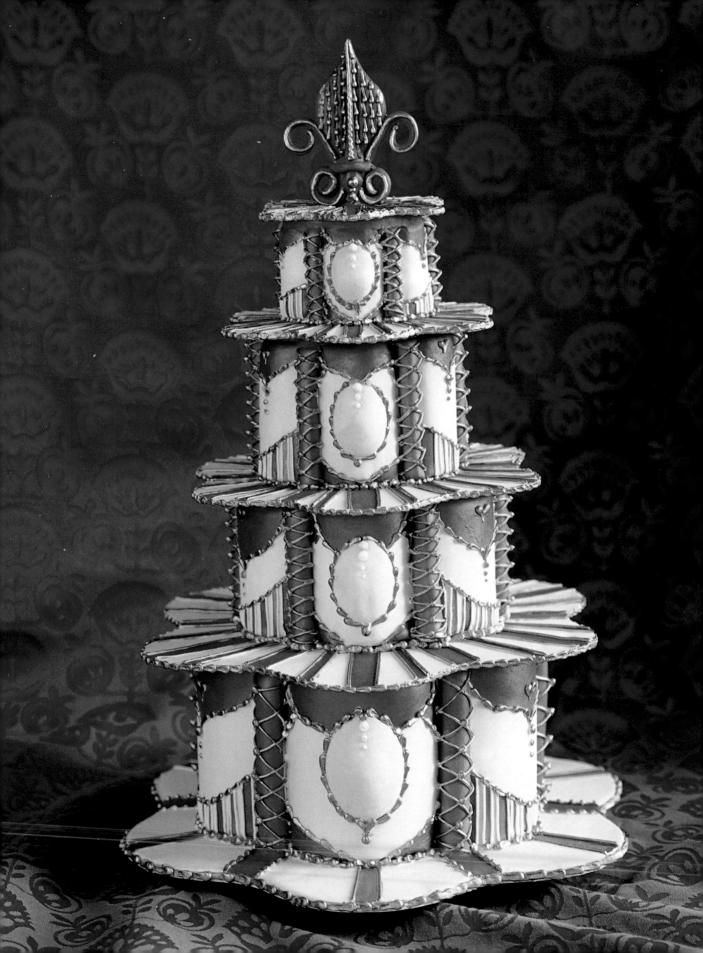

To decorate

The cakes are all covered with white fondant. Use the patterns (Figure 3) provided to mark the decorations on each tier. The front of each tier is different from the rest of the tier, so make sure that you remember which is the front.

The easiest way to decorate this cake is one tier at a time, rather than stacking them all and then painting and piping. Place the bottom tier on the board and make an oval out of gumpaste for the front. Attach it with water. Make 8 thin tubes of fondant, the same height

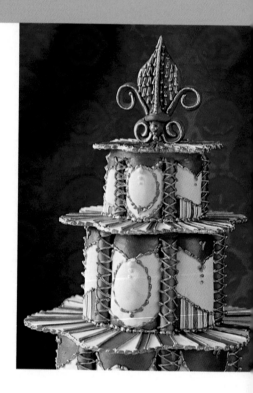

as the tier, and attach them to the indentations in the scallops. Paint the blue and gold areas with luster dust mixed with lemon extract, then add the piping. Attach the 12-inch gumpaste collar to the top of the tier and pipe a border of royal icing along the area where the top of the cake meets the bottom of the collar.

Continue doing the same thing with each tier as you go up. When you are finished, paint all of the piping gold, and insert the finial on the top.

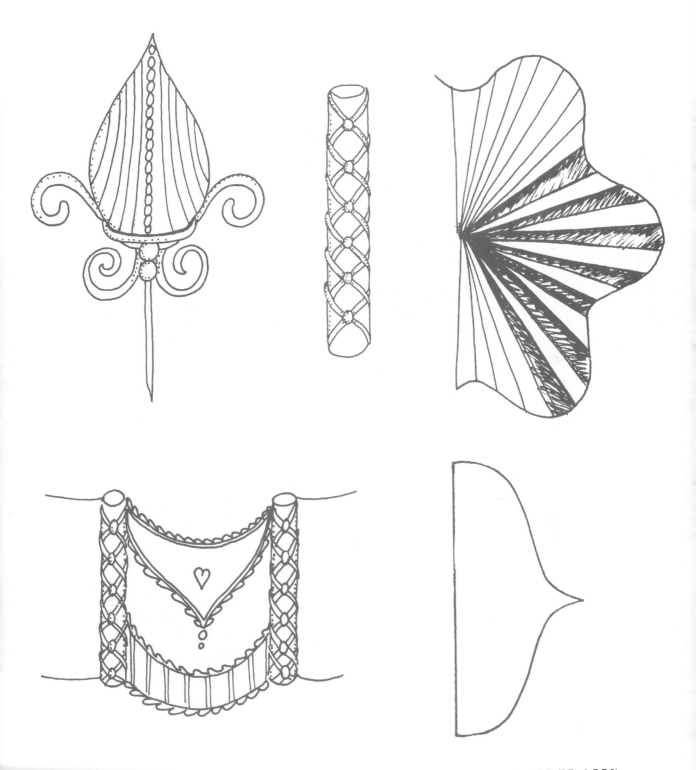

FIGURE 3

ENLARGE TEMPLATE TO 125%

Amethyst Arabesque

Just because a work of art is tiny doesn't necessarily mean it can't carry a lot of weight. Just think of a Fabergé egg, for example. You can pack quite a bit of decoration onto a pint-sized cake.

Curved cutouts give an average-shaped cake an exciting new profile. I use a few cutters in many different ways to get as much variation as I can, such as curving them, cutting out the centers, and attaching them to the cake in either a concave or convex way. Enhanced by swags, strings, and dots of royal icing, this diminutive cake is fit for a king (or a queen).

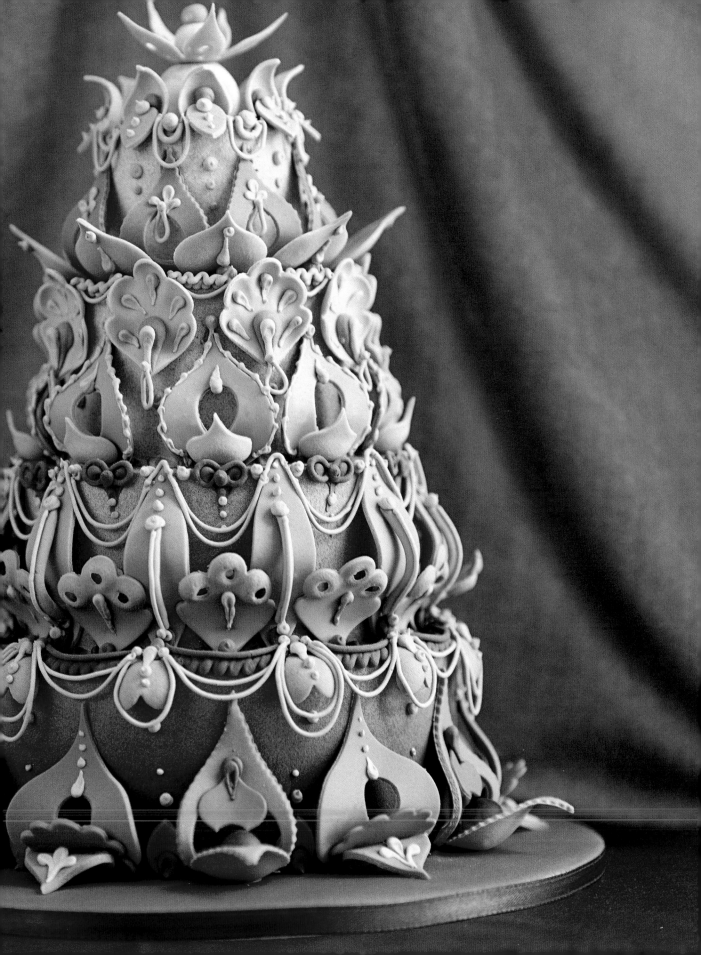

In advance

Tint the fondant burgundy and cover all of the tiers. Cover the base with burgundy royal icing and let it dry.

To decorate

Mark each tier in sections accordingly: bottom tier, 12 divisions; second tier, 12 divisions; third tier, 8 divisions; top tier, 8 divisions. (See the section on dividing a cake, page 244.) Stack the cakes on the base. Start at the top and work down.

THIS IS THE ORDER IN WHICH YOU'LL NEED TO PLACE THE DECORATIONS, STARTING AT THE TOP: (Note: All of the royal icing piping is in either pink or burgundy.)

1. Top of the first tier: 8 evenly spaced pink cupped rose petals. Dot of dark burgundy in center. Blue flat petal, 3 pink dots on petal, 3 pink dots on cake under petal.

2. Bottom of the first tier: Place large, curved pink leaf shapes, with the centers cut out using the rose petal cutter. Place these in between the blue petals above. Attach a cupped cucarda in between each leaf. Pipe a fleur-de-lis in the center of the dark pink leaves, then a closed drop string. Pipe 3 dots on the cupped cucarda.

3. Top of the second tier: Pipe a pink rope under each cucarda, then a short drop string under each rope. Attach a pink orchid throat to the cake so that its top reaches just above the top of the tier. Pipe a teardrop in each scallop of the cutout, then a burgundy teardrop in the center and a smaller pink one on top of that. Pipe a closed drop string from the end of the double tear drops.

4. Bottom of the second tier: Attach 8 curved blue cucardas with a rose petal cutout in the center. Pipe a dotted border around the edge of the cucarda, with a teardrop hanging from the top of the hole. Attach a smaller, pink cucarda without a cutout under the blue one.

USE ROYAL ICING IN THE SAME COLOR AS THE CUTOUTS TO ATTACH THEM TO THE CAKE SO THAT THE ICING DOESN'T STAND OUT FROM THE DESIGN. USE THE CUTTERS SHOWN TO CUT OUT GUMPASTE PIECES. DRY THEM ON FLOWER FORMERS TO BEND THEM INTO THE SHAPES SHOWN. USE A BALL TOOL TO CUP THE CENTERS OF OTHER CUTTERS.

IF YOU DON'T HAVE THE EXACT CUTTERS SHOWN, YOU CAN ALWAYS SUBSTITUTE SOMETHING SIMILAR.

GUMPASTE CUTTERS

5. Top of the third tier: Pipe 12 evenly spaced burgundy hearts around the top edge of the tier. Pipe 2 pink dots at the points of the hearts. Attach a pink curved orchid petal in between each heart, the height of the tier. Make a thin blue rope and attach it to the center of the petal, curving away from the surface.

Between each petal, pipe 2 pink strings, then 3 dots on the top of each petal, and a pink line down the center of the blue rope.

6. Bottom of the third tier: Cut out 12 blue orchid throats. Cut a circle in the scallop of each one with the #3 tip. Cup each scallop. Attach each orchid throat in between each petal. Pipe a pink teardrop in the center of each. Pipe a burgundy shell border around the entire base of this tier.

7. Top of the bottom tier: Attach 12 upside-down cupped hearts at the base of each blue rope on the tier above. Pipe 2 pink drop strings in between each, then 2 closed drop strings around each heart, and

finally a teardrop and 2 dots in each heart. On the cake below each heart, pipe 3 dots, decreasing in size.

8. Bottom of the bottom tier: Cut out 12 large burgundy cucardas. In the center of 6, cut out a rose petal; cut a smaller cucarda in the centers of the rest. Attach the 12 cucardas to the bottom edge, alternating the centers. Attach them to the top of the tier, cupping out slightly. Pipe a pink teardrop and 3 dots above the center opening made by the rose cutters. Attach a small blue cucarda, point up, to the centers of the others. Pipe a burgundy teardrop to the top of the blue cutout. Attach small burgundy rose petals, from the centers of the cucardas, in between each large cutout. Pipe a burgundy dot at the base of each.

9. Finally, using the centers of the cucardas, cup them slightly and attach them to the base of each large cucarda. Insert a flat blue orchid throat between every other cucarda, then make a small burgundy ball in the centers of the others. Pipe a pink fleur-de-lis at the tips of all of the curved cucardas without the balls.

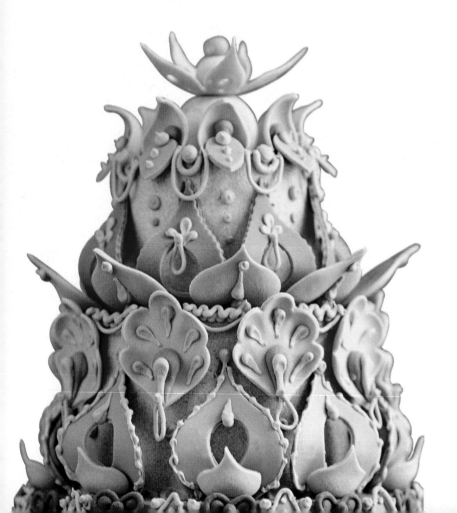

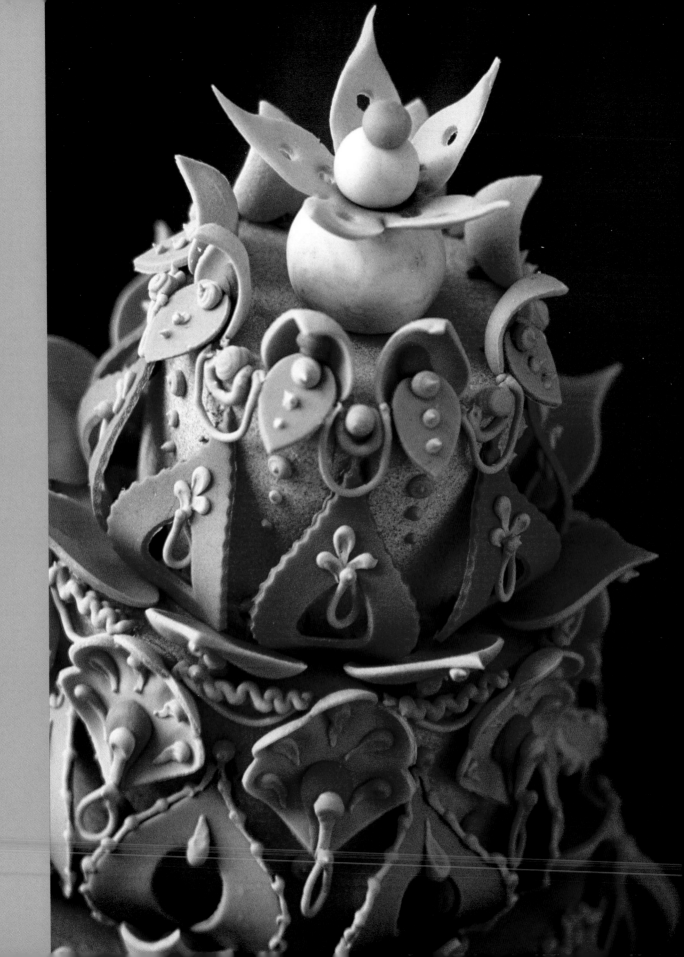

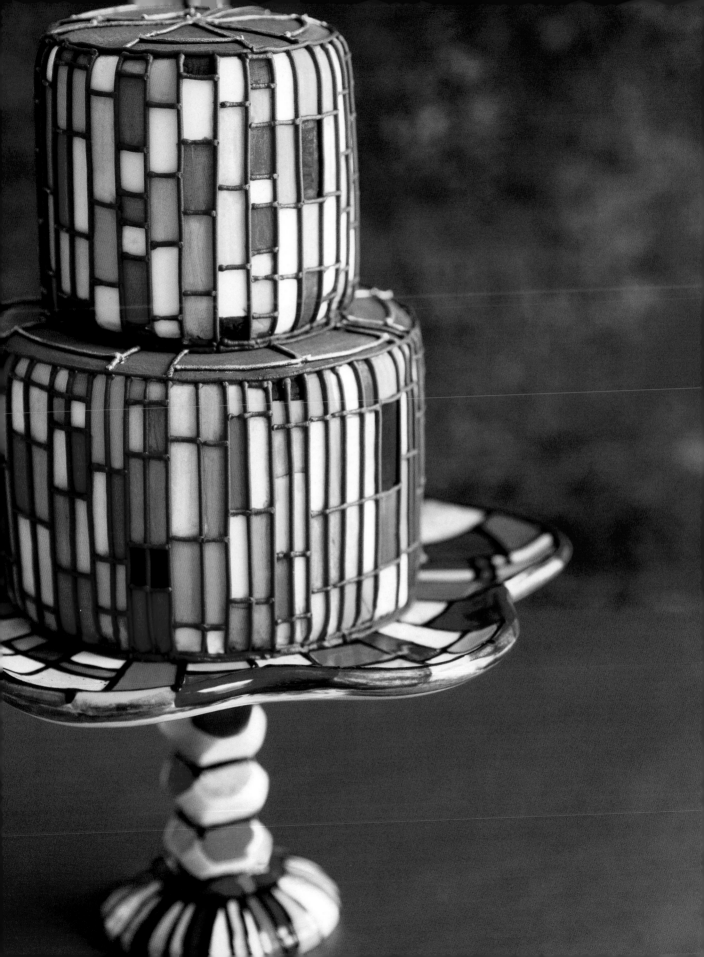

Colorful Cloisonné

SERVES 10

The inspiration for this little cake was a striking cloisonné
box I saw in a gift-shop window. Since this cake is very small,
I felt it needed to be raised up a little to give it more impor-
tance, so I designed a ceramic cake stand to match.

TECHNIQUES USED

Painting with luster and nonluster
dusts, piping with royal icing

CAKES

- 3¼-inch round, 3 inches high
- 5-inch round, 3 inches high

OTHER MATERIALS

- cake stand or 8-inch foamcore base
- fondant
- royal icing
- piping bag and #2 PME tip
- nontoxic gold luster dust
- royal blue, yellow, ochre, sienna, moss, and kelly green petal dust
- lemon extract
- brown paste food coloring
- dowels
- flexible cardboard triangle
- edible marking pen (found in cake-decorating stores)
- paintbrush

To decorate

Cover the cakes with white fondant. Mark the cakes with ¼-inch vertical divisions on the side of each tier. They do not all have to be exactly the same size. Next, mark horizontally in a random manner, using the photo as a guide. Then draw the lines with the marking pen, using a triangle to keep the lines perpendicular. The tops of both tiers do not have a regular pattern of lines, but they need to be painted blue before you pipe them. Fill in the rectangles with various colored paints, as shown. Pipe vertical and horizontal lines with brown royal icing on the sides. Pipe random lines radiating from the center of the top. Mix the luster dust with lemon extract and paint the lines gold on the top of the cake.

Decorating tip

WHEN PIPING DOWN THE SIDE OF A CAKE, HOLD THE BAG SLIGHTLY AWAY FROM THE CAKE WITH THE TIP AT A 45-DEGREE ANGLE AND LET THE ICING FALL OUT OF THE BAG RATHER THAN DRAGGING THE TIP ON THE SIDE OF THE CAKE. THIS WAY YOU'LL GET A MUCH NEATER AND STRAIGHTER LINE.

Aqua Appliqué

Besides sugar and food coloring, another material I like to work with is wood. I love the clean smell of it, the surprise you get when you sand it, and the buttery feel it has when you finish it. Wood has the same sensual smoothness as the smooth fondant on a cake. So for this design, I wanted the look of a dresser with decorative appliquéd drawers. I even made one of the hexagonal sections of this cake an open drawer.

The shiny surface is achieved by lightly spraying the cake with water from an airbrush.

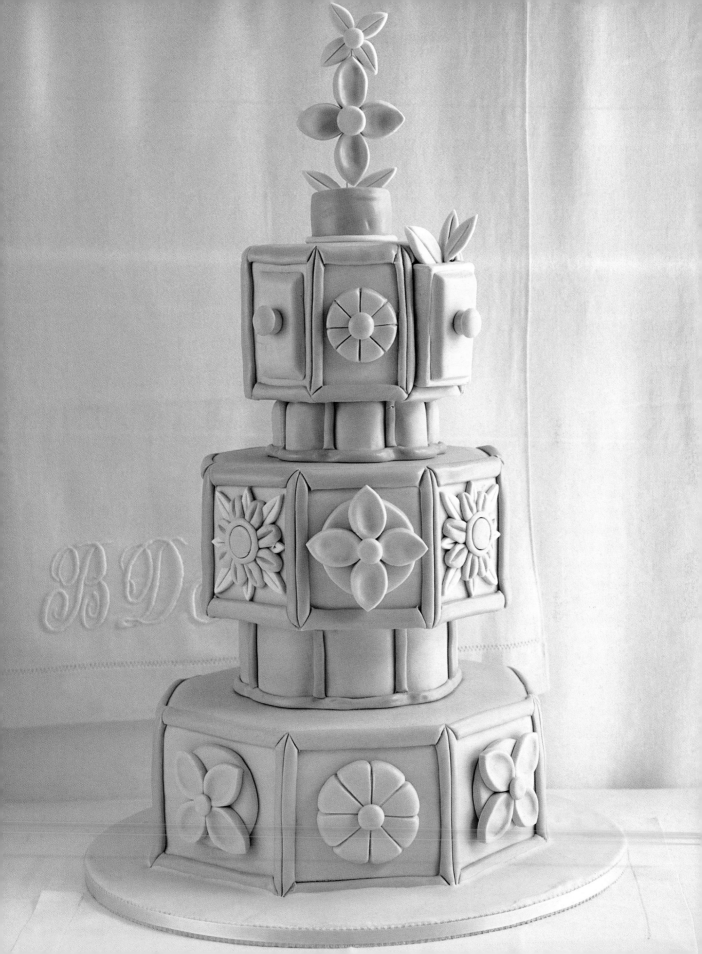

TECHNIQUES USED

Fondant cutouts, cake drums

CAKES

- ☐ 5½-inch octagon, 4 inches high
- ☐ 8-inch octagon, 4 inches high
- ☐ 10-inch octagon, 4 inches high

OTHER MATERIALS

- ☐ 2-inch Styrofoam round, with a foamcore bottom
- ☐ 5-inch Styrofoam petal, 2 inches thick, with a foamcore bottom
- ☐ 6-inch Styrofoam petal, 2½ inches thick, with a foamcore bottom
- ☐ 16-inch round for base
- ☐ 5½-inch hexagonal foamcore board
- ☐ 8-inch hexagonal foamcore board
- ☐ 10-inch hexagonal foamcore board
- ☐ dowels
- ☐ fondant
- ☐ royal icing
- ☐ gumpaste
- ☐ teal paste coloring (or green and blue)
- ☐ #22 wire
- ☐ cutters: 1¼-inch, 2-inch, and 2¾-inch circles, 3 petal cutters

In advance

Mix some fondant to a light teal and some to a darker teal; these will be the only colors used. Make the cutouts for the top ornament and insert a damp wire into them. Make the cutouts for the "drawers." Let them dry.

To make the drawer, cut out a wedge of gumpaste to measure 2 by 3¼ inches and ⅜ to ½ inch thick. Attach a smaller piece to the top front of the wedge. Let this dry (Figure 1).

To make the handles for the drawers, make a small gumpaste cylinder, then add a larger gumpaste half-ball to the top of the cylinders (Figure 2).

Cover the base and the petal-shaped Styrofoam drums with pale teal fondant; cover the small round drum with the darker teal. Roll out a rope of darker teal, trim to the height of the drums, and attach vertically at the intersections of the petals. The bottom borders will be added when you stack the cakes. Cover the base with teal-colored royal icing.

FIGURE 1

FIGURE 2

FIGURE 3

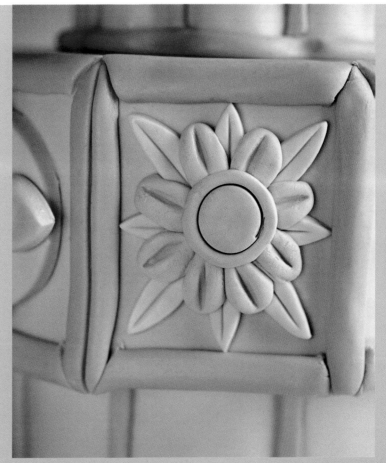

To decorate

Stack the cakes and drums on the base. Insert a sharpened dowel through the entire cake. Make a rope around each division on the hexagons and the petals with the darker teal fondant.

Attach the appliqués, the drawer, and the top ornament.

GUMPASTE CUTTERS

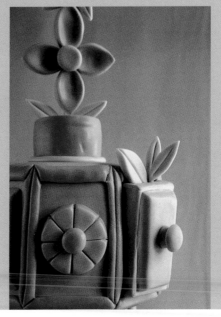

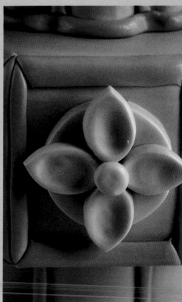

Dreams

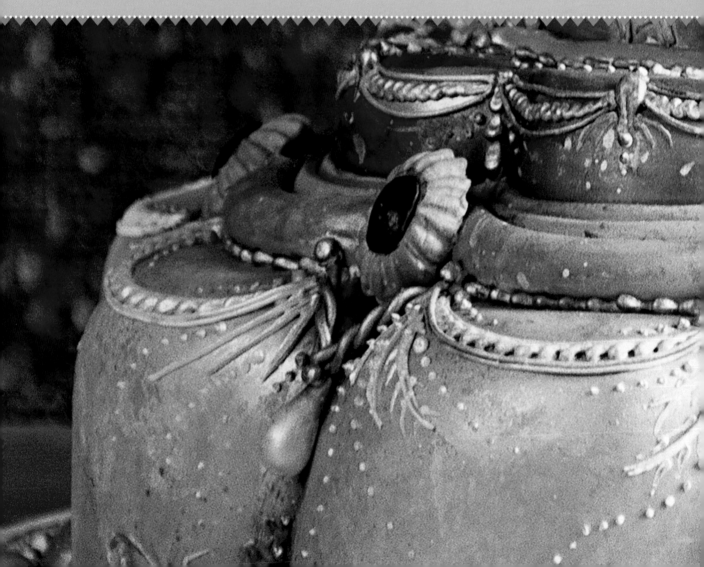

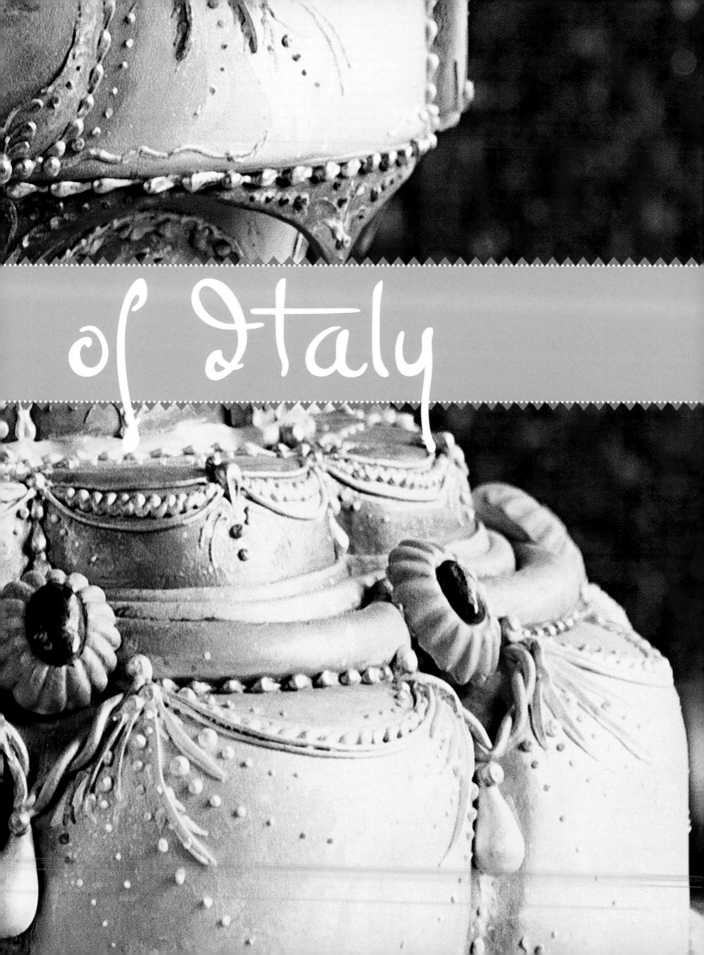

of Italy

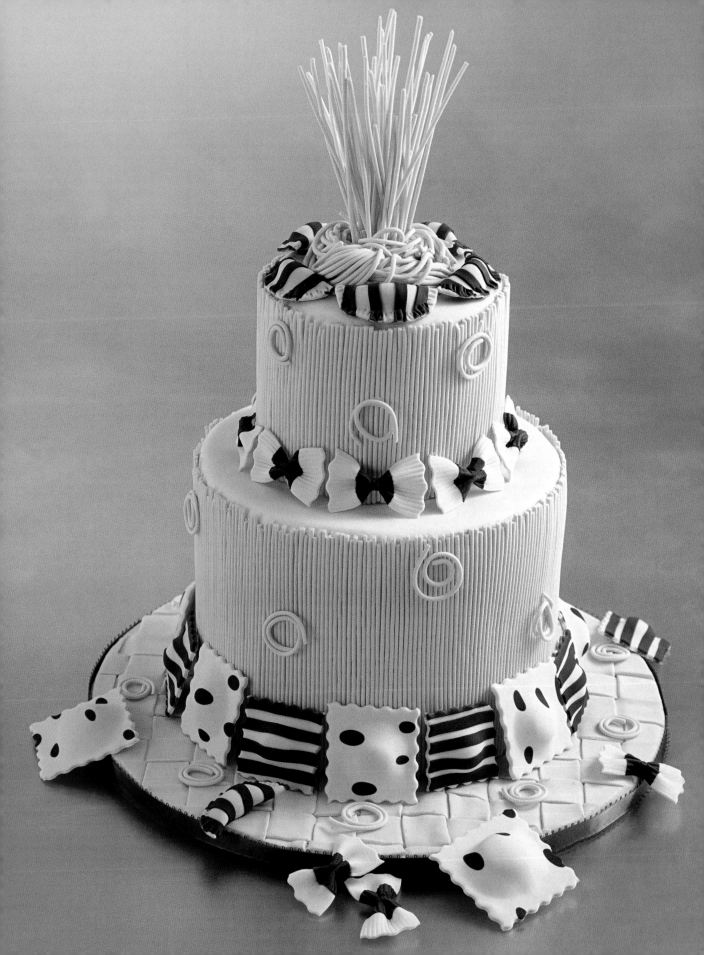

Cake-
a-Roni

SERVES 40

I use a pasta machine almost on a daily basis, but I have
never made pasta in my life! I use it for rolling out gumpaste,
fondant, and modeling chocolate because it speeds up the
rolling process, especially if you have a motorized machine.
But I thought, since pasta dough is similar in consistency to
the sugar doughs I use, why not make white chocolate pasta,
which looks identical?

Pasta comes in such interesting and varied shapes that it
makes great decorations for a cake. The only thing this cake
doesn't need is a little tomato sauce!

To decorate the base

You can either use white modeling chocolate or white fondant that has
been tinted a pale yellow (the color of pasta) to cover the base. It's easier to
make the woven piece in a big square and adhere it to the base with water,
and then trim it, than to try to make the piece circular. Roll out a piece of
fondant or chocolate the size of the base, then cut it into ½-inch-wide
strips using a pizza cutter. Begin weaving the strips, starting in the center.
When you are finished, brush the back with a little water and attach it to
the base and trim..

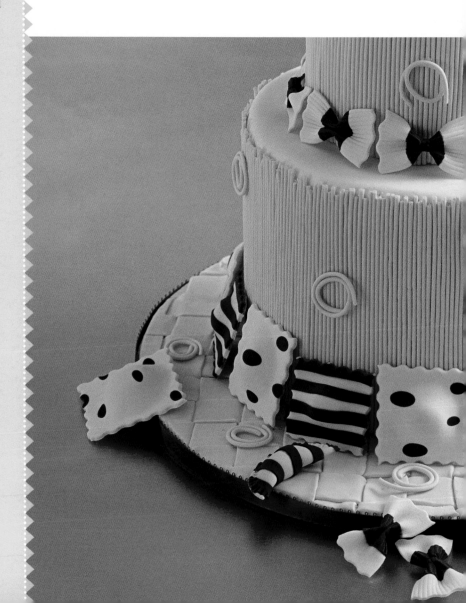

To make the pasta

Make the white modeling chocolate (if you haven't made it for the base). When it is cool, you can begin making the pasta.

To make the pasta striped, roll out a piece of the white modeling chocolate about 1/16 inch thick and cover it with a piece of plastic wrap to keep it from drying. Meanwhile, roll out a piece of chocolate fondant about the same size and thickness as the white chocolate and cut it into 1/4-inch-wide strips. Lay the strips on the white chocolate in straight lines and gently roll with a rolling pin, being careful not to make the lines wavy. When the strips have attached themselves to the base, you can cut them into circles.

To make polka-dotted pasta, use the same procedure as for the stripes, but attach circles of chocolate instead. Roll the pieces together.

SPAGHETTI: Use the clay gun with the plain round opening, and simply squeeze the dough through. Keep it straight or, to make a nest, gather many pieces and wrap them in a circle.

Decorating tip

TO MAKE THE STRIPES AND CIRCLES ON THE PASTA, RUB A LITTLE SHORTENING ON THE BOTTOM PIECE (THE WHITE CHOCOLATE) TO KEEP IT SOFT AND PLIABLE. THIS WILL MAKE THE CHOCOLATE ADHERE BETTER. ALSO, REMEMBER THAT WHEN YOU ROLL THE 2 COLORS TOGETHER, THE STRIPES OR DOTS WILL GROW, SO START WITH THEM SMALLER SO YOU DON'T END UP WITH HUGE STRIPES OR DOTS.

AGNOLOTTI (half-moon-shaped filled pasta): Cut out 2½-inch fluted circles of white modeling chocolate. Place a dollop of chocolate ganache in the center and then fold one half of the circle over onto the other half. Press the edge together to seal. Cut with the wavy pastry wheel.

FARFALLE (bow ties): Roll out a piece of the white chocolate and roll out another piece of chocolate fondant, both about ⅛ inch thick. Cut the chocolate into a strip about ¼ inch wide. Place the chocolate strip on top of the white chocolate and roll the 2 pieces together. Then, with a ridged rolling pin, roll horizontal lines in the piece. Use the pastry wheel to cut pieces about 1¼ inches high and 2¼ inches wide. Pinch them in the middle .

RAVIOLI: Make striped or polka-dotted sheets of chocolate as described above, then cut them into 2-inch squares with the pastry wheel. Roll out a very thin piece of white modeling chocolate and cut it into 2-inch squares. Place a dollop of ganache in the middle of each plain square. Then place the striped or dotted square on top of the ganache, and pinch around the edges to seal.

To decorate

Cover all of the cakes with pasta-colored fondant. Stack on the prepared board. Attach the spaghetti to the side of the cake with clear piping gel. Attach all of the rest of the pasta on the cake with piping gel. Make a nest of spaghetti and stand some spaghetti in the center.

AGNOLOTTI

FARFALLE

RAVIOLI

Dolce de Medici

SERVES 160

During the Italian Renaissance, the use of ornament and color was at its height. The ruling Medici family were great patrons of the arts. When I was asked to design a cake for a wedding in Florence, I was inspired to create a memorable and majestic piece of edible sculpture, worthy of the Renaissance artists. I used Florence as my inspiration, and looked at the treasures of the city's great museum, the Uffizi, for decorative flourishes, patterns, and patinas.

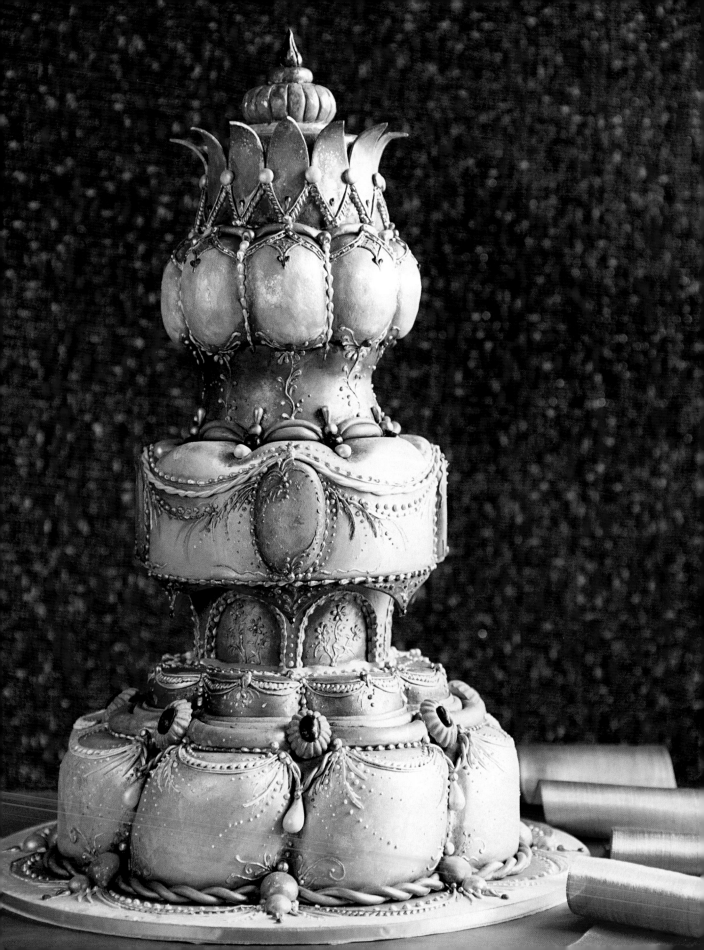

Cake carving, painting, and splattering with luster dust, gumpaste cutouts, fondant ropes and pearls, cake drums, piping with royal icing, sugar molds

CAKES

- ☐ 6-inch round, 3 inches high, carved to measure 5 inches on top
- ☐ 8-inch petal, 3½ inches high, carved to 6 inches top and bottom
- ☐ 10-inch round, 4 inches high
- ☐ 10-inch petal, 2 inches high
- ☐ 15-inch petal, 4 inches high

OTHER MATERIALS

- ☐ two 6-inch Styrofoam rounds, 3 inches thick
- ☐ two 6-inch round foamcore boards
- ☐ 10-inch round foamcore board
- ☐ 10-inch petal foamcore board
- ☐ 15-inch petal foamcore board
- ☐ 20-inch board for base
- ☐ two 3-inch round tart pan sugar molds, hollowed (see page 241)
- ☐ eight 1½-inch fluted oval tart pans
- ☐ royal icing
- ☐ fondant
- ☐ gumpaste
- ☐ piping bag and #2, #3 tips
- ☐ gold, super-pearl, pink luster dust
- ☐ teal, purple, red, beige, dark blue, and orange petal dust
- ☐ lemon extract
- ☐ 3½-inch oval cutter
- ☐ leaf cutter
- ☐ paintbrush
- ☐ dowel
- ☐ sponge

In advance

Carve the bottom Styrofoam drum so it has 6 equal arches, stopping about ¾ inch from the top. Carve the top Styrofoam drum so that it measures 5 inches in the center. Glue a 6-inch foamcore round to the bottom of each drum. Cover each drum with fondant.

Cut out 12 leaf-shaped gumpaste pieces and dry them with a curved tip against the inside edge of a sheet pan.

Make the sugar molds and hollow out the insides. When they are dry, glue them together with royal icing and cover them with fondant. Make 8 orange fondant "tarts" in the oval tart pans. Adhere a fondant oval to the bottom of each oval tart and paint them dark blue. Cover the base with white royal icing.

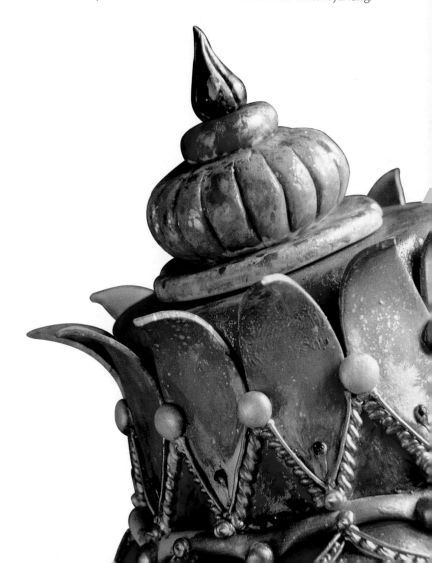

Decorating tip

To decorate

Carve the 15-inch bottom tier so that all of the petals curve on the diagonal and are rounded on the top edge. Round the top of the 10-inch petal. Carve the top of the 10-inch round so that it has 8 upward curves (see page 244). Carve the 8-inch petal so that it is rounded on the top and bottom. Carve the 6-inch round so that it measures 5 inches on the top. Cover all of the tiers with white fondant.

Attach the bottom tier to the base with royal icing. Add all of the tiers and drums as indicated in the photo. Insert a sharpened dowel through the entire cake.

Hanging below the middle tier is a scalloped gumpaste border, which is attached under the cake. Cut a 1½-inch-wide strip of paper to fit the exact circumference of the 10-inch tier. Fold the paper into 6 equal parts. While it is still folded, cut an arch from A to B (Figure 1). This will serve as a template for the arches. Cut out the gumpaste arches and attach them with water.

All of the rest of the decorations are fondant, except for the piping, which is royal icing. Make a ½-inch-wide braid for the border of the bottom tier. Make a 1-inch and a ¾-inch ball of fondant in between each petal on the bottom tier. Roll out 3 ropes to use as borders on the 10-inch petal tier. They should get progressively fatter. Make a rope for the bottom border around the arched drum.

The border for the concave drum is made out of thick and thin ropes. Make a thinner rope and attach it to the top of the thick and thin rope (Figure 2).

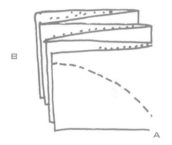

FIGURE 1

FIGURE 2

GUMPASTE CUTTER

Make a rope around the base of the 6-inch tier. Form 4 fondant ovals and attach them to the middle tier with water, as shown in the photo. Make a thin braid that reaches from the top of each oval in a garland shape.

To color the tiers, first paint the red areas, which consist of the top tier, the concave drum, the scalloped drape, the intersections between the petals on the 8-inch tier, and the 10-inch petal. Sponge on the red dust mixed with lemon extract to make a paint. Sponge on blue over the red on the bottom edges of these tiers.

The orange tiers are the 8-inch petal, the 10-inch round, the 2 borders around the large petal tier, and the bottom tier. Sponge on orange paint all over these areas. Sponge gold pearl paint on the 8-inch tier and the bottom tier, as well as above and on the braid on the 10-inch round. The bottom tier has blue paint sponged around the bottom border, and in between the petals. Also, sponge blue around the inside of the arches and around the edges of the ovals.

Paint the ovals, the gumpaste cutouts, the sugar mold, the thick and thin borders, and the large borders in front of the 10-inch petal cake teal blue. Add a 3-inch orange disk on the top of the cake, then attach the teal sugar mold, a small red disk, and a tiny dark blue teardrop on the top. Attach the gumpaste cutouts around the top tier. Make a ½-inch flattened ball in between each cutout.

On the bottom tier, in between each petal, make a 2-inch braid, shaped into a "V" shape. It should begin and end at the teal rope and hang down in the indentation. Make a teardrop for each braid and attach it to the end of the "V."

Above the middle tier, in between the thick and thin teal borders, attach 2½-inch balls. Make a teardrop above and below these balls.

Now you are ready to do the royal icing piping. Start at the top and use the #3 tip. Pipe a braid around the border of the gumpaste cutouts below the dots, which will form a "V." Then pipe a vertical snail trail on the next tier, in between each petal. Switch to the

#2 tip and, from about 1 inch down from the top of the snail trail, pipe an upside-down "V"-shaped braid. Pipe a small "V" below the upside-down "V" to make a diamond shape. Then over-pipe a line on top of the braid and next to it. Pipe a tiny heart at the point of the diamond (Figure 3).

Pipe vines vertically in the middle of the concave tier, below each petal of the cake above. Pipe a snail trail above the braid coming from the ovals. Pipe dots and leaves below each braid, connecting the ovals.

Pipe a snail trail around the ovals and along the bottom edge of that tier (Figure 4). Pipe a snail trail around the arches below. Pipe tiny flowers inside the arches and on the center of the scallop on the 10-inch petal tier (Figure 5).

Pipe snail trails, dots, lines, and leaves around the rest of the cake and on the bottom tier and board, as illustrated (Figure 6).

Paint gold, super-pearl, and other iridescent colors as show in the photo. Splatter with gold luster paint.

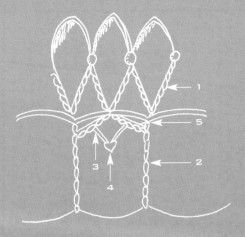

FIGURE 3, ENLARGE TEMPLATE TO 167%

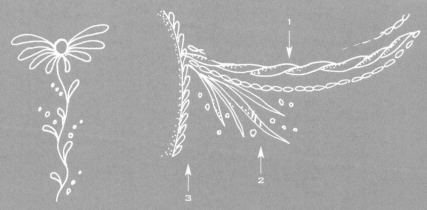

FIGURE 4

FIGURE 5,
ENLARGE TEMPLATE TO 167%

FIGURE 6,
ENLARGE TEMPLATE TO 167%

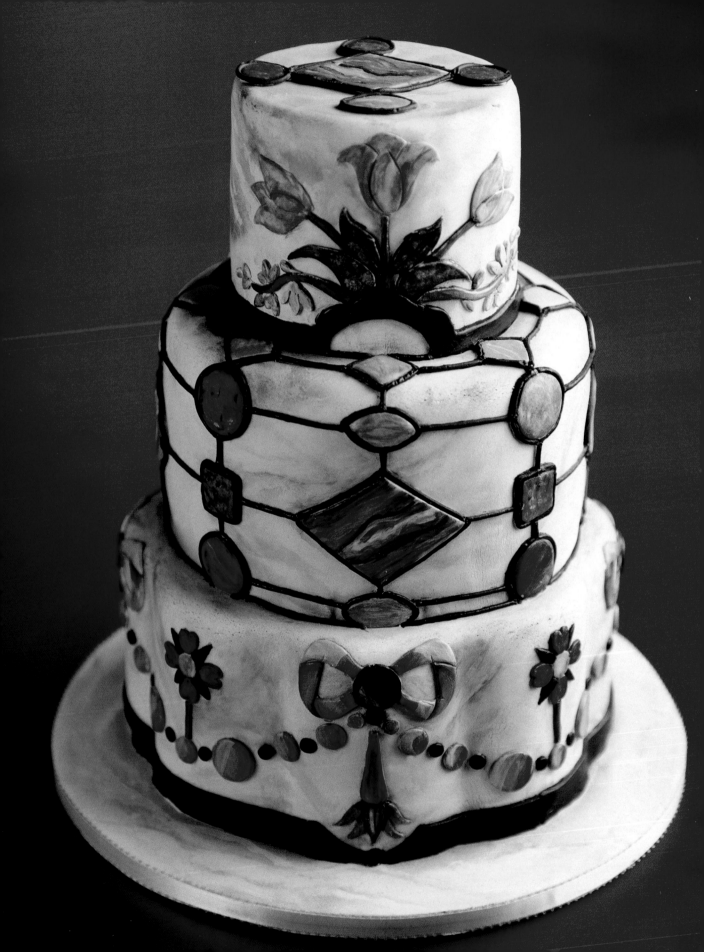

Mother-of-Pearl Mosaic

SERVES 35

The inspiration for this cake was seeing all of the inlaid stone designs in Italy. In this version, I decided to add pieces of fondant, as in real mosaics, and then to paint them to recreate the look of *pietro dure*, using faux painting to represent the different kinds of stones.

126

TECHNIQUES USED

Painting, fondant cutouts, piping with royal icing

CAKES

- 5-inch round, 4 inches high
- 7-inch round, 4 inches high
- 8-inch petal, 4 inches high

OTHER MATERIALS

- 5-inch round foamcore board
- 7-inch round foamcore board
- 8-inch petal foamcore board
- 12-inch round board for base
- fondant
- royal icing
- blue, brown, and green paste colors
- black, brown, orange, blue, and red powdered colors
- lemon extract
- piping bag and #3 tip
- paintbrush

In advance

Cover the base with marbleized royal icing, made by mixing a few dabs of blue, green, and brown paste coloring with the white royal icing just until it looks marbleized.

To decorate

Cover the cakes with marbleized white fondant, made by adding dabs of blue, green, and brown paste colors while kneading the fondant just until it is streaked. Paint streaks on all the tiers with pale green, blue, and black colors to enhance the marbleization. Stack the tiers on the base. Use the patterns in the illustration to cut out pieces of fondant and attach them to the cake with water. Paint the stones with the powdered colors mixed with lemon extract to look marbleized, like the photograph.

Pipe black lines as shown.

Decorating tip

LIGHTLY SPRAYING THE FONDANT STONES WITH WATER FROM AN AIRBRUSH WILL MAKE THEM SHINY, SO THEY LOOK MORE LIKE REAL STONE.

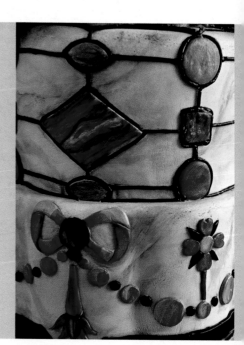

ENLARGE TEMPLATE TO 223%

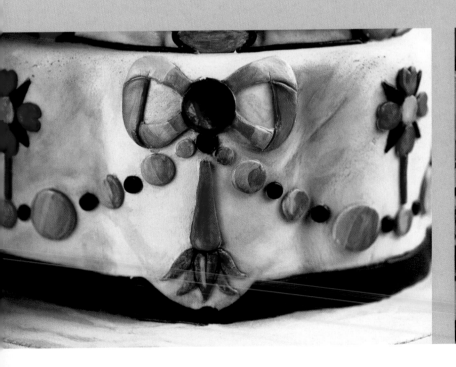

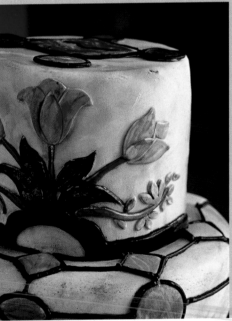

Cake for Michelangelo

SERVES 75

In 2002, in the Cooper-Hewitt Museum, a small drawing was found in a storage box labeled lighting fixtures. This drawing was examined and found to be by Michelangelo, done some-time between 1530 and 1540. It was his sketch for an elaborate lighting fixture, a candelabra. This is an amazing story and a wonderful find—one which makes the *Antiques Road Show* look like small potatoes. When I finally saw this drawing, my immediate thought was that it looked like a large birthday cake, complete with clawed feet. Michelangelo was someone I would have loved to have made a cake for, so I dedicate this cake to him, for his 529th birthday.

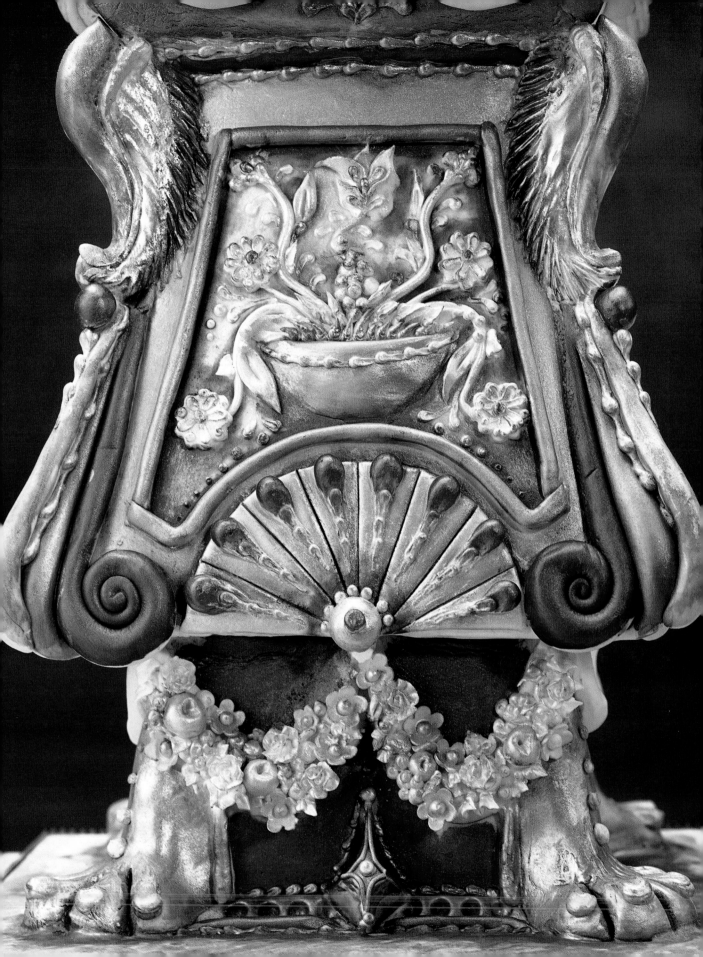

130

TECHNIQUES USED

Cake carving, piping with royal icing, shaped fondant, sugar mold, painting with luster dust

CAKES

- 6-inch hexagon, 4 inches high
- 7-inch square, 2½ inches high, the top carved to measure 6 inches
- 8-inch square, 2½ inches high
- 8-inch square, 8 inches high, carved to be 6 inches wide at the top (this is a double-layered cake)

OTHER MATERIALS

- 6-inch hexagonal foamcore board
- 6-inch square foamcore board
- 7-inch square foamcore board
- 8-inch square foamcore board
- 12-inch square board for base
- 14-inch square board for base
- 6½-inch Styrofoam square, 4 inches thick
- dowels
- sugar mold from 4½-inch bowl
- sugar molds from two 4-inch tart pans
- upside-down sugar mold from 6-inch bowl
- white fondant
- royal icing
- gumpaste
- burgundy, blue, green, gold pearl, super-pearl, gold, purple, and yellow luster dust
- lemon extract
- piping bag and #2, #3, #10, #352 tips
- gumpaste veining tool, ball tool
- 1¼-inch fluted biscuit cutter
- paintbrush

In advance

Make the sugar molds (see page 241) and hollow them out so they will be lightweight.

Glue the 12-inch base in the middle of the 14-inch base. Cover them both with thinned royal icing and let dry. Paint them with light green and dark blue luster paint.

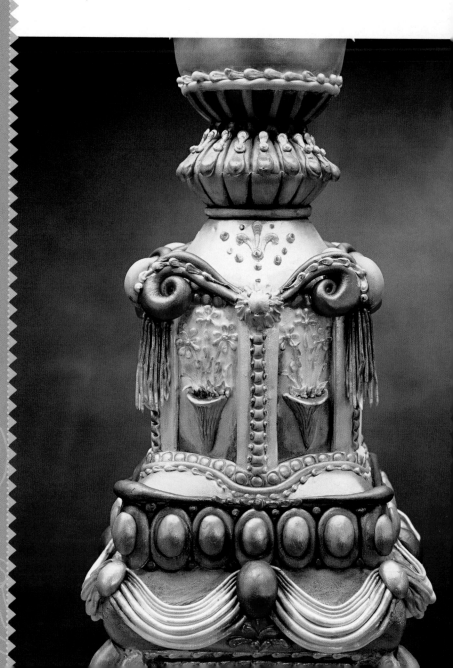

To decorate

All of the sides of the cake are decorated the same, but you can simplify the design if you wish. Carve the cakes. Cover the cakes, the Styrofoam, and the sugar molds with white fondant. Using royal icing as glue, attach the Styrofoam square to the center of the base. Attach the 8 by 8-inch square cake to the top of the Styrofoam on the base. Insert a dowel all the way through the cake and the Styrofoam. Stack the rest of the cakes as shown (Figure 1). Inset another dowel through the entire cake.

Starting at the bottom, form the 4 feet out of fondant for each corner of the Styrofoam square. Attach them with water. Make the toes using a gumpaste tool to shape. Make a rope and attach to each side between the feet. Use a ball tool to indent circles into the border. Drape 2 strips of fondant between each foot, attaching them in the center to the tier above for the garland. Below the garland, on the bottom border, form an elongated fondant diamond and attach it to the base with water. Add a smaller diamond on top of the first one. Make a thin rope for the bottom border.

Cut out the fan-shaped piece of fondant by cutting out a 5-inch half-circle and indenting 7 radiating lines from the center. Make a ball of fondant and glue it to the center of the fan. Make a ¼-inch-wide rope of fondant and attach it around the fan, up the sides, and across the top. Form the half-bowl shape inside the rope and roll out thin ropes for the stems of the flowers to look as if they are growing out of the bowl.

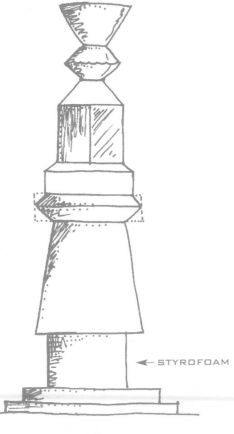

FIGURE 1

← STYROFOAM

FIGURE 2

For the front corners of the cake, form 8-inch elongated teardrops with a point on both ends. Roll the thicker end of the piece about halfway. These are attached on either side of the fan and up the corner (Figure 2). Make another thinner version of the same thing and attach it to the corner next to the first teardrop. Make a third teardrop, thinner than the last one, and attach it on top of the previous teardrop.

On the upper corners, attach a teardrop shape of fondant that meets the lower teardrops in the center of the corners. With the gumpaste tool, score it with many lines to indicate feathers. On top of these, make a small elongated teardrop, and attach it with the point curling up at the end. Make a small ball of fondant and attach it between the wing and the first teardrop below.

Make a thin rope of fondant as a border between the first 2 tiers. On the third tier, make 1 by 1½-inch ovals and attach them next to each other all around the tier. Make smaller ovals and place them on top of the larger ones. On the upper corners of this tier, attach ropes that are thick in the middle and taper to a point on each side of the center, and curl at one end.

Make the garland for the second tier that starts from the upper part of each corner and curves up to the center of the tier. This garland is made of many ropes of fondant, larger ones at the bottom and thinner ones as it goes up (Figure 3). Make a large oval of fondant and attach it in the center of each garland; set a smaller one in each corner.

FIGURE 3

Between the hexagonal tier and the one below, attach a strip of fondant, and emboss circles all around it with the #10 tip. Make a thin rope for below this strip. On each corner of the hexagonal, make a 1-inch strip going from top to bottom. On top of this strip, make a smaller one measuring ½ inch wide. Emboss horizontal lines all along the thinner strip. In the rectangles in between the corners, make small triangle shapes to serve as flower holders (Figure 4). Make lines in this with the gumpaste tool. Roll 3 balls about 1¼ inches wide, and flatten them so that they form a half ball. Cut them out with the fluted biscuit cutter and flatten

FIGURE 4

each "flute" with the ball tool. Attach one to the front of the hexagon, at the corner. Attach the other 2 at every other corner.

Make 2 elongated teardrops and curl them, and attach the point at the biscuit shape and the curl at the other corners. Repeat this at all of the corners.

Stack the sugar molds as in the photograph. Make a rope around the seams where the molds join, on the top edge of the top mold. On the rope above the middle mold, indent circles with the ball tool. Make a rope halfway up the top sugar mold and add vertical strips on the lower half.

The next step is to add royal icing piping. Start with the #10 tip and pipe teardrops around the center of the middle sugar mold, on each section of the fan, and on each toe of the feet.

Switch to the #3 tip and pipe smaller dots on each foot, on the bottom garland, and around the rope above the bottom tier. Pipe flowers at the top of each stem in the vases. Pipe curved teardrops below the garland centers and dots in between the ovals in the center tier. Add the fruit and flowers to the garland.

To make the tassels on the hexago-
nal tier with the #3 tip, start at the
top and touch the icing to attach
it, then let the icing drop from the
tip and pipe until it reaches three-
quarters of the way down the
corner.

Fill in the rest of the shells with the
#2 tip, as shown in the photo.

Start at the top, with the #352 tip.
Pipe leaves all around the top edge
of the sugar mold. Pipe leaves on
the vase in the hexagon rectangles
and in the bowl of flowers on the
bottom tier. Pipe leaves in the gar-
land and the 2 vases of flowers.

When the piping is dry, paint the
cake. Use the colors given mixed
with lemon extract and follow the
photo as a guide. Paint the crevices
darker than the open-faced areas.

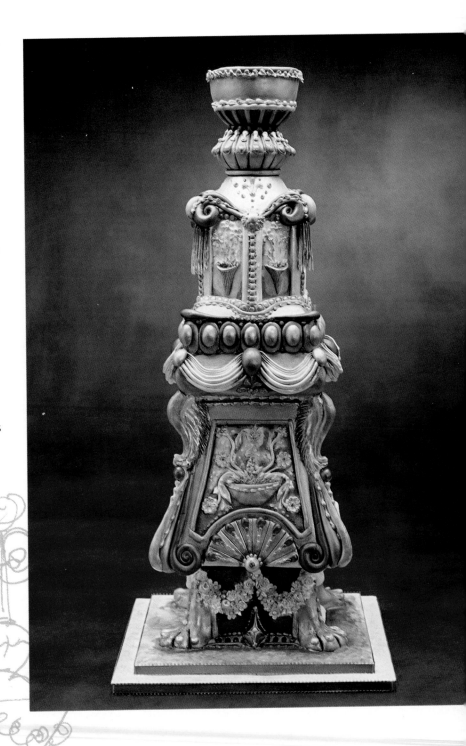

Dreams of

Balance

Mad Tea Party

SERVES 40

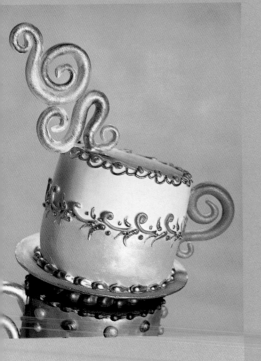

A fantastically wacky stack of tea cups and a teapot will

amuse and amaze everyone, even the Mad Hatter! From its

first splash at the bottom to the wisp of steam at the top,

this cake will be a towering showpiece. And afterwards, you

can tell your fortune by reading the crumbs on the plate!

In advance

Make the handles, the splashes, and the steam out of gumpaste (Figure 1). The spout is made out of Styrofoam and covered with fondant to make it lighter in weight (Figure 2). Insert a dampened toothpick into all of these when you make them so they can be attached easily to the cake without sliding off. Place them on a bed of cornstarch so they won't have a flattened bottom as they harden, and let them dry completely. Decorate and paint them according to the photo.

To make the saucers, you can use saucer molds (found in cake-decorating stores) or the back of a real saucer. For each, roll out a piece of gumpaste about ⅛ inch thick. Cut it into a circle about ½ inch wider than the saucer or mold to make up for the raised portion. Cut a hole about 3 inches in diameter in the center. (This is where the dowel will pass through.) Dust the mold with cornstarch so that the gumpaste won't stick and lay the circle on the underside of the saucer or the decorative side of the mold. Let this dry until firm. Then remove from the mold or saucer and let it harden totally, right side up.

Cover the base with pink royal icing.

FIGURE 1, ENLARGE TEMPLATE TO 111%

FIGURE 2, ENLARGE TEMPLATE TO 111%

Decorating tip

PUT THE DOWELS IN EACH TIER AS THE CAKES ARE STACKED, NOT BEFORE;

OTHERWISE, THE DOWELS WILL BE CROOKED.

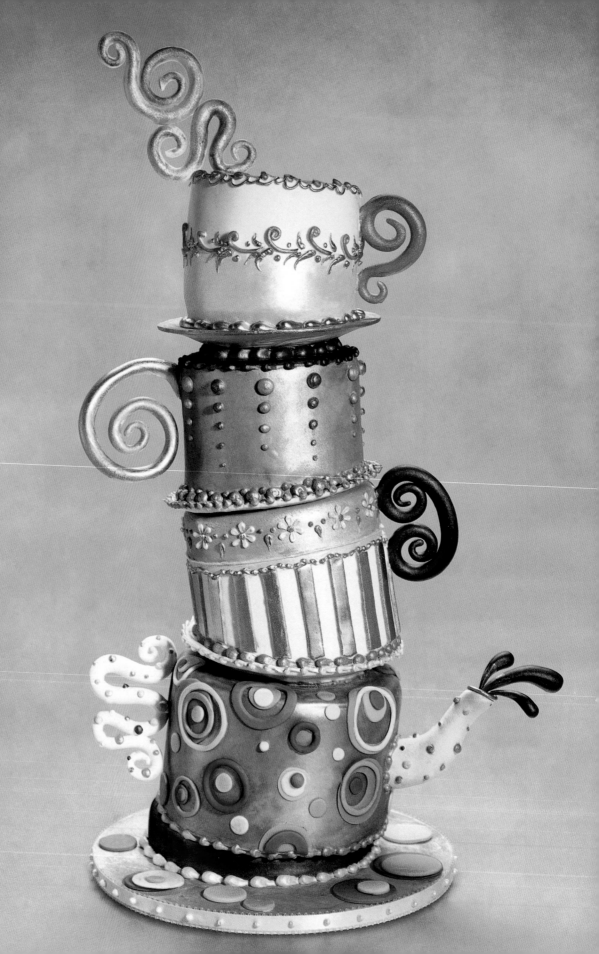

To decorate

Stack the cakes on the base, putting dowels in all of the tiers except the top one as you stack them. Then insert a dowel through the entire cake.

For the teapot on the bottom, paint the background of the cake green luster, then cut out different-size fondant circles in different colors and attach them to the cake and the base with water.

For the striped cup, cut out ⅜-inch-wide strips of fondant and attach to the cup about three-quarters of the way up, making sure that they are parallel to the side and to each other. Paint the top one-quarter of the cup pale blue, then pipe yellow daisies above the stripes. Pipe green dots and teardrops in between the daisies.

The next tier is first painted blue. The pink and blue dots are piped vertically, as shown in the photo.

The top tier is divided in half, and the bottom half is painted yellow luster. Pipe curls, dots, and teardrops of royal icing along the mid-line. Then paint them gold and pink as shown in the photograph.

Pipe snail trails around the base of each teacup, the wedge, and the teapot. Paint the piping according to the photograph.

Finally, add the steam, splashes, and handles, using royal icing to hold them in place.

Sweet Offerings

SERVES 65

Individual cakes for guests are very popular these days, and a

stack of colorful presents is a common sight at many parties.

So, why not combine the two and have a stack of colorful

cakes? Actually, even though they are small, these cakes can

be shared by two or even three guests. These can be deco-

rated in a variety of ways for whatever the occasion is: a

birthday, holiday, anniversary, or even a wedding.

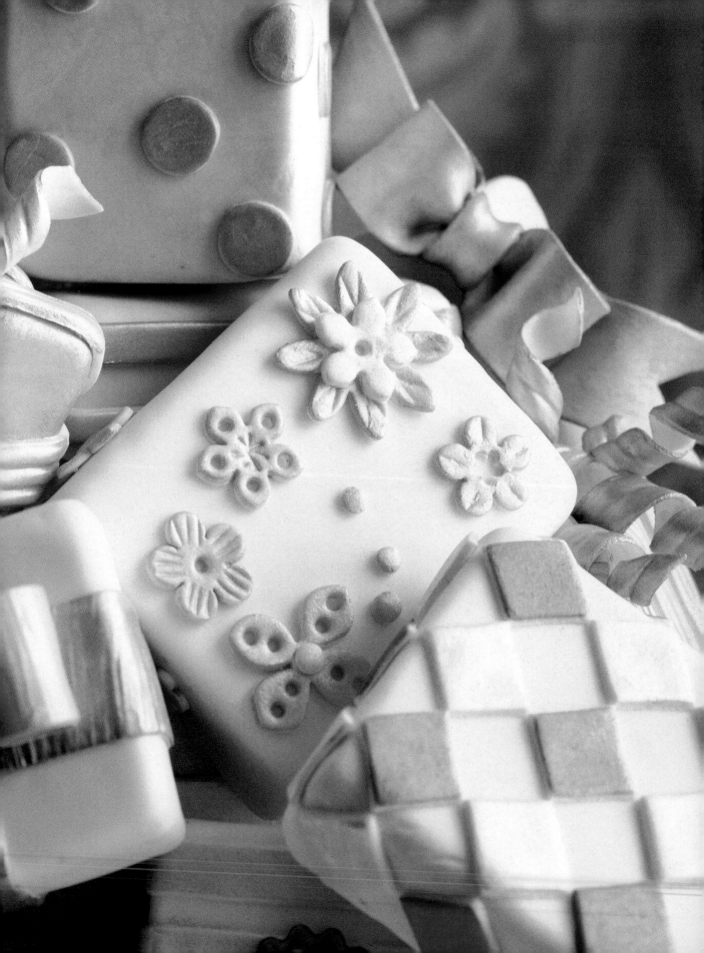

In advance

Make gumpaste bows for each cake, except for the 2 large ones (see page 229). Paint them with luster dust mixed with lemon extract.

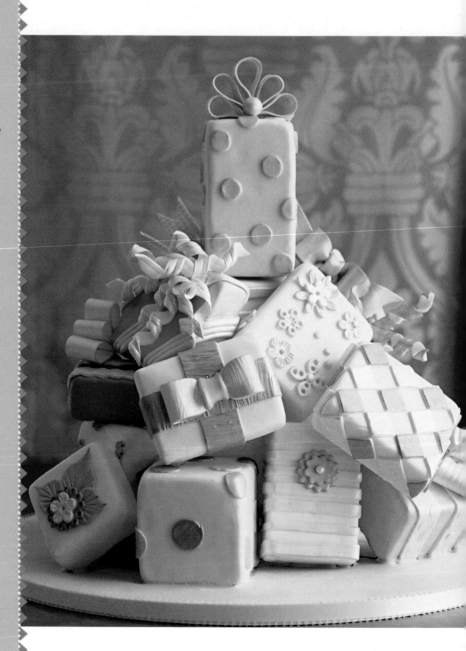

WHEN COVERING SMALL CAKES WITH FONDANT, YOU NEED TO WRAP THE FONDANT UNDER THE FOAMCORE BOARD BY ABOUT ½ INCH, SO THAT THE CAKE WILL STAY ON THE BOARD WHEN IT IS AT AN ANGLE.

Decorating tip

To decorate

Cover all of the cakes with fondant. Decorate the cakes as shown, with dots, stripes, flower cutouts, squares, or as you please. Cut strips of fondant to make ribbons on the packages, also.

Place the 6-inch cake in the center of the base, then place the half-ball on top. Insert a dowel through the entire cake. Attach the packages around the center cakes, starting at the bottom, using royal icing to attach them and then inserting a skewer, point down, through the package and into the larger cakes. Finally, add the bows to the packages with royal icing. Prop them with a toothpick until the icing sets.

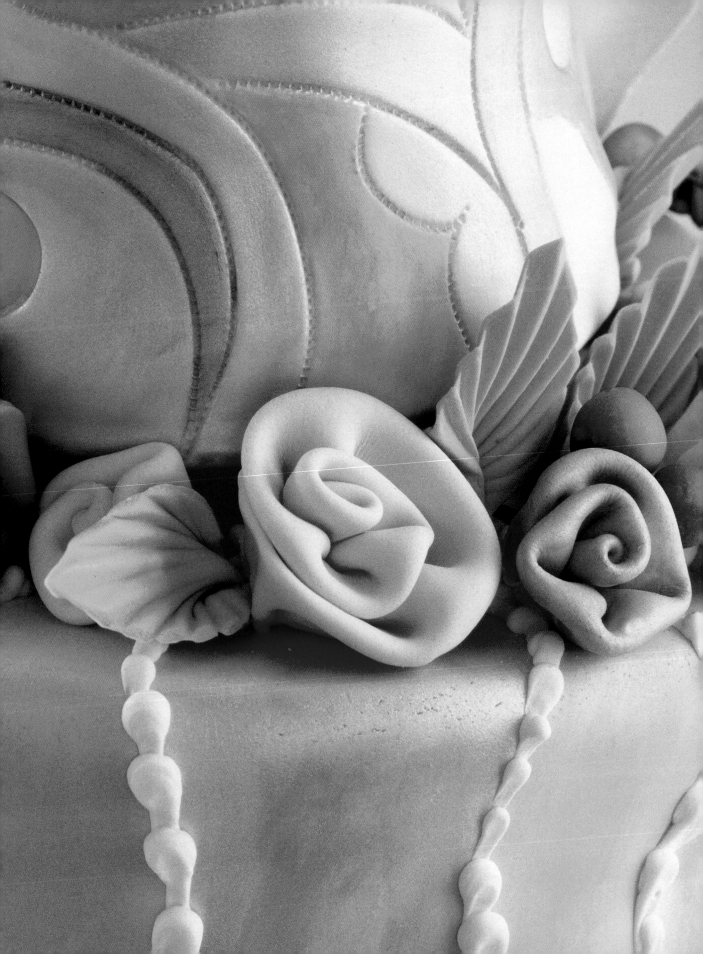

Caprice de Jacques

SERVES 280

I was invited to design and decorate a cake on the *Jacques Torres Show* for the Food Network. The pattern I made was loosely based on brightly colored Pucci prints, with alternating designs on every other tier.

TECHNIQUES USED

Painting with luster dust, cake carving, gumpaste bows, flowers, leaves, pearls, piping with royal icing, embossing fondant, crooked cakes

CAKES

- 5-inch round, 4 inches high
- 9-inch round, 5 inches high
- 12-inch round, 5 inches high
- 14-inch round, 5 inches high
- 18-inch round, 4 inches high

OTHER MATERIALS

- 4-inch round foamcore board
- 8-inch round foamcore board
- 11-inch round foamcore board
- 24-inch round for base
- 4-inch, 8-inch, and 11-inch Styrofoam wedges, ½ inch high on one side and 2 inches on the other (see page 9)
- dowels
- royal icing
- green and white fondant
- gumpaste
- leaf green, yellow, pink, purple, teal, and sky blue paste colors
- pink, super-pearl, blue, green, and yellow luster dust
- piping bag and #2, #3 PME tips
- small smooth-edged tracing wheel or veining tool
- green floral tape
- #24 green wire

In advance

Make the bows; white pearls; purple, yellow, pink, and white ribbon roses; and teal, lime green (made with yellow and leaf green), and leaf green leaves; and berries out of gumpaste. To make the berries, roll a ball of gumpaste about ¼ inch in diameter. Take a 3-inch length of #24 gauge wire and make a tiny hook on one end. Wet the hooked end of the wire and insert it into the gumpaste. When dry, use green floral tape to tape 3 or 4 berries into clusters.

String the pearls as described in the section on gumpaste pearls (page 227). Then paint them with super-pearl luster paint. Paint the roses with the corresponding luster colors.

To decorate the base to match the cake, make about ¾ cup of royal icing for each of the colors on the cake, then outline the designs onto the board with the various colors, using the #3 tip. Next, thin the icing as if you were making a run-in (see page 238), and fill in the spaces with the corresponding colors. Let dry overnight.

You can make the Styrofoam wedges yourself, or you can have them custom-made from the Dummy Place (see Sources, page 252). You should first attach a foamcore circle to the bottom of each wedge, then cover the sides of the wedges with pale green fondant.

To decorate

Cover each tier with white rolled fondant. Before going on to the next one, make sure that you emboss the design in the fondant as soon as it is applied. You can use a tracing wheel or a gumpaste veining tool. The bottom, third, and fifth tiers are the same, and the other tiers are wavy vertical lines.

Stack the cakes on the base. Put dowels in all of the tiers except the top one. Then insert a dowel through the entire cake. Decorate the cakes by painting the areas with luster paint as shown. Then attach the flowers, leaves, and berries in the wide areas of the wedges. Pipe a snail trail between the stripes on the second and fourth tiers. Attach the pearls, and then the bows as shown in the photograph.

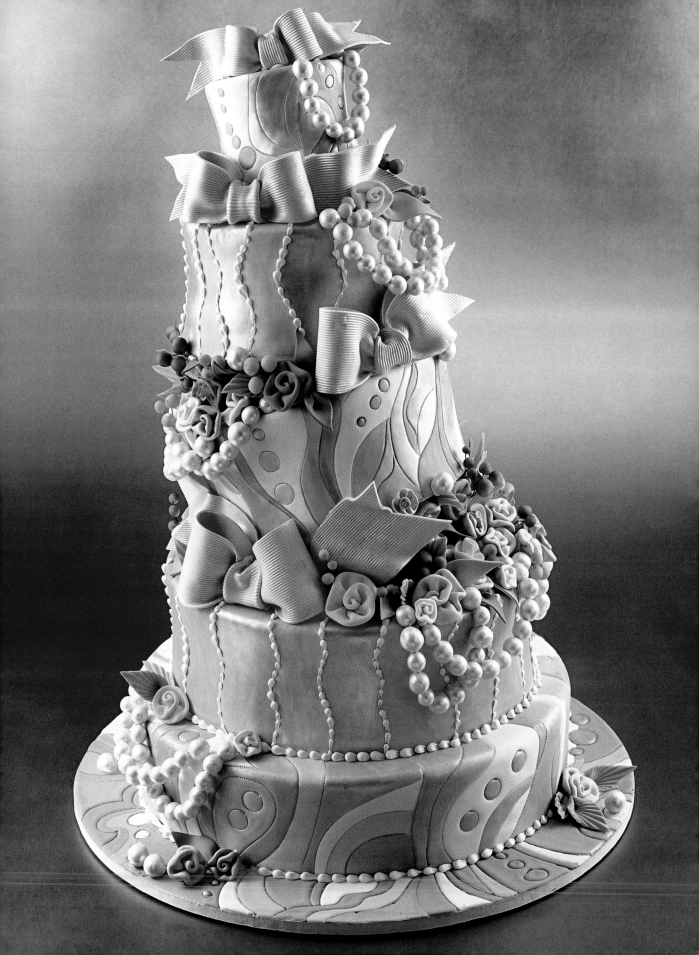

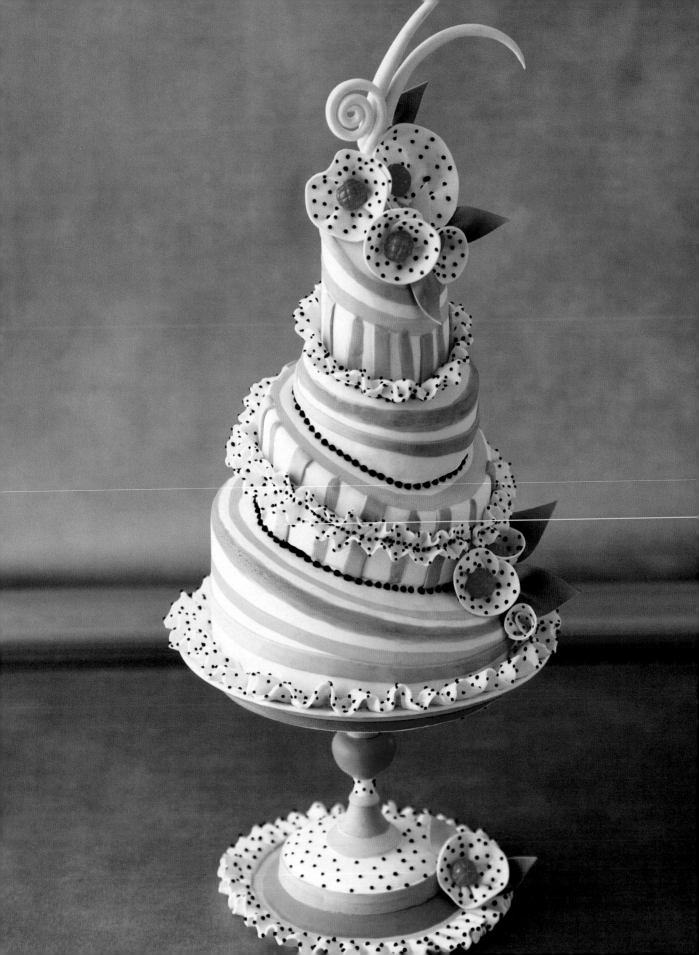

Torte of Babylon

SERVES 38

This was a small wedding cake that needed more height,

so I put it on a cake stand and decorated it to match the cake.

Fantasy flowers give this a sophisticated, yet jaunty look.

TECHNIQUES USED

Gumpaste fantasy flowers, leaves, ruffles, and curls on wires, piping with royal icing, painting

CAKES

- 3-inch round, 4 inches high, cut into a wedge 3 inches on one side and 4 inches on the other

- 4½-inch round, 2 inches high, cut into a wedge 1 inch on one side and 2 inches on the other

- 6-inch round, 3 inches thick, cut into a wedge 3 inches on one side and 2 inches on the other

- 8-inch round, 4 inches high, cut into a wedge 4 inches on one side and 2 inches on the other

OTHER MATERIALS

- 3-inch round foamcore board

- 4½-inch round foamcore board

- 6-inch round foamcore board

- 8-inch round foamcore board

- cake stand or 10-inch foam-core base

- dowels

- royal icing

- gumpaste

- pink and black paste coloring

- pink, green, and yellow pow-dered colors

- acrylic paints (optional)

- piping bag and #2 tip

In advance

Make the gumpaste fantasy flowers, leaves, curls on wires, and elongated curls on wires. Decorate the stand as in the photograph. You can use acrylic paint to paint the stand, if you wish, and then use gumpaste and royal icing to decorate it. Let dry.

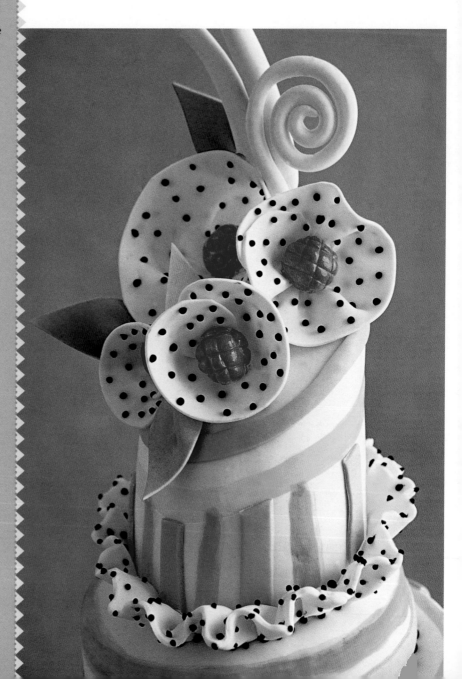

To decorate

Carve the cakes as shown in the illustration (Figure 1). Cover them with white fondant. Stack them on the stand. Insert dowels in each tier and a dowel through the entire cake. Paint green and yellow stripes on the cake. Add pink fondant stripes.

Add a gumpaste ruffle to the bottom edge, the middle of the second tier, and the bottom edge of the top tier, using toothpicks to hold up the ruffle while it dries (Figure 2). Pipe black dots on the ruffles and larger black dots on the borders of the 2 middle tiers. Add the gumpaste decorations.

FIGURE 1

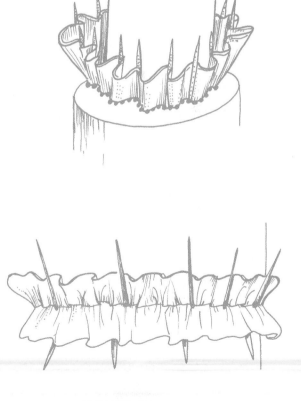

FIGURE 2

Dreams of

Grandeur

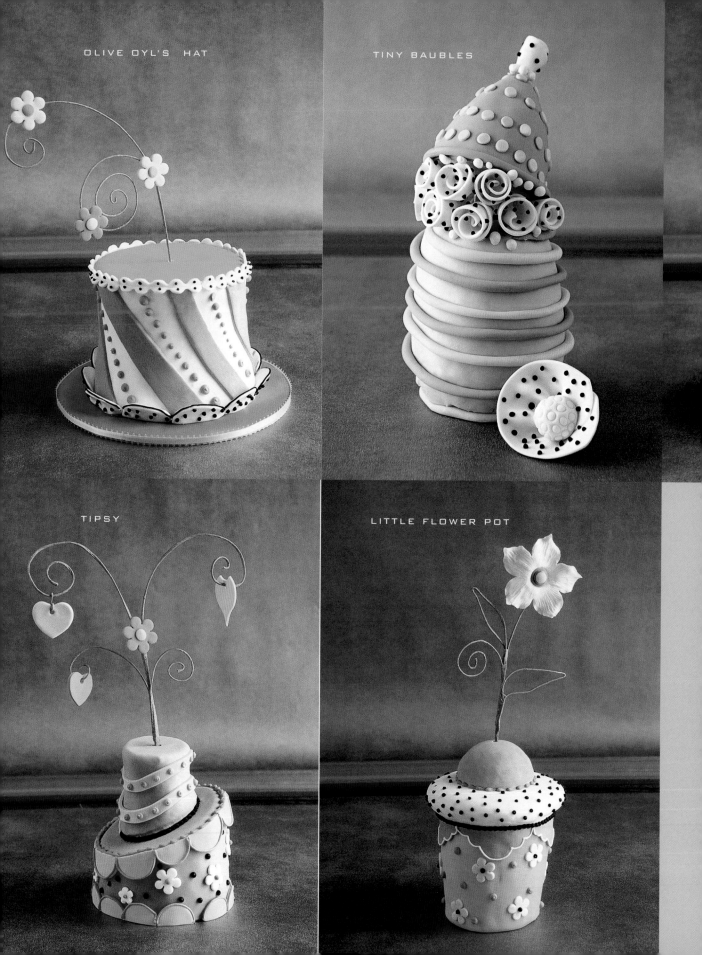

OLIVE OYL'S HAT

TINY BAUBLES

TIPSY

LITTLE FLOWER POT

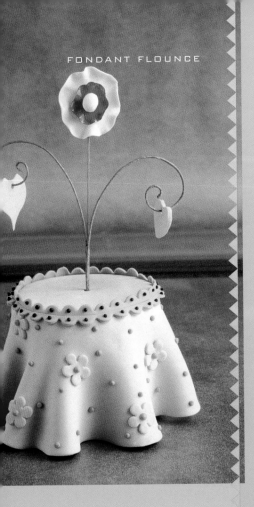

Five Little Tartlettes

EACH CAKE SERVES 2 OR 3

These cute little cakes were made to mix and match with a

larger wedding cake. The bride had chosen bright patterned

fabrics and paper flowers to adorn the tables, each of which

would be different. They wanted jaunty cakes all around the

table to complement the vividly colored room. I tried to

reproduce the paper flowers in gumpaste.

GUMPASTE CUTTERS

Olive Oyl's Hat

Cut out 2 pink and one green 1¼-inch-wide gumpaste daisies. Cut 2 pieces of #20 green wire to 14 inches long. Tape the bottom half of the 2 wires together. Bend them into curls. When the gumpaste is dry, attach the daisies to the wire with royal icing. Pipe yellow, green, and pink royal icing dots in the centers of the daisies.

Make a 7¾-inch-wide round of foamcore and cover with green royal icing.

Make the cake to measure 5 inches round and 4½ inches high, cut to 4½ inches wide in the middle. Attach evenly spaced ⅞-inch-wide pink fondant stripes diagonally to the side of the cake. Using the #2 tip, pipe pink and green royal icing dots, starting larger on the top and getting smaller in the middle, then getting larger again. Paint the top of the cake with yellow paint. Cut out a white border of fondant with the border cutter and attach to the top edge of the cake. Attach 1½-inch wide half-circles around the bottom edge. Using the #2 tip, pipe black dots on the border cutout and dots and outlines on the half-circles.

Tiny Baubles

Make 9 white gumpaste fantasy flowers (see page 231). When dry, pipe black royal icing dots on each flower.

To make the "hat" on the top, carve a piece of Styrofoam to measure 2¼ inches wide and 2½ inches high, making it come to a point. Cover the bottom with a piece of aluminum foil, then cover the top with green rolled fondant. Cut out ¼-inch dots of pink and yellow fondant and attach them with water, alternating the colors, in a spiral line winding around the hat. Attach one of the black and white flowers to the tip of the hat with royal icing and pipe pink royal icing dots around the base of the flower for stability. Set this aside.

Carve the cake to 3¾ inches high and 3 inches wide in the middle, and 2⅝ inches wide at the top and bottom. Cover the cake with pink fondant. Make a green and a yellow rope of fondant and wrap each one around the cake diagonally. Attach the rest of the black and white flowers to the front of the cake with the royal icing, leaving enough room for the hat. Then attach the hat with royal icing.

Fondant Flounce

Take three 12-inch-long #20 green wires and tape the bottom halves together. Make 2 gumpaste hearts, one pink and one yellow, and make a hole in the top to attach them to the wires. For the third flower, cut 2 gumpaste circles, one white, 2 inches wide, and one pink, 1 inch wide. Run the ball tool around the edge of each to ruffle. Glue the smaller one to the center of the larger one, then attach a small ball of gumpaste to the center. Let dry. Attach the 2 hearts to the wires by putting the wire through the hole, then glue the ruffled flower to the top of the middle wire with royal icing.

Carve the cake to measure 4 inches round and 3½ inches high. Place on a 6-inch board. Cut out a 12-inch fondant circle. Drape the fondant over the cake and let the folds hang naturally. Add wires.

Tipsy

Cut out one pink 1¼-inch-wide gumpaste heart, one green heart the same size, one green 1-inch-wide daisy, and one yellow 1¼-inch-wide cucarda. Cut a small hole in the top of the hearts and cucarda. Let dry.

Cut 4 pieces of green #20 wire, two 7-inch-long pieces and two 12-inch-long pieces. Tape the 4 wires together with green floral tape. Insert the wires in the holes and bend the wires into curls. Attach the daisy to the center wire with royal icing.

The top layer should measure 2 inches wide, cut to 2¾ inches long on one side and 1¾ inches long on the other. The second tier should measure 4 inches wide, and 3½ inches long on one side and 2 inches long on the other. Cover the cakes with pale rose fondant. Decorate the bottom tier with 1¼-inch half-circles of yellow fondant. Decorate the top tier with a ⅜-inch-wide strip of yellow fondant, curling up the side. Make small white daisies, and attach them to the bottom tier.

Make green, black, and rose royal icing. Using the #2 tip, pipe rose dots on the yellow strip and outline the half-circles. Pipe black dots among the white daisies and along the border between the top and bottom tiers. Finally, pipe a green snail trail around the top edge of the bottom tier, and a dot in the center of the white daisies.

Little Flower Pot

Make the cake to measure 3 inches wide and 5 inches high. Make a gumpaste petunia and a 1½-inch pink fondant half-ball. When the flower is dry, attach it to a green wire.

Cover the cake with yellow fondant. Make a 7-inch wide circle of thick white fondant and cover the top, tucking the edge under. Cut out 5 pieces of green fondant with the border cutter and attach them evenly spaced below the white edge.

Cut out small white daises and attach them with a little water to the side of the cake in the yellow area. With the #2 tip and white royal icing, pipe an outline on the edge of the green cutouts.

Attach the pink half-ball to the top of the cake and insert the petunia. Pipe a green snail trail around the edge of the ball and dots on the yellow area, between the daisies.

Pipe a black dot border below the white edge and dots on the top. Pipe dots in the center of all the daisies.

Petit-Fish

SERVES 150

A school of bite-size fish dancing through a sea of royal icing provides a special treat for guests, especially when the fish are little petits fours, each one uniquely adorned. The royal icing waves are an extra touch to enhance the briny board. You can practically hear the sound of the waves lapping on the shore.

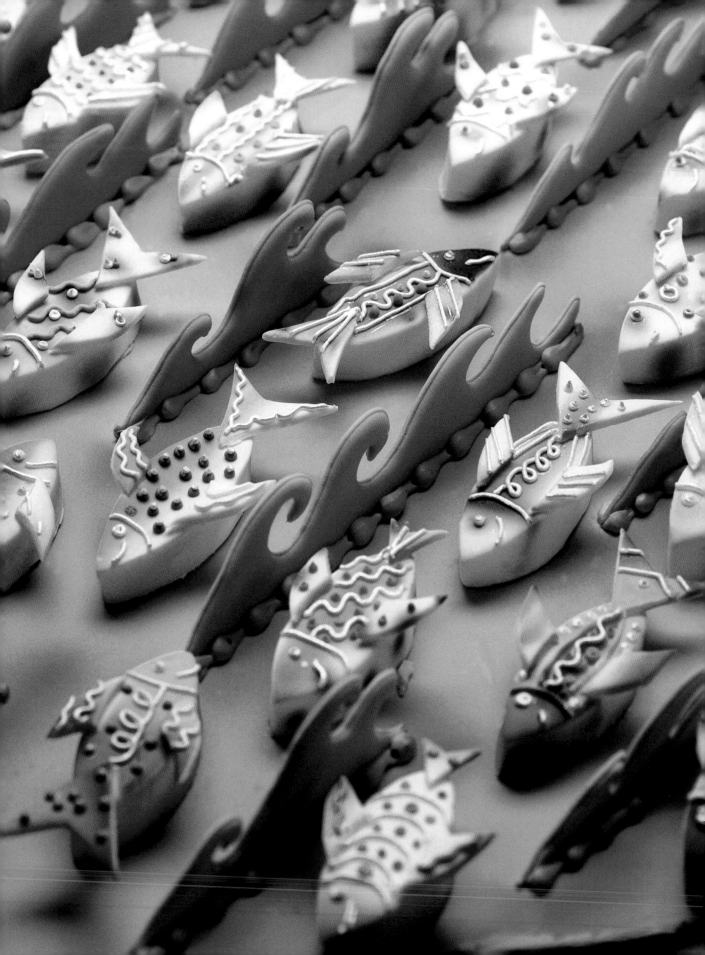

TECHNIQUES USED

Run-in sugar, airbrush painting, painting with luster dust, piping with royal icing, gumpaste cutouts

CAKE

- ☐ 1 sheet cake, 18 x 24 inches

OTHER MATERIALS

- ☐ 26 x 20-inch oval foamcore base, 2 layers thick
- ☐ buttercream for crumb-coating
- ☐ fondant
- ☐ royal icing
- ☐ marzipan and raspberry jam
- ☐ piping bag and #2 tip
- ☐ airbrush
- ☐ variety of luster dusts
- ☐ lemon extract
- ☐ pointed oval cutter

GUMPASTE CUTTER

In advance

Make the fish tales and fins in fondant, using the patterns supplied (Figure 1); make the royal icing waves in three different shades of blue, using the run-in sugar method. Use the patterns supplied (Figure 2). Make about 7 of each. Let dry.

Glue the boards together, and cover with thinned blue royal icing. When dry, attach the waves with a little blue royal icing.

To decorate

To make the petits fours, spread a thin layer of raspberry jam on the sheet cake. Roll out a thin layer of marzipan and use it to cover the cake. Cut the marzipan-coated cake into fish shapes using the cutter shown.

Crumb-coat each fish with buttercream, then cover with fondant. Attach the tails and fins with a little royal icing, then decorate with royal icing dots and loops.

Airbrush the fish. Paint with luster paint mixed with lemon extract, if you wish. Place the fish on the platter.

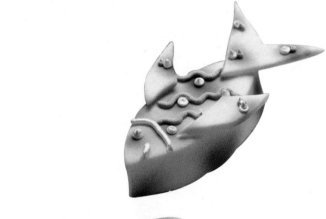

FIGURE 1

FIGURE 2

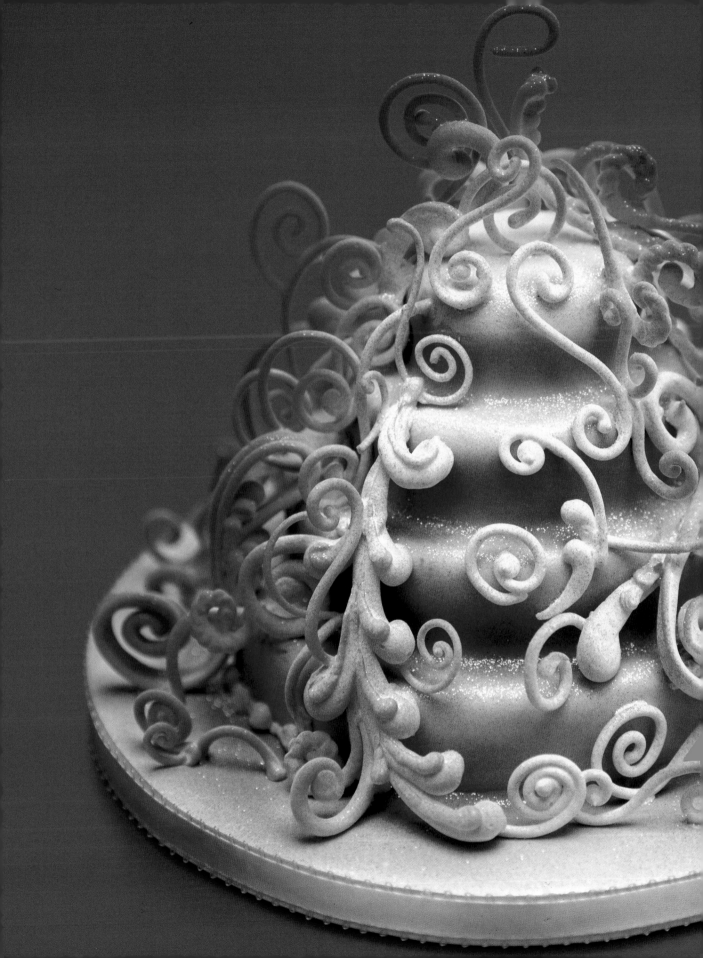

Big Splash

This is an opportunity to channel all your fantasies through your piping bag. Fanciful swirls, curlicues, and lavish loops of royal icing can propel a tiny cake into a large spotlight. Airbrush or paint in vibrant colors, sprinkle with edible glitter, and get ready to make a big splash.

The surprise in this cake is the drama of serving it: The sugar cage has to be cracked before the inner pastry can be enjoyed.

TECHNIQUES USED

Royal icing piping on waxed
paper, airbrushing

CAKES

- ☐ 2-inch round, 1 inch high
- ☐ 3-inch round, 1 inch high
- ☐ 4-inch round, 1 inch high
- ☐ 5-inch round, 1 inch high

OTHER MATERIALS

- ☐ 1-inch round foamcore board
- ☐ 2-inch round foamcore board
- ☐ 3-inch round foamcore board
- ☐ 4-inch round foamcore board
- ☐ 5-inch round foamcore board
- ☐ 8¼-inch round foamcore
 board for base
- ☐ royal icing
- ☐ pale green rolled fondant
 (made with leaf and moss
 green)
- ☐ airbrush and royal blue edible
 airbrush color
- ☐ piping bag and #2, #3 tips
- ☐ edible glitter

In advance

Make the white royal icing swirls on waxed paper, using the pattern suggestions shown on page 170-171 and both the #2 and #3 tips. You can also overpipe #2 lines on the #3 curls. Make approximately 30. Let dry.

To decorate

Cover the base with light green royal icing (made with leaf and moss green). Attach a ribbon around the edge of the board. Cover the cakes with pale green fondant. Stack them on the base. Attach royal icing pieces to the cake with white royal icing. When the icing is dry, lightly airbrush the edges of the royal icing pieces with blue airbrush color. Sprinkle with edible glitter.

Decorating tip

DON'T BE AFRAID TO TRY SOME OF YOUR OWN CURLICUE DESIGNS. BE SURE TO MAKE PLENTY TO ALLOW FOR BREAKAGE.

WHEN SPRAYING WITH THE BLUE AIRBRUSH COLOR, PRACTICE ON A SCRAP PIECE OF PAPER FIRST. IF YOU ARE NEW AT USING AN AIRBRUSH, ADD A LITTLE WATER TO THE COLOR HOLDER CUP ON THE AIRBRUSH TO LIGHTEN THE COLOR. YOU DON'T WANT TO OVERCOLOR YOUR ROYAL ICING PIECES: REMEMBER THAT THEY ARE MADE OF SUGAR, AND PROLONGED WETNESS WILL CAUSE THEM TO BEGIN TO MELT.

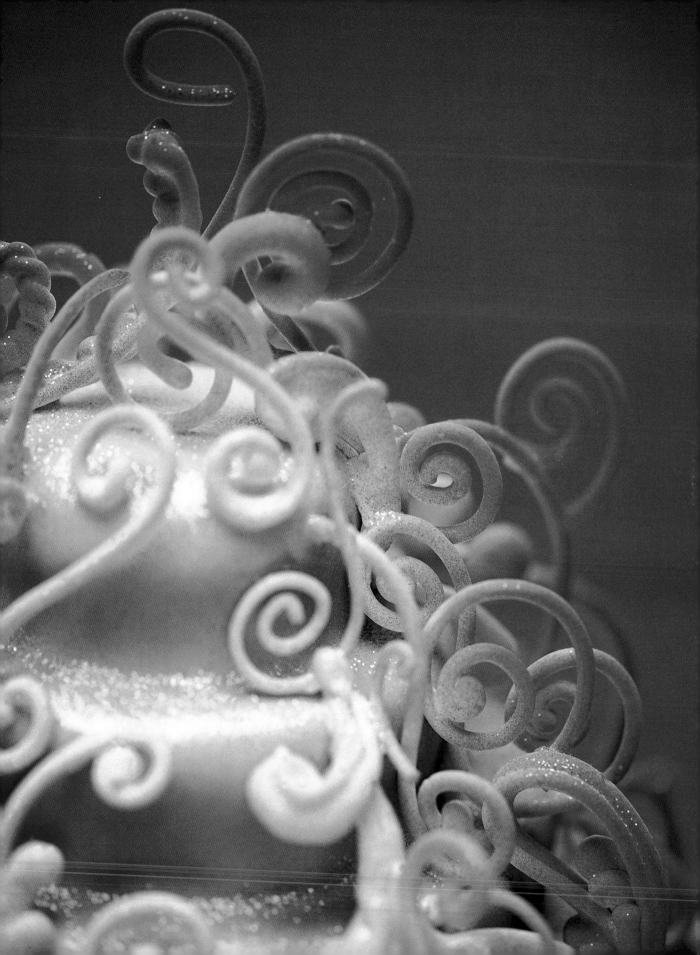

Buttercup Blossom

SERVES 30

The stand holding this cake is actually a candleholder, but

sometimes you can find things that can be used for a purpose

other than what they were meant for. This pretty little cake

fits perfectly on a small stand. It's ideal for a birthday party.

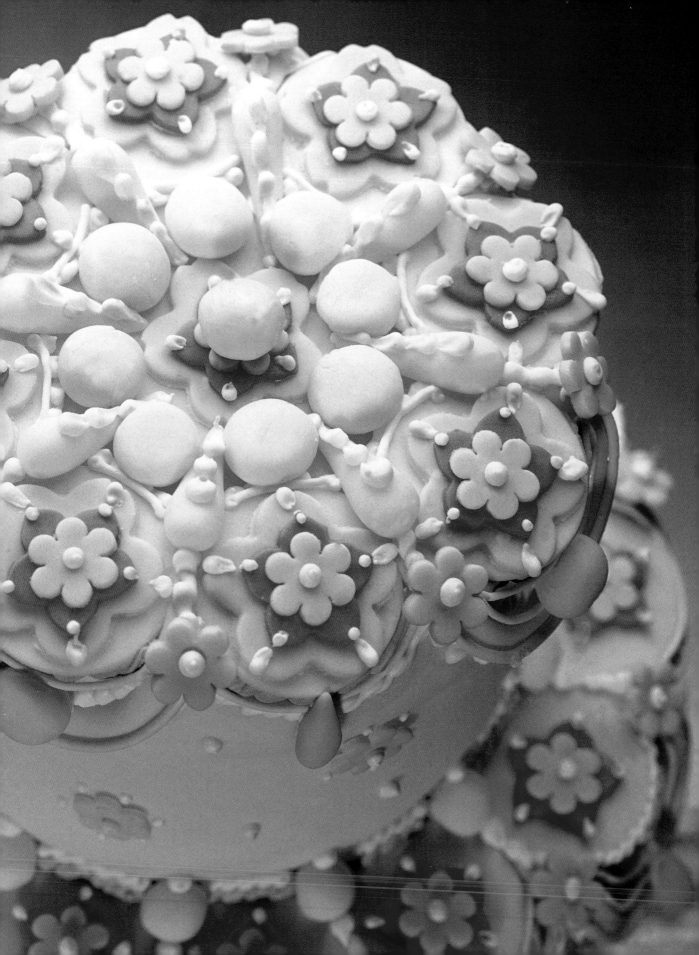

TECHNIQUES USED

Fondant cutouts, pearls, teardrops, ropes, and piping with royal icing

CAKES

- ☐ 6-inch round, 4 inches high
- ☐ 8-inch round, 4 inches high

OTHER MATERIALS

- ☐ cake stand or 10-inch base
- ☐ fondant
- ☐ royal icing
- ☐ lemon yellow, pink, and moss green paste food coloring
- ☐ piping bag and #2 and #3 PME tips
- ☐ 1-inch and 1⅜-inch circle cutters
- ☐ daisy cutters

In advance

Cover the base with thinned, pale yellow royal icing.

To decorate

Cover the cakes with pale yellow fondant, matching the color of the icing on the base. Stack them on the base. Cut out pale pink daisies with the #1 daisy cutter and attach them to the cake randomly with water (see photograph).

On top edge of the cake and around the top edge of the bottom tier, cut out and attach 1⅜-inch circles of white fondant. Use the 1-inch cutter to make fondant circles for the base. On the bottom tier and the base, cut off part of the circles so that they will fit against each other.

GUMPASTE CUTTERS

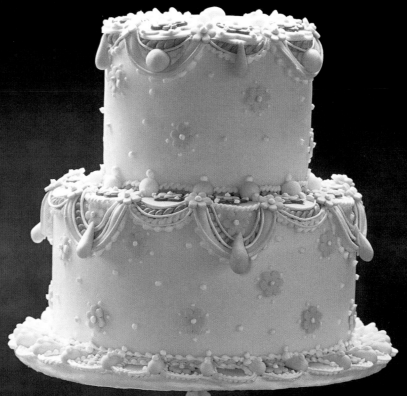

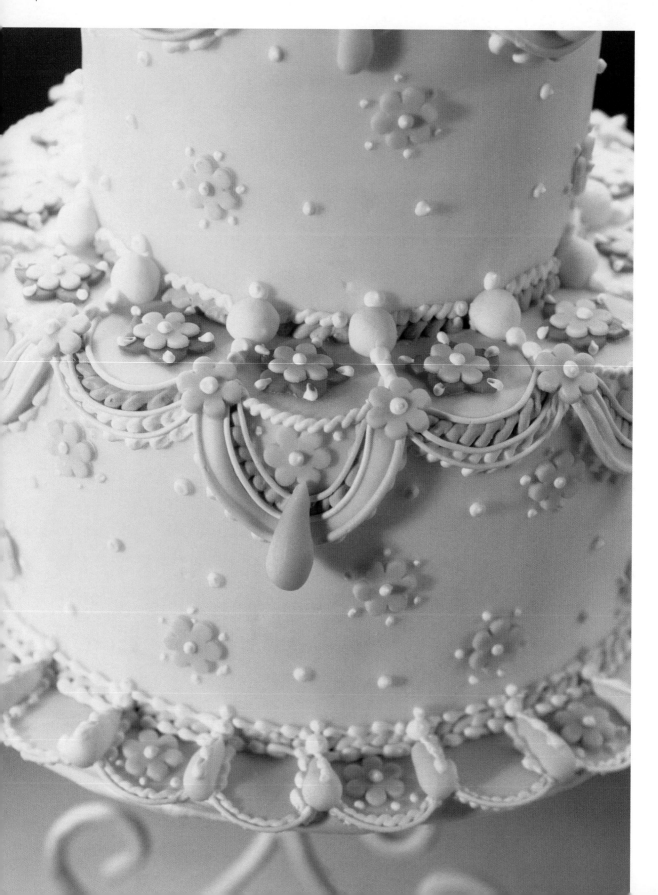

On top of the cake, cut out pink #2 daisies and attach them to the white circles with water. Then place a darker pink #3 daisy on top of that one, then a pale pink #1 daisy on top of that one. Make pale pink teardrops in between each circle and pink dots in between the teardrops. Put a dark pink #2 daisy in the center, with a pale pink dot on top of it.

On the edge of the bottom tier, attach dark pink #3 daisies, then a pale #1 daisy onto each darker one.

On the base, add a pale pink #1 daisy on every other circle.

With pale green royal icing and the #3 tip, pipe a braid under each white circle on the top tier, below every other one on the next tier, and all along the bottom edge.

With pale pink fondant, make small balls and place them between every circle on the top edge of the bottom tier. On the base, place a pale pink teardrop in between every circle.

Make white ropes about ¼ inch thick and attach them under every other circle, below the green piping on the top tier. Do the same on the bottom tier, below the ones without the green icing. Make these a little longer so they hang a bit lower; place a small pale pink daisy in the space made. Pipe a green royal icing braid above the white rope.

With white royal icing, pipe a braid under the green braids under every other circle. Pipe white lines along the edges of all of the green, white, and white fondant lines. Pipe a white braid border along the bottom edge of the cake. Pipe white dots in the center of all of the daisies and around the cake. Pipe white braids along the sides of the teardrops on the base.

Add 8 small pink daisies around the top. Make pink fondant teardrops and dots; attach them to the centers of the white ropes as shown.

Dreams of

Opulence

Family Jewels

SERVES 50

Always searching for new concepts, I had an idea of making a cake where all the tiers are the same size, but a bit off center. I thought wedding rings were an apt symbol for enduring love, even if the sugar decorations they are made of are more ephemeral.

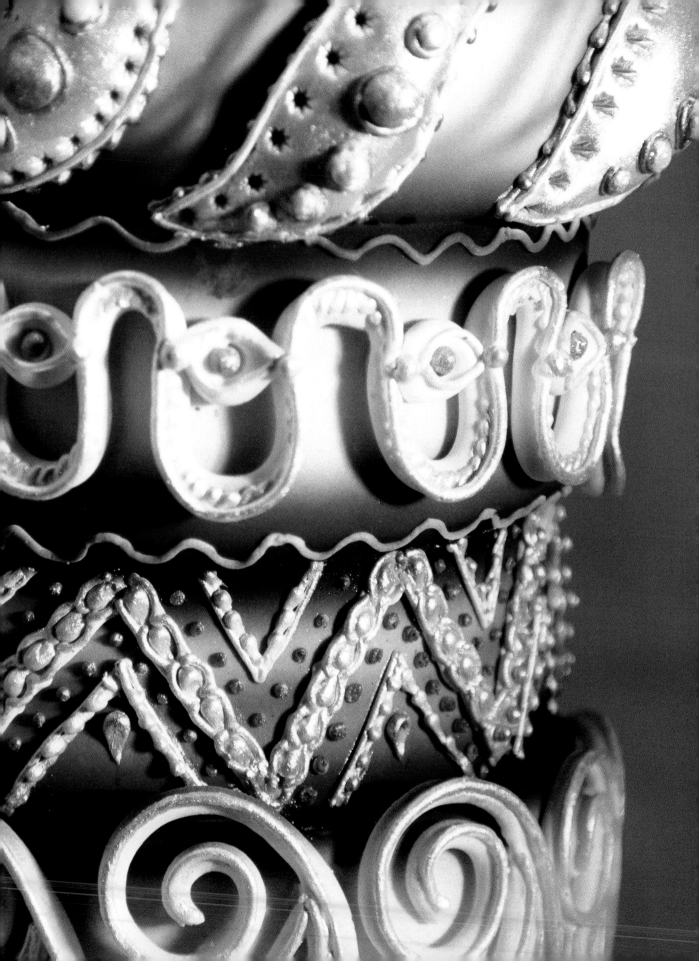

TECHNIQUES USED

Gumpaste curls, fondant emboss-
ing, airbrushing, piping with royal
icing, painting with luster dust

CAKES

- all cakes are 6-inch rounds:

 the top tier is 1¾ inches high

 the second tier is 2¾ inches
 high

 the third tier is 2 inches high

 the fourth tier is 2¾ inches high

 the bottom tier is 4 inches high

OTHER MATERIALS

- 12-inch round board for base

- flexible cardboard

- five 6-inch round foamcore
 boards

- dowels

- rolled fondant

- royal icing

- gumpaste

- piping bag and #2, #3, #5 tips

- super-pearl and gold pearl
 luster dust

- lemon extract

- airbrush and blue airbrush
 color

- umbrella tool

- edible glitter

- piping gel

- paintbrush

- ball tool

In advance

Make many gumpaste curls for the top tier, using the photo as a guide.

To make the cage for the bottom tier, cut a piece of flexible cardboard about 4½ inches wide and the circumference of a 6-inch cake pan (the larger measurement around the rim). Draw the pattern on the cardboard (Figure 1), repeating all the way around, and then tape a piece of waxed paper on top of the cardboard. Pipe the pattern with royal icing and the #5 tip, then overpipe with the #3 tip. Let dry completely.

Cover the base with white royal icing.

FIGURE 1, ENLARGE TEMPLATE TO 182%

To decorate

Bake all the cakes and cover them with white rolled fondant. Secure the 4-inch-high tier to the base with royal icing. Airbrush the bottom edge of the cake with blue. Carefully lift the cage over the cake and attach it to the base.

Stack the cakes, using dowels, and insert one long, sharpened dowel through the whole cake, which should go all the way down into the base. Airbrush the upper and lower edges of all the tiers and the top of the cake.

Divide the fourth tier by marking 16 equal parts on the top and bottom of the tier (see page 244). Draw a line from one mark on the top down to the next one, then up to the next one and so on, making a series of triangles (Figure 2). Cut strips of fondant about ¼ inch wide and attach them with water to the center of the lines.

With a #2 tip, pipe a snail trail of royal icing along the length of each strip and a curved outline around each dot. Pipe a snail trail line above and below as well as parallel to each strip. Pipe dots in between the strip and the snail trails. Then pipe a teardrop in between each "V." Paint all of the piping with super-pearl.

On the middle tier, pipe a wavy line around the entire cake with the #5 tip. Overpipe another line on top of the first with the #3 tip. Pipe a snail trail on the tops and bottoms of the wavy lines. Make a fondant oval about ½ inch wide and attach it between every other wave. Press an indentation in the center with a ball tool, then place a small ball of fondant in the indentation.

On the next tier, cut out 8 pieces of fondant using the pattern shown (Figure 3). Attach them evenly spaced around the cake. Make indentations with the umbrella tool along both lengths. Make 3 small balls of fondant and one larger ball and attach them with water to the center of the shape. Pipe a snail trail of royal icing along each side of the shape, then outline each ball with a line of icing. Paint the piping gold, and the rest super-pearl, then sprinkle each ball with glitter.

On the top tier, attach the gumpaste curls to the cake with royal icing, then paint them with super-pearl.

FIGURE 3, ENLARGE
TEMPLATE TO 182%

FIGURE 2, ENLARGE TEMPLATE TO 182%

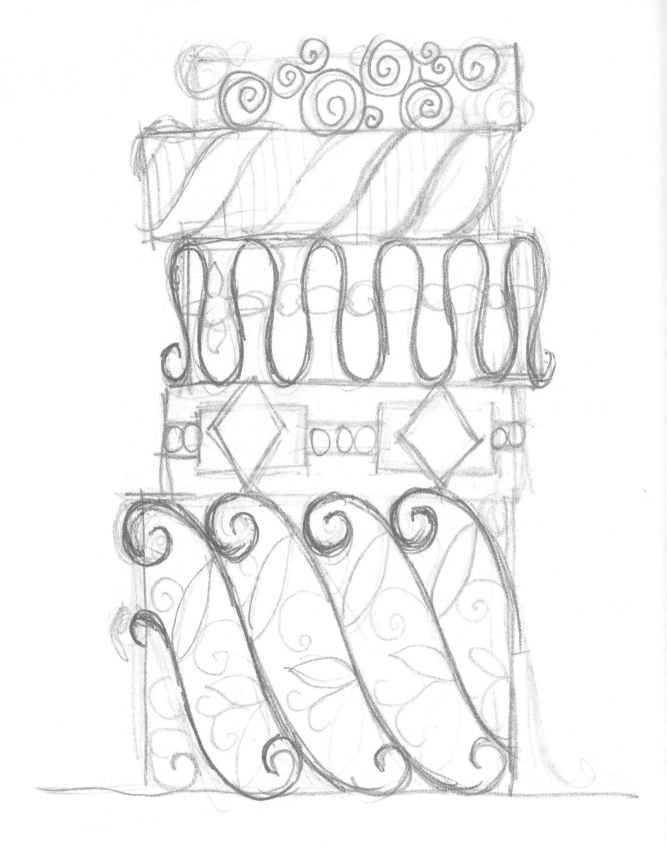

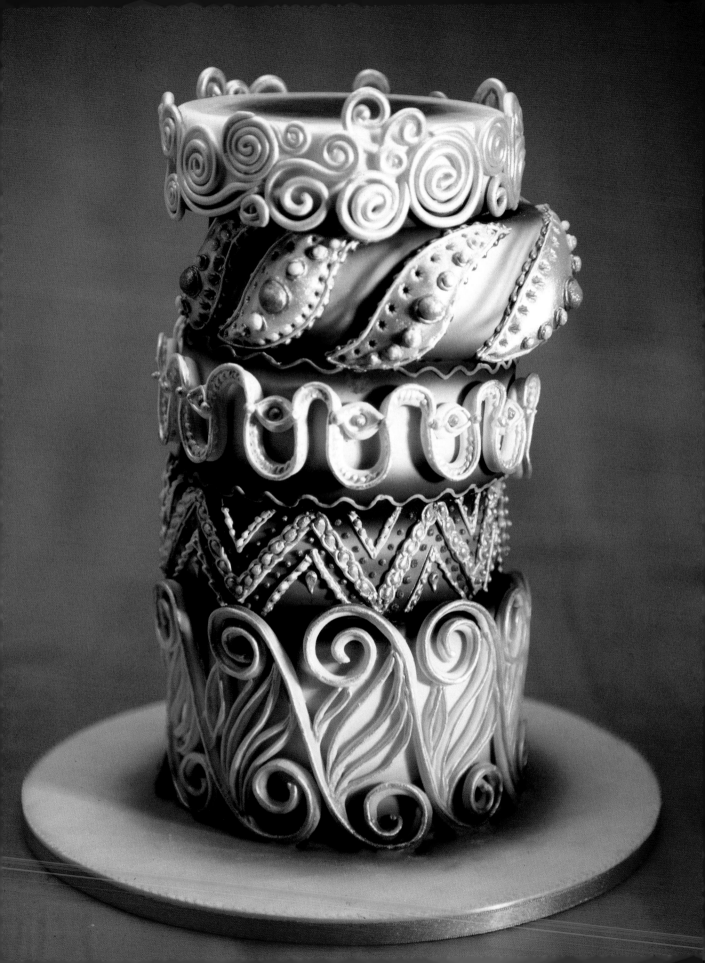

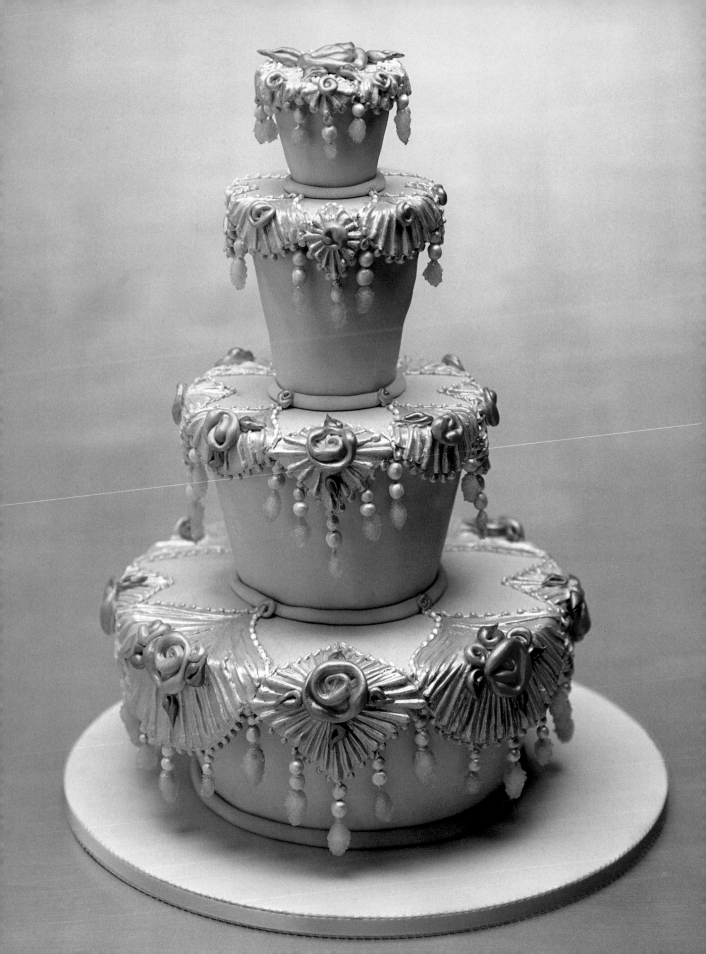

Crystal Nostalgia

SERVES 45

I love the look of Victorian lampshades, with their hanging crystal beads and old-fashioned embroidery. While teaching at the International School of Confectionery Arts, I noticed some interesting pastillage eggs, which had been cracked open to reveal rock sugar crystals, similar to a geode. Chris Hamner, the assistant at the school, taught me how to grow these crystals of sugar, which gave me the idea for making hanging edible beads. I learned that you can grow sugar crystals on gumpaste, which will give the beads the shape you wish.

3–4 days in advance

Make the crystal beads as explained on pages 241–242. Let them dry. Attach small round gumpaste balls to the wires with a little water above the crystals. Let dry. Paint the gumpaste balls with super-pearl luster dust mixed with lemon extract.

1 day in advance

To make the hanging cutouts, cut 4 circles of foamcore, using the measurements in the illustration. Dust them liberally with cornstarch. Cut out pieces of pale green fondant (made with kelly and moss green) ⅛ inch thick using the pattern shown. Place them centered on top of each corresponding foamcore circle and set each on something raised off the table so that they hang straight. Let them dry for a few hours or so, until they hold their shape. They can then be removed from the boards and placed on the corresponding cakes. Cover the base with pale green royal icing made from moss and kelly green paste food colors.

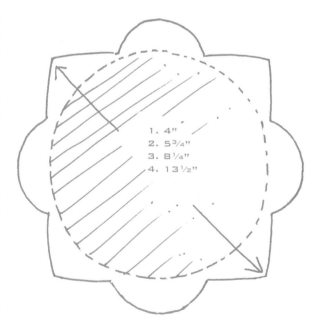

1. 4"
2. 5¾"
3. 8¼"
4. 13½"

To decorate

Sculpt the cakes to match the measurements listed in illustration and crumb-coat them. Cover the cakes with pale green fondant. Attach the bottom tier to the prepared base, then attach the largest cutout with a few dabs of royal icing. Insert dowels as you normally would; the top of the dowel should be level with the top of the cutout piece. Continue stacking the cakes, then the cutouts.

Pipe white royal icing lines with the #3 tip on the overhanging parts of the cutouts. Pipe dots on all of the edges, using the photo as a guide. When the royal icing is dry, paint the cut outs with pale green luster paint (mix avocado with super-pearl to match the color of the cake).

Make pink thick 'n thin roses and green leaves using pale pink and

pale green fondant (see page 227), and attach them to the cake with royal icing. Paint them with pink and green luster paint.

Carefully insert the wires on the end of the beads into the edges of the overhangs as pictured, using a little royal icing to tack them in place.

Decorating tip

WHEN YOU PIPE THE LINES ON THE CUTOUTS, START WITH A THICK LINE AT THE EDGE, USING HEAVY PRESSURE, THEN TAPER IT TO A POINT.

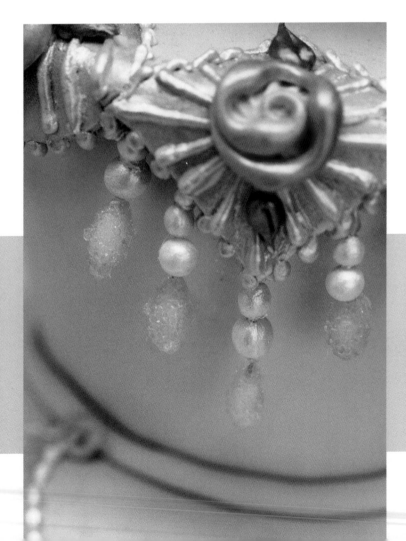

Deco-licious

SERVES 70

I designed this cake for a party in Miami, the home of

American Art Deco architecture. It features geometric

shapes and lines, and a color scheme of red, black, white, and

silver. I wanted to balance shiny silver shimmer with bold

geometric shapes.

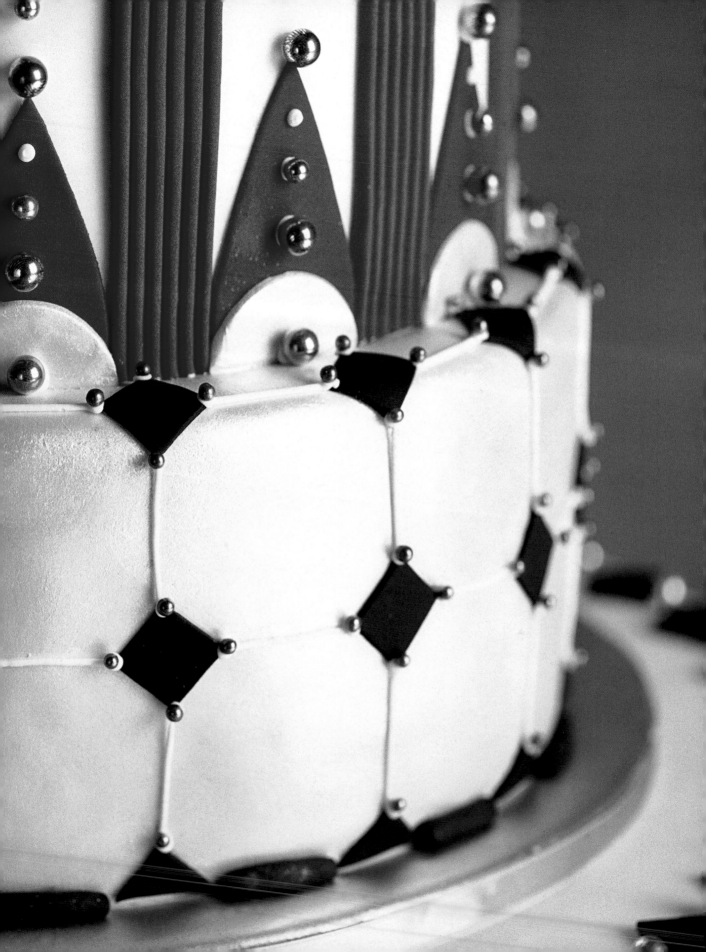

2 days in advance

Make the royal icing run-in sugar decoration for the top of the cake well in advance so that it has time to dry completely. Use the pattern provided, and after you outline the design but before you fill it in with icing, insert 3 skewers into the design, so that you can insert them into the cake. Also complete the back to lock in the skewers and give it a finished look. Add the piping and dragées.

In advance

Cover the base with white royal icing, then with black fondant squares and dragées around the edge of the bottom board.

ENLARGE TEMPLATE TO 154%

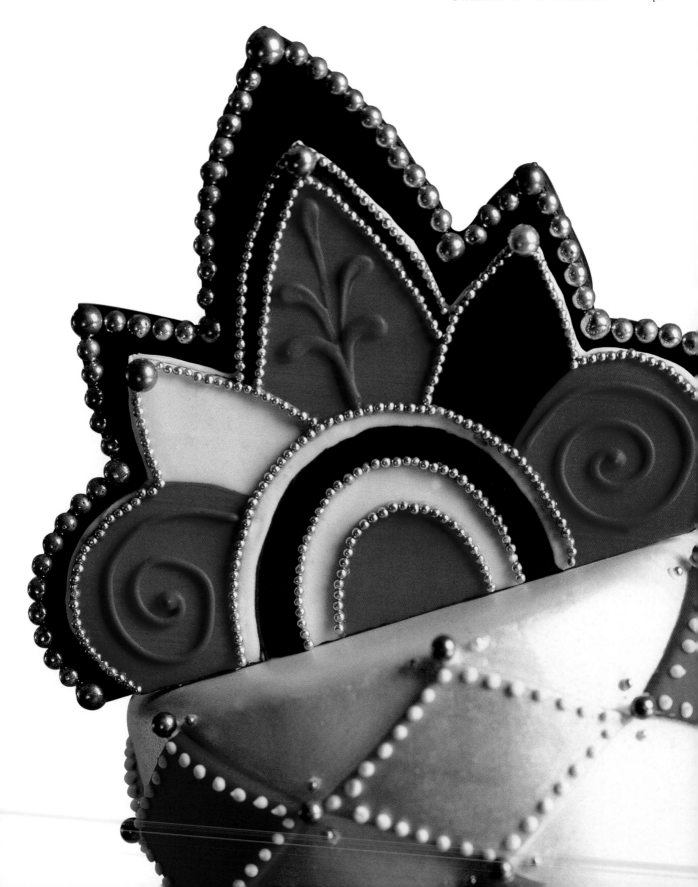

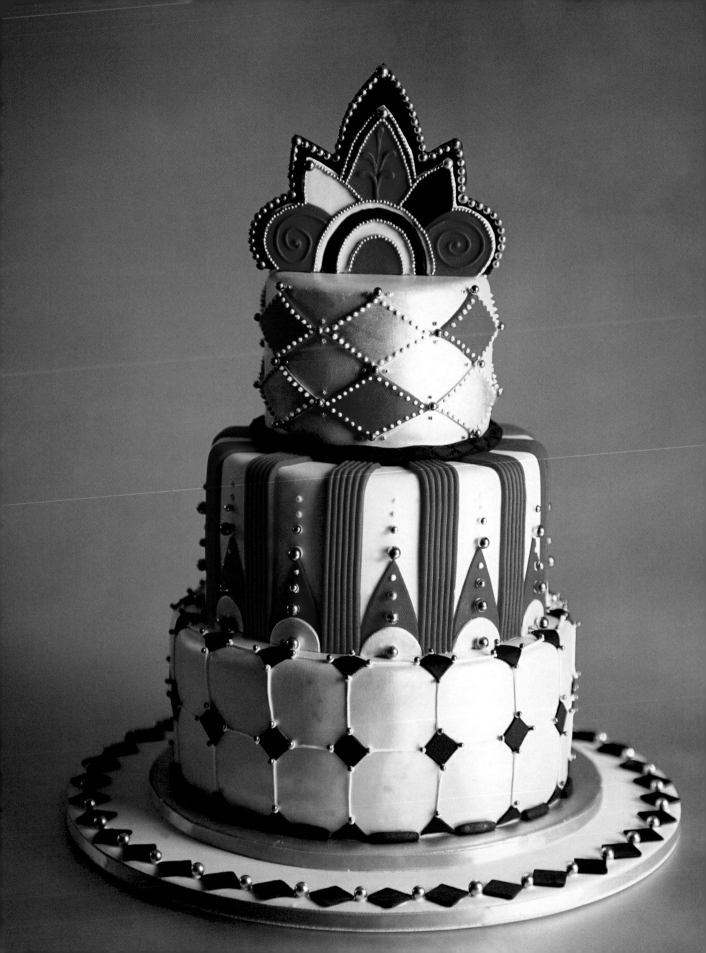

To decorate

Cover all of the tiers with white fondant. Divide the top of the 5½-inch tier into 8 sections. Make a cardboard triangle using the plastic triangle as a template, so that it can bend around the cake. Line up the triangle at each mark using the 30-degree angle, and emboss a line using the tracing wheel. Do 8 lines going in one direction, then turn the triangle and emboss lines in the other direction. These lines will form the diamond shapes (see illustration).

Paint the cake with super-pearl mixed with lemon extract. Cut out diamonds of thin fondant, 8 red and 8 white, using the measurements of the diamonds on the cake. Attach them to the cake, using the photo as a guide. Paint the white ones with silver.

Divide the middle tier into 12 equal sections. Make twelve 1-inch-wide red stripes with the ridged rolling pin. Attach to the cake. Add red leaf-shaped cutouts between the stripes and white 1-inch half-circles at the bottoms of the leaves.

Divide the bottom tier into 16 sections vertically and in half horizontally. Stack the tiers on the base. Paint the bottom tier with super-pearl. Make a black fondant rope for the border between the top and second tier. Use the diamond-shaped crimper to emboss the rope.

Cut out black fondant ¾-inch squares and attach them to the center line of the bottom tier, at each division. Then add black squares to the top and bottom of the tier. Pipe a white line between the squares, finishing the grid.

To finish, with the #2 tip, pipe royal icing dots along the outline of the diamonds on the top tier and add a medium-size dragée at each intersection. Attach larger dragées to the middle tier, and then pipe dots above the leaf shapes.

On the bottom tier, attach tiny dragées to the corners of all of the black squares. Attach the top decoration.

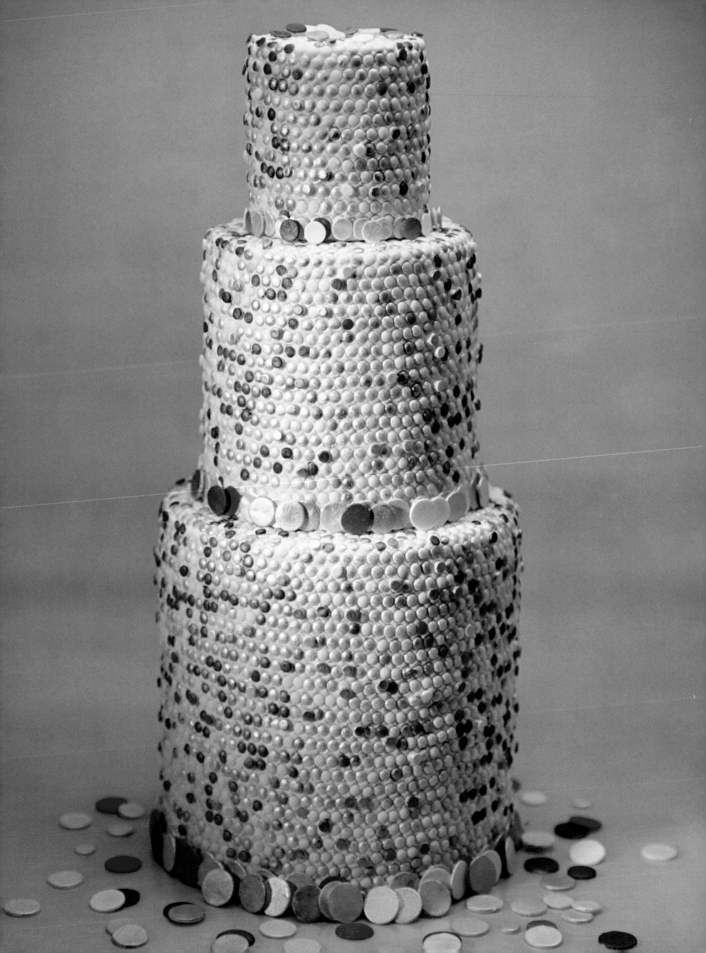

Sequins and Spangles

SERVES 65

I wanted to make a cake that looked like sparkling bits of

light reflecting off little mirrored sequins. Making a sequined

cake was a new challenge that yielded shimmering results.

This cake is very easy to make, although a bit time consum-

ing. But not as time consuming as sewing the real thing!

TECHNIQUES USED

Fondant embossing, painting
with luster dust, fondant cutouts,
double-layered tier

CAKES

- 4-inch round, 4 inches high
- 6-inch round, 6 inches high
- 8-inch round, 8 inches high

OTHER MATERIALS

- 4-inch round foamcore board
- 6-inch round foamcore board
- 8-inch round foamcore board
- 12-inch round board for base
- dowels
- fondant
- royal icing
- purple, white, gold pearl, and royal blue luster dust
- lemon extract
- piping bag and #10 tip
- ½-inch and ⅞-inch circle cutters
- paintbrush

To decorate

Cover the cake with white fondant, and while the fondant is still soft, emboss small circles all over the surface of the cake with the #10 tip. Paint the circles with iridescent colors mixed with lemon extract. The three borders are decorated with 3 different sizes of cutout circles of fondant, which are also painted and attached with royal icing.

Decorating tip

SINCE THE TIERS ARE VERY HIGH, THEY SHOULD ALL HAVE A FOAMCORE BOARD HALFWAY UP (SEE PAGE 5).

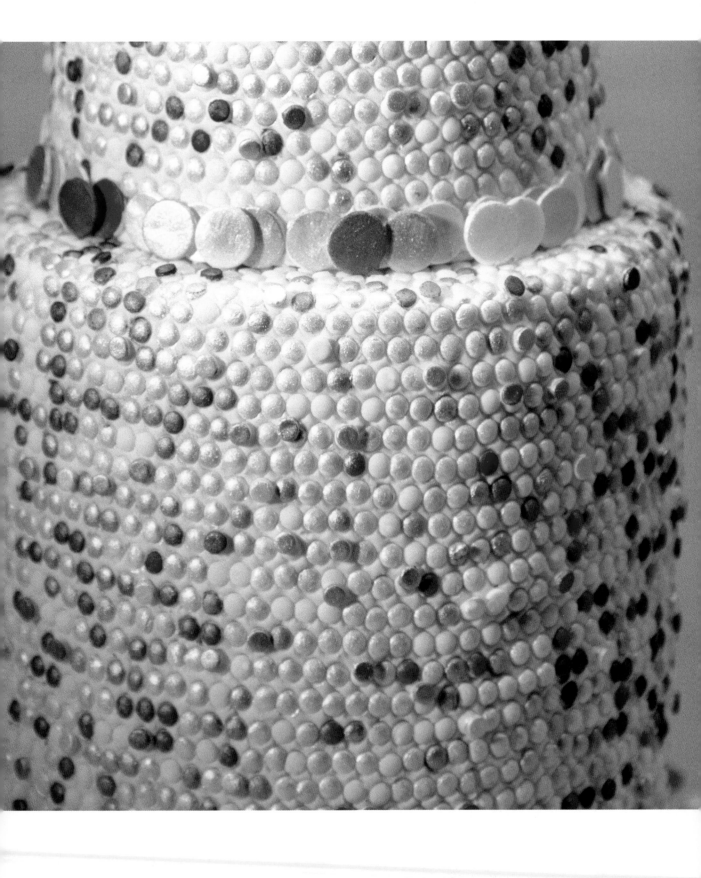

Variations on a Tiara

It's easy for a wedding cake to look regal when its crowning
glory is a royal-icing tiara, enlivened with sugar pearls and
dragées. That same cake, on the other hand, can look a bit
madcap when the tiara theme is taken loosely and the recip-
ient is a young girl. Here I have made two variations of the
same idea, using identical shapes and the basic design, but
changing the royal icing details.

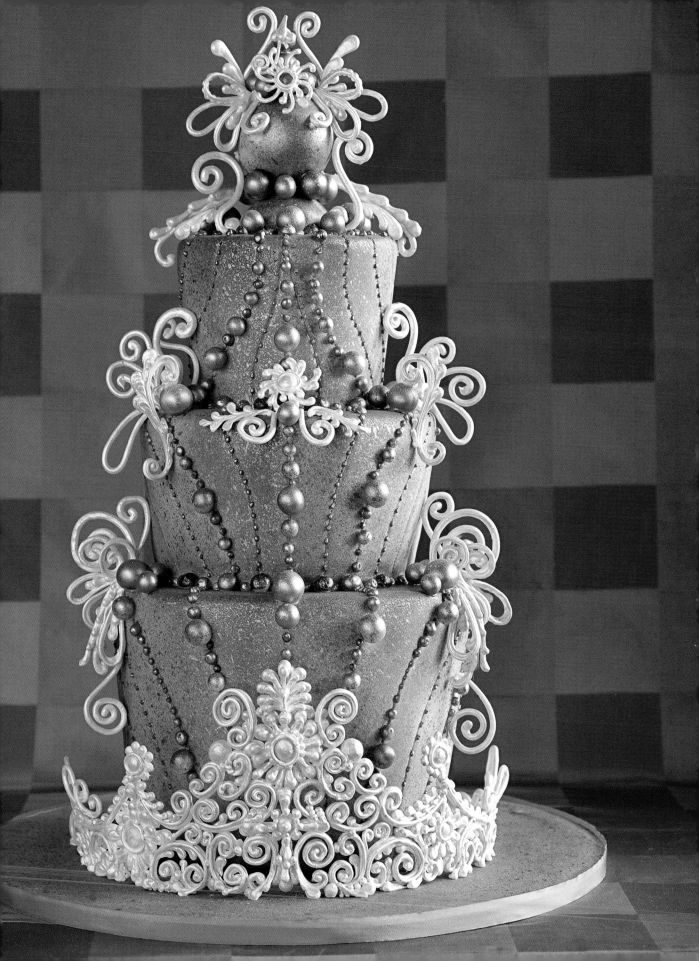

202

TECHNIQUES USED

Quilting, forming fondant pearls, painting with luster dust, cake carving, piping with royal icing, airbrushing, making sugar molds

CAKES

☐ 6-inch round, 4 inches high, carved to be 5 inches on the bottom

☐ 8-inch round, 4 inches high, carved to be 7 inches on the bottom

☐ 10-inch round, 6 inches high, carved to be 9 inches on the bottom

OTHER MATERIALS

☐ 18-inch board for base for each cake

☐ fondant

☐ dowels

☐ royal icing

☐ airbrush and yellow, brown, orange, pale green, and pink airbrush colors

☐ super-pearl, light green, gold luster, gold pearl, pale green pearl, and pale green luster dust

☐ lemon extract

☐ piping bag and #2, #3, #6, and #10 tips

☐ tracing wheel

☐ toothbrush

☐ paintbrush

☐ dragées

In advance for Royal Crown

Pipe curls on waxed paper with royal icing, using the #3, #6, and #10 tips (Figure 1). Pipe the tiara on waxed paper wrapped around a cake pan 12 inches wide and 6 inches high (Figure 2). Many of the shapes on the tiara are over-piped to give the crown detailing and strength. Make the tiara a few days in advance so that it dries completely. Do not paint it until it is attached to the cake board. Let all these decorations dry and paint them with super-pearl.

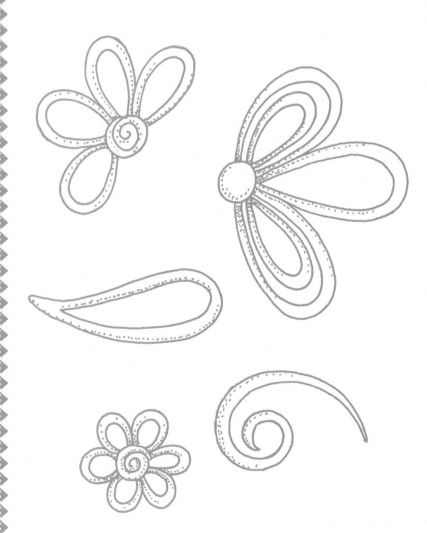

FIGURE 1

Decorating tip

THE BASES CAN BE
COVERED WITH WHITE
ROYAL ICING, SINCE
THEY WILL BE AIR-
BRUSHED ALONG WITH
THE CAKES.

FIGURE 2, ENLARGE TEMPLATE TO 176%

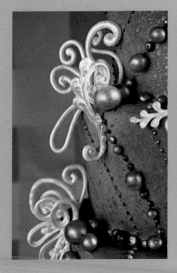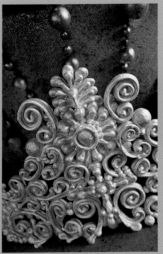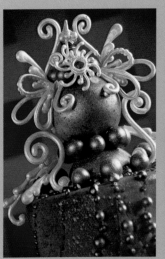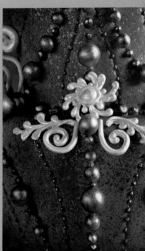

FIGURE 3

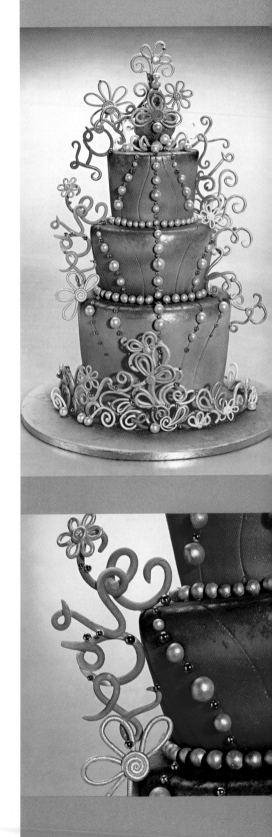

In advance for Love and Kisses Forever

Pipe the royal icing curls, letters (Figure 3), and flowers with the #3, #6, #10 tips. Paint them with light green luster paint, leaving some of them unpainted so that they can be airbrushed later.

In advance for both cakes

Make the 2 halves of a 3-inch sugar ball, hollow them out, and cover them with rolled fondant. Glue the 2 halves together and let dry (see page 241).

To decorate both cakes

Stack the cakes on the prepared boards. Emboss the lines with the tracing wheel, using the photo as a guide.

Coloring Royal Crown

Airbrush the cake with a light butterscotch color, made from a mix of yellow, brown, and orange. Using a toothbrush, splatter the cake with gold luster paint. Then splatter with gold pearl paint. Attach the pearls with royal icing along the embossed lines shown, then paint them with super-pearl. In between the pearls, add a dragée. Then add the painted royal-icing swirls, the sugar mold, and the tiara. Paint the tiara with super-pearl after the icing used to attach it has dried.

Coloring Love and Kisses Forever

Airbrush the top edges of all the tiers with a pale green. Then, use pink airbrush color to paint the rest of the cake. Airbrush the various royal-icing swirls and letters, then paint parts of them with a pale green pearl paint.

Splatter the cake with gold luster paint, then the pale green luster paint.

Attach the pearls to the cake and paint them with pale green luster paint. Add dragées in between the pearls. Attach the royal-icing swirls, letters, and flowers, and the sugar mold. Finish with pearls and dragées.

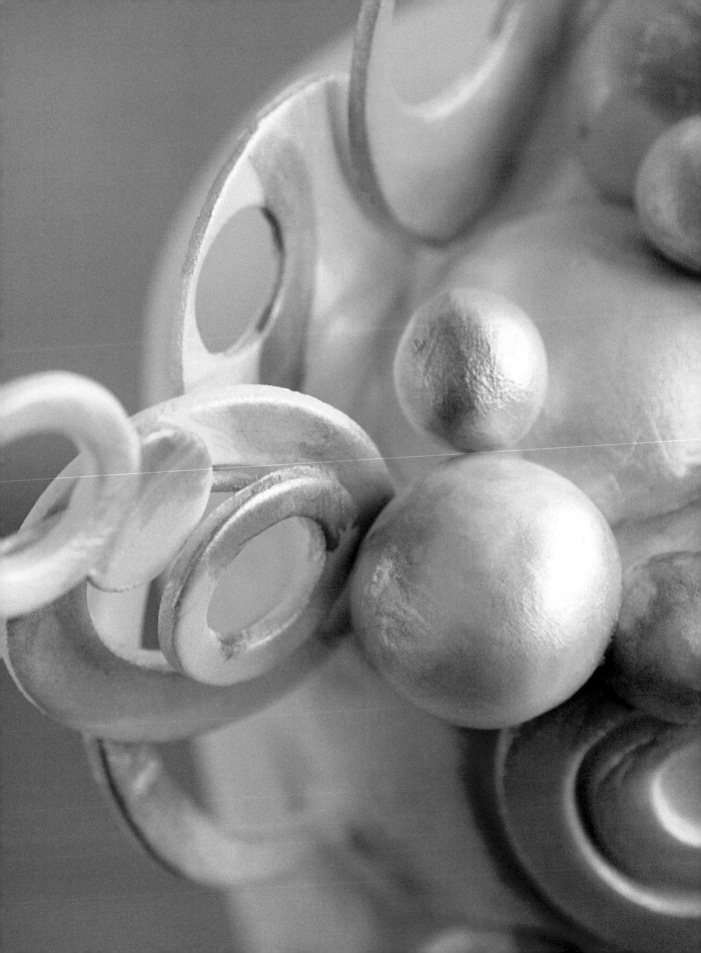

Sudsy
SERVES 65

Being from Chicago, I grew up seeing Frank Lloyd Wright designs all around the area, so I feel connected to his style. Not only did he design buildings, but he also designed the furniture and china and sometimes even the clothes for the owners to wear in his houses.

These bubbles were actually inspired by one of Frank Lloyd Wright's china patterns. I started by making concentric circles on the cake, then they somehow, slowly, turned into bubbles. I'm sure he wouldn't mind if I "soft-soaped" him by using him as my muse.

In between the tiers I use clear plastic cylinders, which give the cake a floating quality.

This cake would be ideal for a shower.

In advance

Cover the board with white royal icing. To make the top ornaments, glue balls and cutouts to the wire with royal icing and let them dry completely, leaving enough extra wire to insert into the cake. When the icing is dry, place the wire in the top of the cake, then glue more circles and balls to hold it in place.

To decorate

Hot-glue a round of foamcore on the top and bottom of each clear, plastic cylinder, the same size, to add strength and so the dowels have something to support. The foamcore boards will appear invisible when the cake is assembled.

Stack the cakes on the board, with the clear cylinders in between. Cut out 3 dozen open and closed fondant circles. Let some dry on a flat surface covered with a light dusting of cornstarch to keep them from sticking. Attach the soft ones to the cake with water. Use royal icing to attach the dry ones. Form different-size balls and half-balls in fondant. Attach these to the top of the cake with icing and to the side with a toothpick inserted halfway into the ball to hold it on the cake while the icing dries. Be sure to remove the toothpick before cutting the cake.

Airbrush with dark blue in the shadow areas. Paint with different colors of luster paint mixed with lemon extract, then sprinkle with glitter.

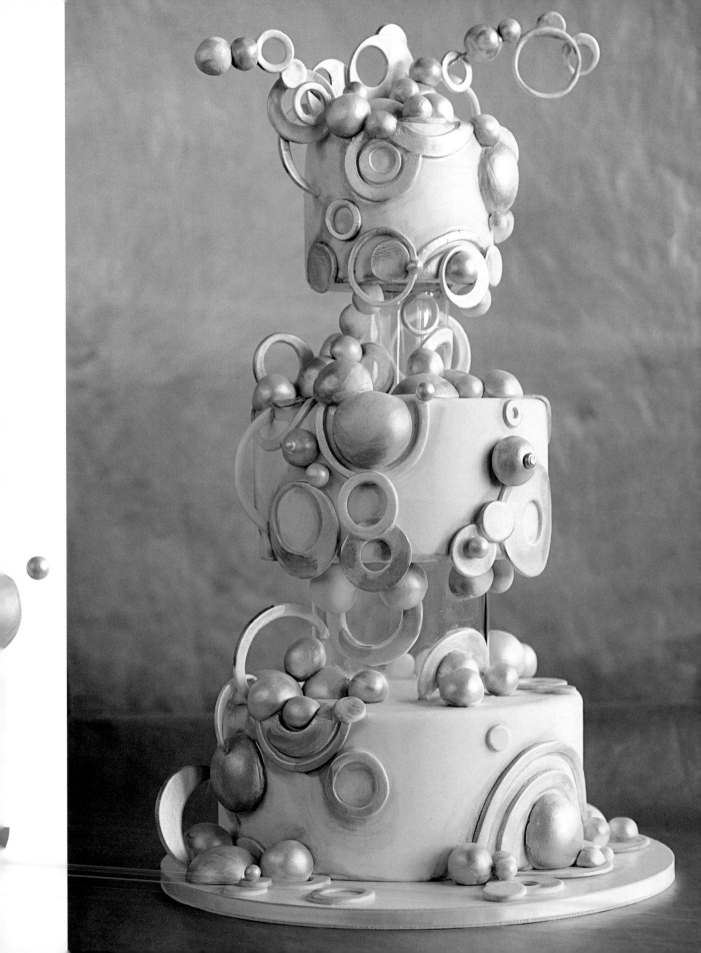

Recipes

Heavenly White Cake

SERVES 20

I love the taste of this delicious, simple cake. Brown sugar gives it a caramel flavor that never disappoints. Egg whites make the batter light, but butter adds richness. You can also use this as a basic cake to flavor many ways (see right).

8 ounces all-purpose flour

8 ounces cake flour

2 teaspoons baking powder

1 teaspoon salt

2 sticks (8 ounces) unsalted butter, at room temperature

10 ounces packed brown sugar

11 ounces white sugar

2 teaspoons vanilla extract

1 cup egg whites, at room temperature

1½ cups milk, at room temperature

Preheat the oven to 325°F. Coat two 8- or 9-inch round cake pans with vegetable spray and line the bottoms with parchment paper. Sift together the flours, baking powder, and salt.

Cream the butter and sugars in a large mixing bowl until airy. Add the vanilla and the egg whites, scraping the sides of the bowl. Mix until light and fluffy. Add the flour mixture in 3 batches, alternating with 3 batches of milk, mixing after each addition and ending with the flour. Mix each addition just until combined. Do not overmix or the cake may become dry.

Pour the batter into the prepared pans. Bake for 30 to 35 minutes, or until a toothpick inserted in the centers comes out clean. Let the cakes cool completely in their pans on wire racks. Wrap, pan and all, and refrigerate until ready to decorate. To remove the cakes from the pans, run a knife around the inside edge of each. Then gently tap the edge of the inverted pan on the counter, and the cake should come out very easily.

Lemon cake
STIR IN THE ZEST AND JUICE OF 2 LEMONS AFTER THE FLOUR AND MILK HAVE BEEN ADDED.

Mocha cake
ADD 1 CUP STRONG COOLED ESPRESSO AND 8 OUNCES MELTED BUT COOL UNSWEETENED CHOCOLATE. ADD THESE AFTER YOU ADD THE EGG WHITES.

Almond cake
ADD ½ CUP ALMOND PASTE WHEN YOU CREAM THE BUTTER AND SUGAR. ADD 2 TEASPOONS ALMOND FLAVORING ALONG WITH THE VANILLA.

Hazelnut cake
ADD 1 CUP PRALINE PASTE AND 2 TEASPOONS HAZELNUT FLAVORING WHEN YOU CREAM THE BUTTER AND SUGAR TOGETHER.

Coconut cake
ADD 1 CUP GRATED COCONUT AFTER THE MILK AND THE FLOUR HAVE BEEN ADDED.

Coco-Loco Cake

SERVES 20

This is one of my favorite cakes, with coconut making it very moist and both chocolate and bourbon adding a rich flavor. I love it right out of the oven, but it's even better (and firmer for sculpting and cutting) the next day, after it's completely cool. Another great thing about this cake is that you don't need a mixer to make it. You can just whisk all of the ingredients together in one big bowl!

2 cups all-purpose flour

1 teaspoon baking soda

Pinch of salt

1¾ cup hot coffee

¼ cup bourbon

5 ounces unsweetened baking chocolate, cut into small pieces

2 sticks (8 ounces) unsalted butter, cut into small pieces

2 cups sugar

2 eggs, at room temperature

2 teaspoons vanilla extract

½ cup shredded sweetened coconut

Preheat the oven to 275°F. Coat two 8-inch round pans with vegetable spray and line the bottoms with parchment paper. Sift together the flour, baking soda, and salt in a separate bowl; set aside.

In a large bowl, combine the hot coffee, bourbon, chocolate, and butter. Cover and let stand for about 10 minutes, until everything has melted. Then whisk in the sugar and let the mixture cool.

Whisk in the flour mixture in 2 batches, then the eggs and vanilla. Whisk in the coconut. The batter will be runny.

Chocolate Cake

LEAVE OUT THE COCONUT; EVERYTHING ELSE REMAINS THE SAME.

Orange Chocolate Cake

LEAVE OUT THE COCONUT, SUBSTITUTE GRAND MARNIER FOR THE BOURBON, AND ADD THE ZEST OF 1 ORANGE.

Pour the batter into the prepared pans and bake for 45 minutes (checking after 30 minutes and rotating the pans for even baking, if necessary), or until a toothpick inserted in the center comes out clean. Let the cakes cool completely in the pans on wire racks. Refrigerate them in their pans, wrapped in plastic, because it's always much easier to decorate this cake when it's completely chilled. To remove the cakes from the pans, run a knife around the inside edges and tap them upside down. The cakes should slide out easily.

Carrot Cake

SERVES 30

I find this recipe perfect for making tiered cakes, since it's firm enough to hold up the weight of multiple layers, but remains moist and very tasty.

18 ounces sifted all-purpose flour

3 tablespoons ground cinnamon

½ teaspoon grated nutmeg

1½ teaspoons baking soda

½ teaspoon baking powder

¼ teaspoon salt

8 eggs

1½ cups vegetable oil

28 ounces sugar

2 pounds carrots, peeled and finely grated

4 ounces walnuts, chopped

1 cup dried raisins or currants

Preheat the oven to 375°F. Coat two 9-inch round cake pans with vegetable spray and line them with parchment cut to fit the bottoms of the pans.

Sift together the flour, cinnamon, nutmeg, baking soda, baking powder, and salt.

In a large mixing bowl, beat the eggs until they are light and fluffy. Turn the mixer to low and gradually add the oil. Then gradually beat in the sugar.

Add the sifted ingredients to the egg mixture and blend. Stir in the carrots, nuts, and raisins.

Turn the batter into the prepared pans and bake for about 45 minutes, or until a toothpick inserted in the center comes out clean. Let the cakes cool in the pans on a wire racks. Wrap the cakes in the pans and refrigerate until you are ready to decorate them. To remove the cakes from the pans, run a knife around the inside edges and tap them upside down on the counter. The cakes should slide out easily.

Meringue Buttercream

YIELDS 10 CUPS

This is a classic buttercream that is very buttery and light. It holds up well and has only four ingredients, so it isn't too complicated. Used as a filling, crumb-coating, final icing, or even for piping, it is amazingly versatile. Store at room temperature for up to a day, or refrigerate for up to a week.

1½ cups egg whites, at room temperature

3 cups sugar

3 pounds unsalted butter, at room temperature

1 tablespoon vanilla extract or other flavoring

In a large bowl, combine the egg whites and the sugar and whisk until well blended. Set the bowl on top of a double boiler and stir constantly with the whisk until the mixture is hot to the touch.

Transfer to a large mixing bowl and beat on high with the whip attachment until the meringue is cool and forms stiff peaks. Slowly add the soft butter about ¼ cup at a time while beating on medium speed. When all the butter is added, it should be thick and creamy. Add the vanilla and blend.

Lemon Buttercream

MIX IN 4 HEAPING TABLESPOONS LEMON CURD (FOUND WITH THE JAMS AND JELLIES IN THE GROCERY STORE) WHEN THE BUTTERCREAM IS COMPLETED.

Raspberry Buttercream

MIX IN 3 HEAPING TABLESPOONS RASPBERRY JAM WHEN THE BUTTERCREAM IS COMPLETED.

Mocha Buttercream

ADD 2 OUNCES UNSWEETENED CHOCOLATE TO ½ CUP HOT ESPRESSO. WHEN THE CHOCOLATE MELTS AND THE MIXTURE IS COOL, ADD IT TO THE COMPLETED BUTTERCREAM.

A Word about Fillings

Since most cakes stand out on display throughout a party, I use only fillings that can be left out at room temperature for a few hours. For that reason I don't use mousses or whipped creams. The fillings that follow here are the ones I normally use. I also incorporate jams and preserves, either by themselves or along with chocolate ganache or buttercream.

Chocolate Truffle Filling

YIELDS 2 CUPS, ENOUGH TO FILL AND
COVER AN 8-INCH CAKE, 4 INCHES HIGH

This ganache is the ultimate for chocolate lovers; rich flavor and a smooth texture that melts in your mouth. Yet this icing is the easiest to make and to use, and it holds up in warm weather. I use it both as a filling and for crumb-coating.

It can be stored at room temperature for two days or refrigerated for up to two weeks.

12 ounces semisweet chocolate (use chips or cut blocks into small pieces)

1 cup (8 ounces) heavy cream

2 teaspoons flavoring or liqueur (optional)

Place the chocolate in a large bowl. Heat the cream in a saucepan just until it starts to boil. Immediately pour the cream over the chocolate, making sure that all of the chocolate is covered. Cover the bowl and let stand for 5 to 10 minutes, until the chocolate has melted.

Whisk until the chocolate is dark and shiny, then cool to room temperature or refrigerate until ready to use. The more you whisk this icing as it cools, the stiffer it will get. If you refrigerate the icing before you put it on the cake, it will get very hard, and you will have to microwave it for a few seconds to soften it to a spreadable state before using.

Rolled Fondant

YIELDS 2 POUNDS, ENOUGH TO COVER A
9-INCH CAKE, 4 INCHES HIGH

In the days before you could buy fondant easily, I used to make my own. But now I buy it ready-made, which is a great timesaver, since I use such large quantities of it. There are many good brands, and some also make chocolate fondant. But if you only need a small quantity of fondant and want to make it yourself, here is the recipe:

> 2 pounds sifted confectioners' sugar
>
> ¼ cup cold water
>
> 1 tablespoon unflavored granulated gelatin
>
> ½ cup glucose (found in cake-decorating stores)
> or light corn syrup
>
> 1½ tablespoons glycerin (found in cake-
> decorating stores)

Marzifon

WHEN A CUSTOMER ASKS ME TO MAKE A MARZIPAN-COVERED WEDDING CAKE, I USUALLY CONVINCE THEM TO USE WHAT I CALL "MARZIFON," A MIXTURE OF HALF MARZIPAN AND HALF FONDANT, SIMPLY KNEADED TOGETHER. UNLIKE MARZIPAN ALONE, IT WILL STAY WHITE AND REMAIN PLIABLE, BUT IT WILL RETAIN THE ALMOND FLAVOR.

Sift the confectioners' sugar into a large bowl and make a well in the center. Place the water in a small saucepan. Sprinkle the gelatin evenly on top of the water. Let the gelatin soften for about 5 minutes, or until it turns translucent. Slowly begin to heat the water, stirring until the gelatin is dissolved and clear. Don't let the mixture boil; it should be hot and almost at a simmer.

Remove the pan from the heat and add the glucose or corn syrup and the glycerin, stirring until well blended. Pour the liquid into the well of sugar and start to mix with your hands to blend. When the mixture is solid enough, you can transfer it to a clean surface and knead it like kneading bread dough. Do this until all of the sugar is incorporated. The fondant should not be sticky or too stiff at this point.

Form the fondant into a ball and rub it with a thin coating of vegetable shortening. Wrap tightly in plastic wrap, place in an airtight container, and let sit at room temperature overnight. If you are not going to use the icing for a while, you can refrigerate it, but the fondant will become very hard and will have to be brought to room temperature before it will be soft enough to roll.

Royal Icing

YIELDS 1 POUND

Most people know of royal icing as the thick, rock-hard icing used to hold gingerbread houses together. It certainly can be used for that, but it can also be used in many other ways. Royal icing is the best medium to use for delicate piped decorations: flowers, bows, stringwork, and curlicue cages. The fact that it dries hard is a plus when making detailed work, but the fact that it is a meringue makes it melt in your mouth.

> 5 tablespoons meringue powder (found in cake-decorating stores)
>
> ⅓ cup water
>
> 1 pound confectioners' sugar
>
> or
>
> 1 large egg white, at room temperature
>
> ½ teaspoon cream of tartar
>
> 1 pound confectioners' sugar
>
> 2 teaspoons water

Combine all the ingredients in a mixing bowl and beat at slow speed with the paddle until stiff peaks form and the icing becomes pure white. If you don't use the icing immediately, place a damp cloth over the bowl to prevent the icing from hardening. Stir the icing whenever you use it, as it becomes spongy when it sits for awhile. It's not necessary to rebeat the icing. In fact, overbeating can break down the strength of the icing.

Let royal icing decorations dry at room temperature for at least 24 hours, depending on how thick they are, before attaching to a cake.

White Modeling Chocolate

YIELDS ABOUT 1 CUP

Modeling chocolate is similar in consistency to fondant, and doesn't harden like gumpaste. It has a nice chocolatey flavor and can be used to cover a cake as an alternative to fondant, or for making flowers, bows, leaves, or even "pasta."

10 ounces white chocolate

6 tablespoons light corn syrup

Melt the chocolate in a heatproof bowl over a saucepan of hot—but not boiling—water. Be careful not to burn the chocolate. Stir in the corn syrup. As you stir, the chocolate will thicken. Stir until the ingredients are completely combined. Turn out and form into a flat disk. Wrap in plastic wrap and let stand at room temperature overnight. The mixture should feel very hard, but it will immediately soften when you start to knead it. You can either roll it out with a rolling pin or run it through a pasta machine, starting at the widest opening and rolling it progressively thinner until it reaches the desired thickness.

Masterclass Materials and Techniques

Sugarwork Techniques
ROLLED FONDANT

Decorating with Rolled Fondant: When I started decorating cakes many years ago, it was fashionable to use buttercream exclusively as the icing. At first, I wanted the finished cake to look swirly and gooey, the way they looked in commercials. I tried and tried, but my cakes never quite looked like that. Then, I tried to get the icing smooth and perfect, as in bakeries. This I could do, but I never really enjoyed the effort. I liked piping with buttercream, though, and this, to me, was the fun part of making a cake.

A few years later, I went to a cake-decorating convention, and there were people from Australia who had a new product for decorating cakes, called rolled fondant. This was the thing I needed to make my cakes look smooth and perfect, plus it was easy to use. And it tasted good. I liked the smooth chewiness of the fondant in contrast with the cake, and I liked what you could do with it. You could tint it, paint it, crimp it, roll it, shape it, and mold it; and it actually kept the cake fresh and sturdy.

Coloring Rolled Fondant: Since painting has always been a love of mine, I've looked at a cake as if it were a blank canvas. Unfortunately, the difference between a blank canvas and an icing-covered cake is that sugar melts when water-based colors are brushed on. I have experimented with edible techniques and mixtures for painting a cake over the years; and after much trial and a lot of error, I feel that I have come up with some useful, easy, and creative solutions.

If you try to paint rolled fondant with a water-based food coloring using a brush, the fondant starts to melt and the color comes off with each brush stroke, which can lead to a lot of frustration. Therefore, when you paint on a cake covered with fondant, use a pigment mixture that contains a lot of *alcohol* instead of water. When you use alcohol as your liquid, it doesn't melt the icing, and it evaporates quickly, allowing the color to stay in place on the fondant.

The one exception to this rule is when using an airbrush with airbrush food colors, which are water based. With the airbrush you do not need to worry about water melting the icing because you're *not brushing* and the spray is so light it won't melt the fondant.

Here are the ways to color fondant that I've found successful:

1. Mixing Paste Colors into Fondant

This is the simplest way of getting an even pastel color. It takes a bit of muscle, but the results can't be achieved any other way. Food colors in paste form should always be used for this, since anything else will water down the icing and not have the intensity needed. Only a little bit of paste on the end of a toothpick is necessary. If you need a more intense or dark color, airbrushing or painting is a better way to go, since you'd have to use so much coloring that it would alter the taste of the fondant, and make everyone's mouth and teeth that color, which is not too attractive at a wedding.

Marbleizing is achieved by kneading white or colored fondant with another colored fondant, or, one or more paste colors. To get a marbleized effect, knead the icing only until the right amount of coloration is achieved. When the fondant is rolled out, the different streaks of color will appear in a translucent layering of color.

2. Painting with Powdered Colors

This is done when a flat color (not a luster color) is needed in specific areas, as opposed to all-over color. When you use powdered colors, you should mix them with an alcohol-based liquid instead of water. I use lemon extract because (1) it is easily found in grocery stores, (2) it has more alcohol than gin or vodka (it has about 87 percent) or other tasteless liquors, and (3) the taste evaporates along with the alcohol. You can use any powdered food colors, such as petal dust or candy colors. Simply make a mixture of the lemon extract and powder that is thick enough to paint an area without streaking but not so thick so that it looks lumpy. Roll out a small piece of fondant and paint it with a brush to check the consistency of the color before you put it on the cake.

Painting with a nontoxic luster dust with a brush: This is done when a shimmery, iridescent effect is desired. Decorating a fondant-covered cake or other kinds of sugar decorations, such as gumpaste, royal icing, or modeling chocolate, with iridescent powdered colors is done in the same way as if using flat powdered colors, described above. Mix the luster dust with the extract and test it with a paintbrush on a small piece of fondant.

To splatter a cake: If you want to paint a cake in a less controlled way, you can splatter it or sponge it. Use a toothbrush dipped into a watered-down solution of luster paint. Shake off the excess paint on the brush, then run your thumb across the bristles, aiming toward the cake.

To sponge on a color: Put the paint in a shallow dish or saucer, dip the clean sponge into the color, and apply it to the cake. You can apply multiple layers of different colors for a surface with more depth. When you finish painting, set the container aside and let the mixture dry. Rather than throwing it away and wasting a lot of powder, you can use it again.

3. Airbrushing a Cake

When you want to cover a cake completely with a dark color, or with a soft gradation of one or many colors, use an airbrush with edible food colors specially designed for cake decorating. A company named Kopykake makes airbrushes for cakes, and they also make the colors for it (see Sources). Airbrush colors are edible water-based liquids, and they come in many colors. You can use any brand airbrush, but the colors *must* be food colors.

An airbrush is held like a pen. It has a lever on top that controls the amount of air and paint that flows through the tip from the compressor. I follow a few general rules when airbrushing.

Always test the color on a paper towel before spraying something important, to make sure that the color and airflow are correct.

Avoid using colors straight from the bottle. I have found that mixing two or more colors in the airbrush produces richer, more subtle shades. For example, adding a little pink to bright green will tone down the green.

Most important, keep the airbrush clean at all times. If you leave colors in the airbrush, they will dry out and clog it.

To clean an airbrush, run hot water through it until the spray comes out clear. Put some Windex in the color cup and spray it through; this will clean the inside completely. Then run plenty of clean water through the airbrush so that it will be ready to use next time.

To paint a large area evenly, hold the airbrush perpendicular to the surface. Spray slowly back and forth, passing the nozzle beyond the edge of the area you're covering. I put the cake on a turntable so I can have a continuous stroke of color without having to stop painting while I turn the cake. Start with a light color and build up layers to achieve the color you want. Also, if you are too close to the cake, you may get a splotch of color that can't be removed, so stand back a little. Remember, you can always add more color, but you can't take color away.

An airbrush is also a great way to color leaves, flowers, bows, or other sugar ornaments quickly. Just remember: If the flowers or leaves are small, they can blow away when you try to paint them, so you may need to hold them in your hand.

FONDANT DECORATIONS

There are many ways of manipulating and shaping rolled fondant. With these simple techniques you can make practically anything.

THICK AND THIN ROPES

Ropes: To make a simple rope, first rub a small amount of shortening on the surface of your table, which will give the fondant some friction. Take some fondant and shape roughly into a thick rope, then begin to roll it back and forth on the table with your fingers to elongate it and thin it out. Move your hands along the rope to prevent any very thick or very thin areas. Continue until the desired thickness is reached.

Thick and thin ropes. These are wavy strands that are thick in some places and thin in others. Shape the rope with your fingers by pressing into the rope to make the thin areas while pushing toward the center.

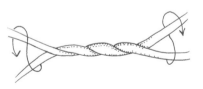

BRAIDS

Braids: To make a braid, start with a rope, making it half as thin as you want the braid to be. Then double over the rope and twist the two pieces together.

Embossing and Indenting: Embossing is simply the process of pressing a design or pattern into fondant, either while it is already on the cake or into a separate piece that will be applied later. Embossing on a cake must be done immediately after the cake is covered, while the fondant is still soft, to ensure that the design will be clear and sharp.

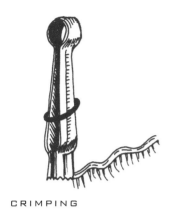

CRIMPING

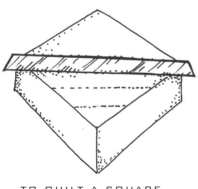

TO QUILT A SQUARE
CAKE

Simple embossing. You can buy tools from cake-decorating stores that are made particularly for embossing into fondant, or you can use items found around the house, such as cookie cutters, a piece of lace, a pattern on the end of a spoon, a piece of jewelry, or anything that captures your imagination. Simply press the design into the fondant, firmly but not too deeply, so that you don't go through the icing and into the crumb-coating.

Crimping. Another type of embossing is done with a tool called a crimper. It is made solely for use on fondant, gumpaste, marzipan, or modeling chocolate and can be found in cake-decorating stores. A crimper looks like a pair of small tongs with a pattern on the end. The crimper is pressed into the fondant, pinched, then removed.

Quilting. Running a serrated tracing wheel over the surface of fresh fondant will indent a line of dots, giving the cake a stitched look. Tracing wheels—smooth or serrated—can be purchased at cake-decorating or sewing stores. To make sure your lines are straight, use a straightedge with the tracing wheel.

To quilt a round cake, first divide the top edge into equal sections, as described in the section "Dividing a Round Cake Evenly for Decorating," page 244. Then use a flexible triangle made out of cardboard to emboss lines with the tracing wheel. Line up the top edge of the triangle with the mark on the top edge of the cake, making sure that you keep the bottom edge of the tracing wheel flat on the table or board.

To make a crisscross pattern, make the lines first in one direction, then turn the triangle and make the lines in the other direction.

To quilt a square cake, you don't have to measure anything. Simply use a straightedge that is the width you would like the distance of your lines to be. Or you can make a straightedge out of cardboard. For instance, if you want your lines to be 2 inches apart, then you would use a straightedge that is 2 inches wide. Line up the straightedge with the two opposite diagonal corners on the top of the cake. Make lines along both sides of the straightedge with the tracing wheel. Then move it over one ruler width so that the left edge of the ruler is lined up with the lines made with the right side of the ruler. Continue across the top of the cake.

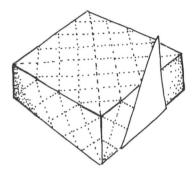

TO QUILT THE SIDES
OF THE CAKE

To make a crisscross pattern, turn the straightedge so that it lines up with the other two corners; repeat the same as above.

To quilt the sides of the cake, line up the diagonal side of a triangle with the marks on the top edge of the cake made previously and make lines in the same manner.

Textured rolling pins. You can find all sorts of textured rolling pins from cake-decorating companies these days, which can add a lot of interest to your cakes. From simple lines to basket weave, to floral designs and polka dots, they come in many types. You can also find decorative embossing mats; these are placed on the fondant when it is rolled almost to its desired thickness, then the mat is placed on top and rolled once, producing a textured surface. These can all be found in cake-decorating stores.

Cutouts: Cutting out pieces of fondant and attaching them to a cake is another way to use this kind of icing. When decorating a cake with cutouts, you can put them on the cake right away, or dry them flat or curved and attach them later. Normally, I use water to glue the soft pieces onto the surface of a cake, but when attaching cutouts that are already dry, I need to use royal icing.

Inlaid Surfaces: An inlaid surface is one in which you lay pieces of colored fondant on top of another larger piece and then roll them together so that the added pieces become part of the larger one.

To do inlay work, roll out a piece of fondant slightly thicker than you want the fondant to be when you place it on the cake. Rub a little vegetable shortening on the surface of the fondant, then press thin hand-shaped pieces or cutouts of soft fondant on top of the fondant. Roll the fondant until the pieces are imbedded. Vary the direction in which you roll so that the design stays in the shape that you want, otherwise it will get distorted. You can add pieces, roll a little, then add a few more pieces and roll some more. The main thing is to prevent the fondant from drying out. Keep the surface moist with shortening, or cover it with plastic wrap while you are working. Remember also that as you roll the pieces together they will get wider, so start out smaller than you want your design to end up.

Pearls, Teardrops, and Curls: Fondant can be shaped into practically anything you can imagine—pearls, teardrops, curls, corkscrews. Simply roll the fondant in your hands until the shape is achieved.

To dry pearls or other shapes so that they are completely round or have rounded bottoms, lay them in a soft piece of bumpy foam (used for mattresses). You can also make a thick bed of cornstarch on which to lay your pieces. This will enable your pieces to dry rounded on the bottom without flattening.

Thick and Thin Roses: I came up with this simple technique when I was demonstrating the wrong way to roll out a fondant rope. First roll out a thick and thin rope. Do this by rolling out a rope of fondant to whatever thickness you wish, depending on the size of the flower you want. With your fingers spread, roll the rope so that it has thick and thin areas. Then simply start with one end and begin rolling the fondant into a tight roll. The thick and thin areas will make the rose look like stylized embroidery. To make leaves to match, roll out a thick and thin rope. Fold it in half, and pull off one end so that it has a point.

GUMPASTE DECORATIONS

Gumpaste, which is a kind of sugar dough, is the perfect edible medium for making long-lasting flowers, bows, ribbons, tassels, and just about anything else that you can think of. Like fondant, gumpaste can be colored or painted. Gumpaste is much stronger than fondant, so it can be rolled very thin and can be used for making very delicate shapes. I have created bride and groom

THICK AND THIN ROSES

figurines, trees, cages, animals, and even candleholders from gumpaste. The main thing to remember when working with gumpaste is that it dries quickly when it is very thin, but takes a long time to dry completely when it is very thick. So allow enough time for your pieces to dry, at least 24 hours.

When gumpaste dries, it is very hard and brittle, like plaster. Although gumpaste decorations are fragile, they can be kept for years, as long as they are kept away from hot and humid air, which can soften or melt them.

I have tried many gumpaste recipes, but my favorite is actually a combination of equal parts Bakels ready-made gumpaste and either CK or Wilton powdered gumpaste (see Sources). This recipe has always worked best for me, and I find that it doesn't dry quite as fast as some other recipes, and it gives you a little extra time to work on pieces. Also, it's not quite as brittle as some others, so your creations won't break as easily.

Mix the powdered gumpaste with water, following the package directions. Shape the mixture into a ball and rub the surface with a little vegetable shortening. Place it in a plastic bag, squeeze the air out, and seal it. Let it sit overnight before using it.

When you are ready to use your gumpaste, mix the Bakels gumpaste with the powdered mixture in a 1 to 1 ratio, preparing only the amount you will use that day. If the paste seems to be a bit sticky or if it's very humid, add a pinch of Tylose or CMC (synthetic gumtragacanth, the "gum" in gumpaste, found in cake-decorating stores) to keep the paste firm. Gumpaste should snap when pulled apart. Add some shortening if it seems too dry.

MATERIALS NEEDED

gumpaste
cornstarch
cookie sheet
plastic cutting board or rubber
 placemat
paper for making patterns
clay gun

gumpaste tools
paintbrush
pizza cutter
rolling pin, small plastic or wooden
small pair of scissors
small dish of water

TO MAKE A LOOP

TO MAKE STACKED LOOPS FOR A BOW

To Make Ribbons and Bows: Dust a cookie sheet with cornstarch so that the ribbons can dry flat without sticking. Tint the gumpaste, if desired, and knead it thoroughly.

To *make a loop,* roll out the gumpaste about ⅛ inch thick. Cut a 6-by-2-inch strip with a pizza cutter (this will make a medium-size loop). It's a good idea to make a paper pattern so that all of the loops will be the same size. Brush a little water on one end and lay the two ends on top of each other. Then pinch the ends together so that the tip comes to a point. Stand the loop on its side to dry on the sheet.

To *make stacked loops for a bow,* don't pinch the ends together, so that they remain flat and squared off.

To *make notched ribbon ends,* cut a strip of gumpaste the same width as the loops in whatever length the design calls for. Notch one end with a sharp knife. Pinch the other end so that it comes to a point. Lay the strip on its side, folding it slightly to form a ripple.

Let ribbons or loops dry for at least one day before you place them on a cake. They can then be painted with luster dust, if desired.

Before making a *knotted bow,* again make a paper pattern so that the bow turns out to be the size that you want. Cut a long rectangle as wide and three times as long as you want the finished bow to be. Fold the two ends of the rectangle to the center and pinch the paper in the middle. This will give you a sense of what your bow will look like. Roll out a piece of

TO MAKE NOTCHED
RIBBON ENDS

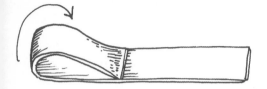

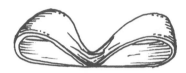

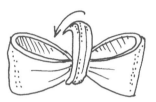

TO MAKE A KNOTTED BOW

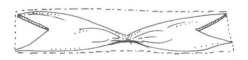

TO MAKE THE RIBBON
ENDS

TO MAKE COILED
RIBBON

TO MAKE CURLS

gumpaste about ⅛ to $1/_{16}$ inch thick and the size of the pattern. For different textures, use a textured rolling pin. Cut out the strip with a pizza cutter. Wet each of the short ends with a little water and bring them both to the center. Stuff a little tissue or paper towel inside the loops to keep them from collapsing while they dry. Pinch the center together. Cut another strip about the same width as the pattern and long enough to wrap around the center of the bow. Brush a little water on each end of this strip and fold it around the center of the bow, allowing it to crease naturally. Let dry for at least 24 hours.

To *make the ribbon ends*, use the same pattern you used for the bow and cut a long gumpaste rectangle to the desired length. Cut a notch in each end and then pinch the center together. Let dry on crumpled paper towels so that it has a slight ripple. Attach the ribbons to the cake first, using royal icing. When the icing has set up a bit, glue the bow on top of the pinched center, so that the bow looks like it was made of one piece of ribbon.

To *make a coiled ribbon*, cut out thin gumpaste strips in whatever length you'd like and wrap them diagonally around a paintbrush, rolling pin, or any smooth cylinder that is the thickness you wish. You can let them dry completely on the form, or take them off in about 15 minutes and bend them into a shape other than a straight line.

To Make Curls: Curls can be formed on wires or not. To make them without wires, simply make a rope of gumpaste as long and as wide as you wish, bend it into a curl, then let it dry on a surface dusted with cornstarch to prevent it from sticking. Turn it over after about 8 hours to make sure that it dries completely.

To make the curl on a wire, do the same as above, but before placing it on the cornstarch to dry, insert a dampened #20 wire into one end, making

TO MAKE RUFFLES

sure you leave enough exposed wire (about 4 or 5 inches) to insert into the cake. Also, make sure that there is enough wire in the gumpaste so that the bulk of the weight is not on a small bit of the curl. These are to be considered only for decoration purposes and are not to be eaten. Be sure to alert both the caterer and whoever is cutting the cake that these decorations cannot be served.

To Make Ruffles: Roll out a strip piece of gumpaste to about ⅛ inch thick and however wide you wish. Again, it's a good idea to make a pattern out of a strip of paper so that all the strips will be the same width. Brush water on one long side of the strip and then gather the damp edge into folds. Wet it again and attach it to the cake. Use toothpicks to raise the folds slightly until the ruffle sets in place.

TO MAKE TASSELS

To Make Tassels: You can use a clay gun, a garlic press, or a potato ricer to extrude gumpaste for tassels. First, start with a small cone of gumpaste. This will serve as the inside shape of the tassel. Squeeze out very thin, long tubes of gumpaste through the clay gun or other tool and cut into lengths the same as the height of the cone. Use water to glue the tubes to the cone, covering it completely. You can then add small balls of gumpaste to the top of the tassel to make the decorative gathered top.

To Make Fantasy Flowers and Leaves: To *make a ribbon rose*, roll out a strip of gumpaste about $\frac{1}{16}$ inch thick, about 2 inches wide, and 6 inches long. Fold the strip lengthwise in half, but do not crease the fold. Hold the end in

TO MAKE FANTASY FLOWERS AND LEAVES

your hand and start rolling the strip, with the folded side facing up. After one and a half turns, pinch the bottom of the strip, then continue rolling and pinching until the flower is the size that you want. Break off the excess at the bottom and let the flower dry upright in bumpy foam.

To *make a matching leaf,* cut a triangle of gumpaste the same thickness as the flower, and roll over two of the sides. Pinch together the two points on the unrolled side. Let dry.

To *make a polka-dotted round flower,* cut out a curved strip of gumpaste about 1 inch wide and 5 inches long with rounded ends. Hold one end in your hand as you gather the long edge at intervals, pleating until it meets the end and makes a cup shape. Let dry upright. Pipe black royal icing dots around the flower and add a center, which is a half-ball with small circles indented in it with a #3 tip. Paint these with raspberry luster.

Wavy flowers are made like the polka dot flowers above, except the strip has straight sides. Let the outer edge ruffle as you gather it. Place a ball of gumpaste in the middle. Dry in bumpy foam.

To *make the wrapped buds,* shape a teardrop out of gumpaste. Then cut a thin strip of gumpaste and begin wrapping it diagonally around the bud, letting the top of the teardrop show.

To *make quilled flowers, leaves, and butterflies,* roll out strips of gumpaste about $1/16$ inch thick and ¼ inch wide. Roll them, as they stand on their sides, as tightly or as loosely as you wish. To make a curl, simply lay the strip on its side and arrange into a curl. To make teardrop shapes, brush a little water on the ends, and press them together. Let the loop dry on its side. To make multiple layers, such as the butterfly wings, start on the inside with the smallest loops and then add longer loops, gluing the ends together as you add them.

Cutout flowers and leaves can be made using a variety of cutters and gumpaste tools to emboss different patterns into them. Let them dry flat or on a flower former if you wish to have them curved.

To Make Plaques and Collars: You can make large pieces in gumpaste, such as plaques, saucers (for the teacup cake), and collars, which are gumpaste or

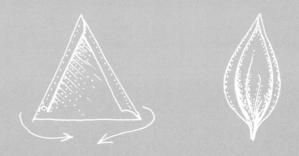

TO MAKE A MATCHING LEAF

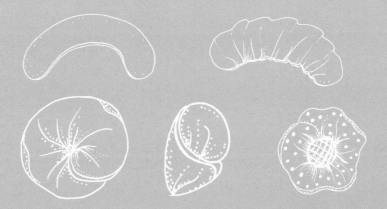

TO MAKE A POLKA-DOTTED ROUND FLOWER

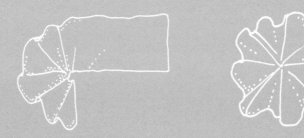

WAVY FLOWERS

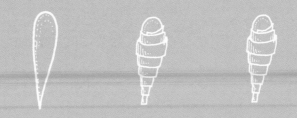

TO MAKE THE WRAPPED BUDS

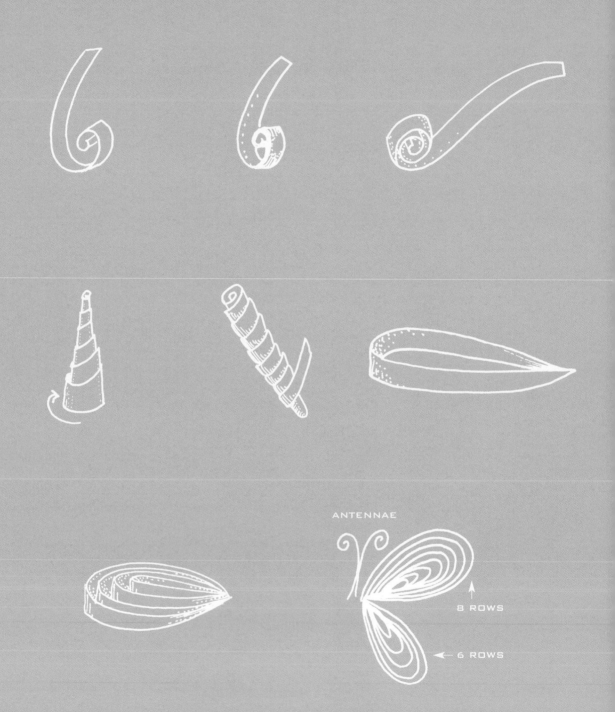

TO MAKE QUILLED FLOWERS, LEAVES, AND BUTTERFLIES

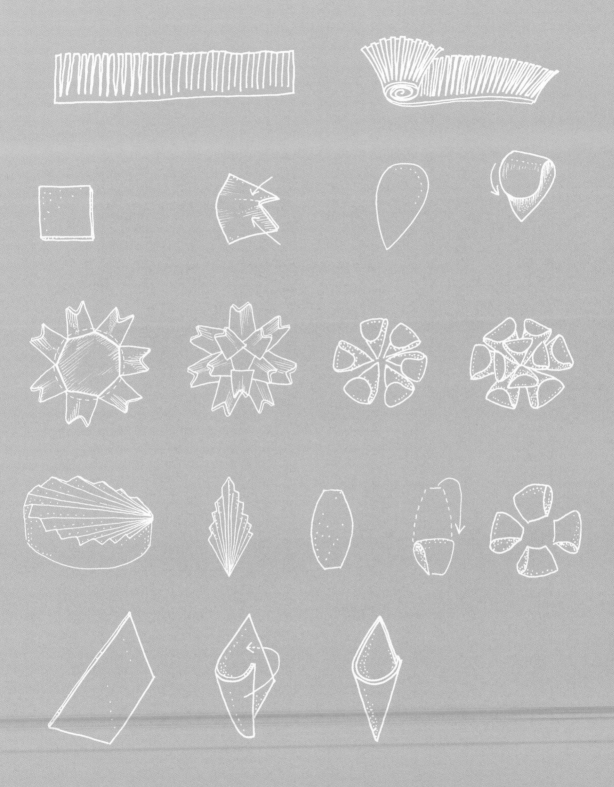

royal icing pieces attached to the top of the cake that extend past the edges of the cake. These can be simply rolled out to about ⅛ inch and cut into whatever shape you wish, then dried on a flat surface and dusted with a thin layer of cornstarch, which keeps the piece from sticking. After 24 hours, flip the piece over and let it dry on the backside for 24 more hours. This way it will be totally flat and totally dry.

PIPING TECHNIQUES

Piping is like handwriting—everyone's is unique. To me, piping is the most skillful and creative, yet difficult technique used by the cake decorator. In addition to technique, consistency of the icing is important because it makes the movements flow with ease or difficulty. It is, literally, the icing on the cake. Like anything else, piping takes practice. When piping borders, designs, or other repetitive parts of a cake, it is easiest to have the icing slightly softened, by adding a little water.

Decorating tip: If you don't fill the bag much, it will be a lot easier to pipe and the risk of carpal tunnel syndrome will be greatly reduced.

Braids: Hold the tip at a 45-degree angle and pipe with a continuous spiral motion as you move the tip sideways. You can use a round tip or a star tip.

Curls: See straight lines or curls.

Daisies: To make simple flowers, use the teardrop technique mentioned on page 238, and pipe a circle of teardrops with the points facing the center. Pipe a stem if needed.

Dots: Dots are made with a round tip that can range in size from #00 to #12. Hold the tip perpendicular to the cake and apply steady pressure to the pastry bag. Squeeze until the dot is the size you want. Slowly pull the tip away from the dot with a slight swirling motion so that the dot is round, not pointed.

Dots on wires: To make the decorative curled wires with royal icing dots, bend a #20 wire into the curve that you wish. Using needle-nose pliers helps

BRAIDS

DAISIES

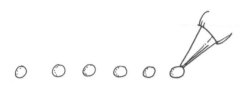

DOTS

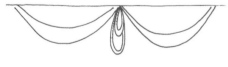

DROP STRINGS

a lot. Lay the wire down on a piece of waxed paper, and try to get the wire to lie as flat as possible. Slightly soften some royal icing so that a dot piped out on the paper will not come to a point. Pipe dots with the #2 tip along the length of the wire. Remember to leave the end uncovered so you have a length to go into the cake.

Drop strings: These are piped on the side of the cake and are simply formed by gravity. Touch the end of the tip to the cake to attach the icing, then pull the tip away from the cake as the icing flows out of the bag. It will automatically make an arc as it drops. Move the icing across the cake sideways until you reach the distance and depth that you want. Then touch the icing to the cake to end it.

To make a closed drop string, attach the icing to the cake, let the icing fall from the tip to the length you want, then attach the end of the icing to the same place it started.

Loops: These are made the same way as braids, only the strokes are much larger and open.

Overpiping: This simply means piping something on top of another piped design to create a more elaborate and richly textured design. The effect can be enhanced by using a different color of icing, another size or kind of tip, or an entirely different technique.

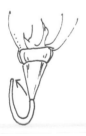

TO MAKE A CLOSED
DROP STRING

LOOPS

OVERPIPING

Shells: Shells can be made with many different tips, but usually a star tip is used. Apply pressure and build up a little icing, moving the tip forward, then pull the icing backwards, to a point, by dragging the icing on the surface. Repeat by placing the next one on top of the tail of the first one. Start slowly in the beginning, and when you become more proficient, you can go a little faster.

Snail trail: Pipe teardrops in a row without stopping. You will make what looks like a continuous dotted line, which is called a snail trail.

Straight lines or curls: When piping lines that are either straight or curled, first touch the icing to the surface that will hold it. Then lift the tip off the surface as you squeeze, moving the tip in the direction you want the icing to flow. When you are finished with that line, simply stop squeezing the bag and touch the end of the tip to the surface to break off the icing. This will give you a much smoother and clean line.

Teardrops: These are simply elongated dots, again made with a round tip that can range in size from #00 to #12. Hold the tip at a 45-degree angle to the cake and apply steady pressure to the pastry bag. Pipe a dot, then drag it to form a point.

STRAIGHT LINES OR CURLS

RUN-IN SUGAR

This technique, in which thinned royal icing is piped into an outlined shape, is used to make many types of icing designs, from plaques to flowers. You can

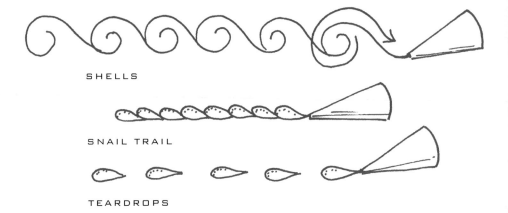

SHELLS

SNAIL TRAIL

TEARDROPS

also make decorations on wires, toothpicks, or bamboo skewers by laying the wire, toothpick, or skewer in the center of the outlined design before you fill it in. After the design is finished, the material is used to attach it to the cake.

To make a run-in-sugar design, place the pattern you want to reproduce on a flat surface and tape a piece of waxed paper or silicone-coated parchment paper on top. Outline the design with stiff royal icing, using the #2 tip for small or intricate patterns and the #3 tip for larger designs. Place some royal icing in a bowl and stir in a few drops of water. Continue adding water, a few drops at a time, until the icing has the consistency of corn syrup and a tea-spoonful dropped into the bowl disappears by the time you count to 10. (Be careful not to make the icing too thin, a common mistake that will cause it to break down and become weak.) Pipe the thinned icing into the outlined design with the #2 or #3 tip, filling in the entire shape.

Depending on the size of the design, and the amount of humidity in the air, the decoration will need to dry for 24 hours or more. I place my designs in the oven with the light on to dry them faster and to keep them shiny.

RUN-IN SUGAR

When coloring royal icing for run-ins, be careful not to make the colors too intense. The pigment will also break down the strength of the icing, and it's not necessary to make it as dark as you want it, because the icing darkens as it dries. So when you are adding color to the icing, make it a few shades lighter than you want; it will end up the right color.

If you are planning on using two or more colors in a run-in design, let the first color dry before you add the next to prevent the colors from bleeding into one another.

When the decoration is dry, gently remove it from the paper. If the design is on a wire or skewer, fill in the back of the design after the front has dried.

BRUSH EMBROIDERY

Many of my designs are inspired by stitchery, sewing, knitting, and other fabric techniques, since rolled fondant can be easily made to look like fabric and piping can look like stitching. I often make cakes based on details from a wedding dress, a favorite purse, or a leather bag. I use brush embroidery when I want to give a cake the look of embroidered fabric.

Brush embroidery must be done right on the cake, rather than in advance on waxed paper. Ideally, it is done with royal icing on rolled fondant or marzipan, although I know of people who practice this technique on buttercream or with buttercream.

The design is first drawn on the cake with an edible marker or toothpick, or embossed into the surface with a cutter or other tool, so you have a guide to follow. Then royal icing is piped on the outline of one petal or section at a time, tapering the icing at the end. You must work in small sections because royal icing dries quickly. The size of the tip is determined by the size of the design. I usually use a #2 PME tip, with slightly softened royal icing. After you outline a section of the design, use a damp paintbrush to pull the icing in toward the center of the design. If you are making a leaf, these should be done in halves. The brushstrokes should always go in the direction of the veins of the flower or leaf. You can leave as little or as much texture as you like by smoothing the icing a little or a lot. But for it to look like embroidery, you need to keep the brush strokes visible..

There are a number of ways to color brush embroidery. One way is to tint the royal icing before piping. This works fine for a design that uses just a few colors, but I generally prefer to pipe the design with white icing and then paint it. This way you have much more variation in the colors of your design, like painting a watercolor.

As with airbrushing, brush embroidery involves building up color from light to dark. I mix powdered color with water instead of lemon extract, which I normally use for making paint for a cake, because the water-based color doesn't set as quickly and is much better for blending. The exception to this rule is when I plan to paint brush embroidery with luster paint. Then I use lemon extract, since the luster dust doesn't mix well with water.

TO MAKE A KNOTTED BOW

SUGAR MOLDS

Sugar cubes are tiny sugar molds. So are hollowed-out sugar eggs at Easter time. A sugar mold is simply moist sugar pressed into a shape, just like a sand castle made on the beach with moist sand. It dries hard, can be hollowed out, and can be used for all sorts of decorations.

You can use any metal, plastic, or glass cup, bowl, tart pan, or measuring cup with a smooth surface as a mold. To make a sugar mold:

> 1 cup sugar
>
> 1 scant tablespoon cold water (liquid food coloring can be added to the water)

Place the sugar in a bowl and add the cold water. Mix the sugar with your hand until all of it is damp. I know it's messy, but using your hand will make it easier to tell when the sugar is thoroughly mixed. If you want the sugar to be colored, add a few drops of liquid food coloring to the water before mixing it with the sugar.

Pack the sugar tightly into the mold, firmly pressing it in with your fingers. Level the top and invert the sugar onto a cookie sheet. Gently lift off the container. If the sugar doesn't come out easily, pick up the container, turn it over again, and tap the bottom. Let the sugar dry overnight, upside down. Don't disturb the mold or it will crumble.

If you want to make the form hollow, before the sugar is completely dry, carefully turn it right side up and scoop out the damp insides with a spoon. Be careful not to remove too much, or you'll make the sides of the mold too thin.

Decorating tip: You can reuse the sugar you take out and use to make more molds. Let the mold dry completely, right side up, for 24 hours.

MAKING EDIBLE CRYSTAL BEADS

Growing sugar crystals is easy and fun, like a science project in grade school. They can be grown on gumpaste, fondant, chocolate, marzipan, or any other type of sugar material, as long as the surface is greased and covered with sugar.

TO MAKE THE CRYSTAL BEADS:

3 pounds granulated sugar

1 pound water

Place the sugar and water in a deep saucepan and stir until dissolved. (You can add a few drops of liquid food coloring at this stage if you want to give the sugar a tint.) Bring to a rolling boil without stirring. Turn the heat off and cover the pan with plastic wrap. Do not disturb the pan. Let it sit overnight to cool completely.

In the meantime, make gumpaste ovals on pieces of #28 wire. Make these by rolling out a small piece of gumpaste and then rolling it into an oval shape, or whatever other shape you desire. Make a tiny hook on the end of the wire, which should be about 4 inches long. Wet the hooked end of the wire with a little water, and insert the bead. Place the wire into a piece of Styrofoam to set. When you are ready to make the crystal beads, paint a thin coating of shortening on each gumpaste bead and sprinkle each one with granulated sugar. This will help the crystallization process get started. Bend the ends of the wires and hang them from a dowel, suspending them over a shallow pan.

Pour the sugar syrup into the pan, making sure that the beads are totally covered, that they don't touch each other, and that they are not touching the sides or bottom of the pan. If they touch anything else, the crystals will connect themselves to the two surfaces touching. Let this sit *uninterrupted* for two or three days, as the crystals grow. If the mixture is moved or disturbed, the growth will stop.

Materials

STYROFOAM

Styrofoam has many uses for the cake decorator, from holding bouquets and flowers, to disguising itself as a cake layer when a larger-looking cake is desired. It is available in two types, one with a dense, coarse texture and the other composed of small beads, making it softer and more flexible.

Styrofoam comes in many sizes and shapes, including disks, sheets, cones, eggs, and balls, which can be found at craft, art-supply, and cake-decorating stores. It's easy to cut and shape, and is both lightweight and strong.

Styrofoam cake dummies can be purchased in the same sizes and shapes as cake pans. These are used for making display cakes, but they are still decorated with icing as if they were real cakes. To cut and shape Styrofoam to make your own shapes, use a serrated knife. Cut in a sawing motion as if you were slicing bread. Cut the Styrofoam roughly, then sand it with a piece of coarse Styrofoam until it is smooth and the size and shape you want. You can also use a hot wire made specifically for cutting Styrofoam, but I think the burning fumes are not healthy to breathe. Try to work outdoors or over a trash can, as the Styrofoam will generate a lot of little shavings that will stick to everything in the room.

To decorate a Styrofoam tier, first hot-glue a piece of foamcore under the piece of Styrofoam as if it were a cake, so that it will have a surface for the dowels below to support, and so that no Styrofoam touches the icing on the cakes. Next, brush a little water onto the top and sides of the Styrofoam so that the fondant has something to make it stick to the sides of the "tier." The water makes the fondant sticky, a kind of "glue." Then, you can decorate the tier just as if it were a real cake.

CAKE DRUMS

A drum is simply a thick piece of Styrofoam placed between two tiers of a cake. The drum can be a way to make the cake look bigger, or it can be used as a section into which flowers are inserted. Drums usually are a more contemporary design element that replaces old-fashioned pillars. They can be round, square, oval, any other shape you want, to match the cake or to contrast with it. They can be an integral part of the cake design or only a place to put flowers. They can also be cut into wedges used when you want to make a crooked cake.

The cake below the drum is larger, while the cake above the drum should be larger than the drum but smaller than the tier below the drum. For example, if the bottom cake tier is 12 inches wide, and the cake above it is 8

inches wide, the drum should be 6 inches wide. It should be wide enough to be sturdy, but smaller than the top tier by about 2 inches.

Drums have to be covered with fondant, just as if they were made of cake, so that they are not obvious—they should blend into the design. Also, the Styrofoam should have a foamcore board under it, as would a cake tier, so that the dowels below don't push into the Styrofoam.

Basic Techniques

DIVIDING A ROUND CAKE EVENLY FOR DECORATING

When you want to create a design that is going to be equally spaced around the perimeter of a round or oval cake, such as quilting or string-work, you can use this easy way to divide it, which requires no math or measuring: Take a thin strip of paper (like that used in an adding machine, or you can make your own) and wrap it around the fondant-covered tier. Cut it so that it is the exact size of the perimeter of the cake. Fold it in half, then into fourths, then eighths, then sixteenths, stopping when the divisions are the size that you would like. Then unfold the paper and rewrap it around the cake. Use a toothpick to mark the divisions in the fondant. This technique only works if you want multiples of four; otherwise you will have to measure.

SCULPTING A CAKE

To make a different shaped cake (other than the shape that comes from the pan), you need to carve it as if it were a piece of sculpture. First, draw the design on graph paper, top and sides, to use as a guide while you are carving. Then find a pan or pans that are the closest size and shape to the design you want, so that you will have as little waste as possible.

The type of cake that you bake is important, because the cake should be dense enough so that it doesn't fall apart while you're carving it. Cake mixes

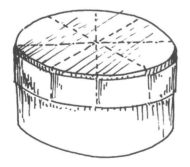

DIVIDING A ROUND
CAKE

are too soft to carve, so the best cake is one made from scratch; these tend to be firmer and denser. After baking, the cake should be chilled and then filled, which also makes it easier to carve. Use a small serrated knife and cut small amounts off as you go. Use a turntable so that you can turn the cake to see all sides easily as you work.

When you have finished carving, give the cake a crumb-coat of icing to smooth out any rough edges that you may have. You can also add a little icing here and there to build up areas that may have been cut away a little too much.

GETTING CAKES FROM HERE TO THERE

When you spend a long time designing and making a cake, you want the cake to get to its destination in one piece. I am always being asked if I have ever had any cake disasters. Well, I haven't had any that I couldn't fix. The main thing to remember when delivering a cake is to plan ahead and anticipate any possible problems that might arise. Here are a few guidelines for delivering cakes:

1. Put the cake in a box that is the same size as the base board. Make sure that no decorations hang over the edge of the board. If they do, you should use a larger box, but tape the board to the bottom of the box—this will keep the cake from sliding around in the box. Concerning boxes, make sure that if someone is picking up a cake or you are delivering a very large cake, that you ask how big the doors are. I once had to deliver a cake to a private jet that was going to Florida. I asked how big the doors to the plane were, and they said they were "huge" and not to worry. Well, when I got to the airport, the door of the tiny plane was about 18 inches wide and the box was 22! We had to take the cake out of the box on the runway, during a blizzard, tilt it sideways to get it through the door, and then try to find a place to put it in the plane. Well, it did get there in one piece, luckily. So, ask anyway.

2. Make sure that your vehicle is air-conditioned in hot weather. Don't put cakes in the trunk.

3. If your cake is tiered or if you are using pillars, or if there is a heavy decoration on the top of the cake, put the cake together when you get to the party. Leave yourself enough time so that you're not rushing to finish when you get there. If you must bring the cake in one piece, put a dowel all the way through the cake (see "Reinforcing the Cake for Delivery," page 8).

4. Always bring a repair kit. I usually bring extra icing in a pastry bag, an X-acto knife, needle-nose pliers, extra flowers and leaves, and an offset spatula.

5. Make sure that you have correct directions to the event. Check a map or go on the Internet before leaving with the cake. Always allow plenty of time for driving, getting lost, and making any touchups that may be needed. Bring a cell phone and the phone number for your destination.

6. Always bring a camera and film. The cake will always look better in the party setting on a beautiful tablecloth than it will in your kitchen, so take a picture of it in its place. You'll also have a record of your work for your portfolio. If you can't take a picture of the cake yourself, ask the customer if you can have a photo of the cake taken by their photographer. They will usually oblige.

Quick Reference Guide to Tools and Ingredients

AIRBRUSH: Used for spraying a fine mist of food color onto cakes, cookies, gumpaste flowers and leaves, etc. The brush is controlled by a simple lever and is attached to a compressor, which sends the air through the brush and mixes it with the paint.

BALL TOOL: A gumpaste tool, which is made up of 2 different sized balls on either end of a dowel. These come in plastic or metal, but I prefer the metal ones because they tend to be much smoother. Found in cake-decorating stores.

BUMPY FOAM: Foam rubber used for mattresses, on which gumpaste or fondant pearls can be dried to keep them round.

CAKE DRUM: A solid nonedible separation in between tiers of a cake, usually smaller than the tiers above and below it. These usually take the place of the old-fashioned pillars, but are also used to add height to the cake.

CLAY GUN: A potter's tool used by cake decorators to extrude fondant, gum paste, modeling chocolate, or marzipan. The clay gun comes with various dies, which have openings of different shapes.

CLOTH-COVERED WIRES: Available in white or green and in a range of thicknesses from #20 (the thickest) to #28 (the thinnest). Used for stems for flowers and leaves made of gum paste or royal icing. Found in florist shops and cake-decorating stores. Also known as florist wire.

CORNSTARCH PUFF: I like to use the foot of a new pair of panty hose to make a cornstarch bag, which makes it easy to dust the surface of your table, or other things. You can also use cheesecloth or a sugar dredger (available from Wilton).

COUPLERS: Plastic couplers make it easy to change tips on a pastry bag. The coupler fits inside the bag and the tip fits on top, secured by a threaded ring. All tips, except for very small and very large ones, fit onto couplers. Large and small tips can be placed directly in the pastry bag, but they cannot be changed once the bag is filled with icing.

CRIMPERS: Pronged decorative tools for embossing rolled fondant, marzipan, modeling chocolate, or gum paste. They are designed to work like tweezers, with the ends embossing a design when pinched into soft icing. They come in a variety of designs and sizes.

CUTTERS: Tools for making a variety of shapes, flowers, and leaves.

DOWELS: Used for supporting tiered cakes, ¼-inch-thick wooden dowels can be purchased at hardware or cake-decorating stores.

DRAGÉES: Gold and silver candy balls that add sparkle to cakes. They are nontoxic, but the Food and Drug Administration recommends that they be used only for decoration. Dragées are currently unavailable in California. They can be ordered from the New York Cake and Baking Distributor.

EDIBLE MARKER: Felt-tipped marking pens made for cake decorating, which contain food coloring for the ink.

FLORAL TAPE: A crepe paper type of tape used to cover wires and to bind flowers and leaves together. Commonly found in brown, white, and green, but also available in other colors at cake-decorating and craft stores.

FLOWER FORMERS: A curved white plastic half-length tube, made by Wilton, which comes in three different sizes, used to dry pieces of gumpaste or other materials in a curve.

FOAM PAD: Firm foam rubber used as a surface for thinning and ruffing gumpaste with ball or veining tools. Can be purchased at cake-decorating or gardening stores.

FOAMCORE: A thin piece of Styrofoam sandwiched between 2 pieces of thin white cardboard. Commonly used for matting posters, foamcore is the perfect material for cake bases and support boards for tiers. It is much stronger than corrugated cardboard and does not bend as easily or absorb grease. It can be cleanly cut with an X-acto knife into any shape. Available at craft and art-supply stores.

FOOD COLORING: Food coloring comes in many forms, including paste, powder, and liquid. Paste is the most concentrated type. A little dab on the end of a toothpick is usually all you need to make a pastel tone for gumpaste, fondant, modeling chocolate, or marzipan. Found at cake-decorating supply stores.

Powdered food color is used for metallic and iridescent effects or to create very deep colors. Flowers can be dusted with powder to make them look

more realistic. You can paint with iridescent powdered colors by adding a few drops of lemon extract. Metallic powders are nontoxic but should be used for decoration only.

Liquid food color, commonly found in the grocery store, sometimes comes in handy; however, to achieve a dark color you must add large amounts, which will thin the icing and make piping difficult. Liquid paste, found in cake-decorating stores, is highly concentrated but thinner than paste coloring.

Airbrush color, manufactured specifically for use in the airbrush, is a thin, water-based liquid. Available at cake-decorating stores.

GLUCOSE: A thicker version of corn syrup, used for making rolled fondant. Available at cake-decorating stores.

GLYCERIN: A thick, sweet oily syrup that keeps fondant soft and pliable. It can also be used for thinning paste coloring. Available at cake-decorating stores.

GUMPASTE TOOLS: A variety of gumpaste tools for shaping and modeling can be found at cake-decorating stores. See the section on gumpaste.

HOT GLUE GUN: It may seem like this is an odd item to be used around food, but actually I use it all of the time, from gluing ribbon onto the edge of the board to attaching a styrofoam ball to the inside of a sugar mold. Of course, this is for nonedible decorations only.

ICING SMOOTHER: A flat paddle-shaped piece of smooth plastic with a handle used for smoothing rolled fondant onto the surface of the cake.

LEMON EXTRACT: Flavoring found in the grocery store that contains a high amount of alcohol and is mixed with luster dust; it makes a quick-drying paint.

LUSTER DUST: Nontoxic food coloring with a pearlized luster. Used mostly as a paint, mixed with lemon extract.

PAINTBRUSHES: Flat or round, soft paintbrushes and pastry brushes come in handy for almost every aspect of decorating. Natural-hair brushes are recommended over synthetic ones.

PASTA MACHINE: A machine for rolling out pasta is also a great tool for gumpaste, modeling chocolate, and fondant. Used instead of a rolling pin, it saves a lot of time and effort. A motorized model makes the work even easier because it permits you to use both hands.

PASTRY BAGS: Lightweight polyester pastry bags are recommended over cloth ones, which are bulky and hard to clean, or disposable plastic bags, which tear easily.

PIPING GEL: Ideal as a clear, edible glue, piping gel also comes in colors. I prefer to add liquid colorings to clear gel to create my own tones for translucent decorations like gemstones. Available at cake-decorating and grocery stores.

PIZZA CUTTER: Handy for trimming rolled fondant and for cutting strips of gumpaste or modeling chocolate.

PME TIPS: Stainless-steel and seamless piping tips, which are a little expensive, but worth it for piping delicate stringwork and brush embroidery.

PRUNING SHEARS: For trimming wooden dowels.

ROLLING PIN: A large rolling pin is essential for rolling out fondant, and a small wooden or plastic one for rolling out gumpaste. There are also many textured or patterned rolling pins you can find at cake-decorating stores.

SILICONE VEINERS: Flexible food-grade silicone molds used to emboss realistic veins in gumpaste, fondant, or modeling chocolate flowers, leaves, or other decorations. Can be purchased from cake-decorating stores.

STYROFOAM: Used for making dummy layers, drums, and wedges. Found at craft or cake-decorating stores. See the section on Styrofoam.

TIPS: There are hundreds of decorating tips to choose from. Beginners may want to purchase a basic set and buy additional tips as needed. I use small round tips more than any others. PME brand tips are seamless and more expensive than ordinary seamed tips, but for certain techniques, such as stringwork, they are essential. Tips with seams tend to force the icing out in spirals, whereas seamless ones form the icing in small straight lines. I suggest that even beginners buy a few of the more expensive tips, in sizes #1, #1.5, #2, and #3.

TRACING WHEEL: Used for embossing designs on rolled fondant, gumpaste, or marzipan. Some tracing wheels have a plain edge, others have teeth, making a dotted line, and some have a zigzag edge. Available in cake-decorating and sewing stores.

TURNTABLE: Invaluable for working your way around a cake. Cake-decorating stores sell turntables on stands, but you don't have to buy an expensive model; the plastic ones carried by most hardware stores, designed for storing spices, work nicely and will support even very heavy cakes.

TYLOSE: An ingredient in gumpaste, which takes the place of gum tragacanth, a more expensive natural ingredient. CMC can also be used to replace tylose or gum tragacanth. Used to help dry gumpaste in humid weather.

VEINERS: Plastic or X-acto knife: I use an X-acto knife with a long, pointed blade (#11). The knife has a thin handle and a blade that screws in and can be changed easily. You will need a lot of extra blades because they tend to dull quickly. They can be found at craft and art-supply stores.

VEINING TOOL: A gumpaste tool usually used for making embossed lines in leaves and flowers.

Sources

AMERICAN BAKELS
Ready-made rolled fondant in a variety of colors and flavors, as well as ready-made gumpaste.
(800) 799-2253

AVALON DECO SUPPLIES, INC.
Ready-made gumpaste and royal icing flowers, and dragées.
P.O. Box 570
Glen Cove, NY 11542-0570
(516) 676-1966, Fax: (516) 676-6076
e-mail: info@avalondeco.com
www.avalondeco.com

BERYL'S CAKE DECORATING AND PASTRY SUPPLIES
Bakeware and decorating supplies, by mail order only.
P.O. Box 1584
North Spring, Springfield, VA 22151
(800) 488-2749 or (703) 256-6951
Fax: (703) 750-3779
e-mail: beryls@beryls.com
www.beryls.com

CK PRODUCTS
Cake-decorating supplies.
310 Racquet Drive
Fort Wayne, IN 46825
(260) 484-2517 or (800) 837-2686
Fax: (260) 484-2510

COUNTRY KITCHEN
Retail cake-decorating supplies.
310 Racquet Drive
Fort Wayne, IN 46825
(219) 484-2517
Fax: (219) 484-2510

CREATIVE CUTTERS
Gumpaste cutters and decorating supplies.
561 Edward Avenue #2
Richmond Hill, Ontario L4C 9W6
Canada
(905) 883-5638, Fax: (905) 770-3091

FOR U.S. CUSTOMERS:
Tri-Main Building
2495 Main Street, #433
Buffalo, NY 14214
(888) 805-3444

COLETTE'S CAKES
www.colettescakes.com

INTERNATIONAL CAKE EXPLORATION SOCIETY (ICES)
An organization geared to cake-decorating enthusiasts, hosting an annual convention in August.
www.ices.org

KOPYKAKE
Airbrushes and airbrush supplies.
3699 W. 240th Street
Torrance, CA 90505-6087
(310) 373-8906, Fax: (310) 375-5275

NEW YORK CAKE AND BAKING DISTRIBUTOR
Cake-decorating and baking supplies.
56 West 22nd Street
New York, NY 10010
(800) 942-2539 or (212) 675-CAKE

NOTTER SCHOOL OF PASTRY ARTS

Classes in pulled sugar, chocolate, and cake decorating.
8204 Crystal Clear Lane
Orlando, FL 32809
(407) 240-9057, Fax: (407) 240-9056
e-mail: notterschool@aol.com

THE DUMMY PLACE

Styrofoam dummies, foamcore boards cut to any size.
44 Midland Drive
Tolland, CT 06084
(860) 875-1736

SUGARPASTE, LLC

538 East Ewing Avenue
South Bend, IN 46613
(574) 233-6524
www.sugarpaste.com

WILTON ENTERPRISES

Bakeware, decorating tools, edible supplies, and
decorating classes.
2240 West 75th Street
Wooderidge, IL 60517
(800) 942-8881
www.wilton.com

Index